art:21

Eleanor Antin

Janine Antoni

Charles Atlas

Vija Celmins

Walton Ford

Trenton Doyle Hancock

Tim Hawkinson

Elizabeth Murray

Gabriel Orozco

Raymond Pettibon

Paul Pfeiffer

Martin Puryear

Collier Schorr

Kiki Smith

Do-Ho Suh

Kara Walker

Interviews and essay
by Susan Sollins

Edited by
Marybeth Sollins

art:21

ART IN THE TWENTY-FIRST CENTURY

2

HARRY N. ABRAMS, INC., PUBLISHERS

For Harry N. Abrams, Inc.:
Project Director: Margaret L. Kaplan
Production Manager: Maria Pia Gramaglia

For Art21, Inc.:
Assistant Curator: Wesley Miller
Designer: Russell Hassell

Library of Congress Cataloging-in-Publication Data

Art 21: art in the twenty-first century 2 / by Susan Sollins.
 p. cm.
Summary: Companion book to Art in the Twenty-
First Century, the first broadcast series for National
Public Television to focus exclusively on contempo-
rary visual art and artists in the United States today.
 ISBN 0-8109-4609-2 (vol. 2)
 1. Art, American—20th century. 2. Art—
Forecasting. 3. Artists—United States—Biography.
4. Artist—United States—Interviews.
I. Title: Art in the 21st century 2. II. Title: Art
twentyone. III. Sollins, Susan.
 N6512.A6685 2001
 709'.73'09051—dc21 2001001268

Published in 2003 by Harry N. Abrams, Incorporated,
New York

Printed and bound in Singapore
10 9 8 7 6 5 4 3 2

Harry N. Abrams, Inc.
100 Fifth Avenue
New York, N.Y. 10011
www.abramsbooks.com

Abrams is a subsidiary of

LA MARTINIÈRE GROUPE

Endpages
Walton Ford, *Falling Bough*, detail, 2002. See
pp. 130–31

Pages 2–3
Trenton Doyle Hancock, *Strudi Flooo*, detail,
2002. Mixed media on felt, 78 x 127 inches
Collection of Linda Pace, San Antonio

Pages 4–5
Raymond Pettibon, Installation view at Regen
Projects, Los Angeles, 2002. See p. 149

Page 7
Kiki Smith, *Constellation*, detail, 1996.
See pp. 46–47

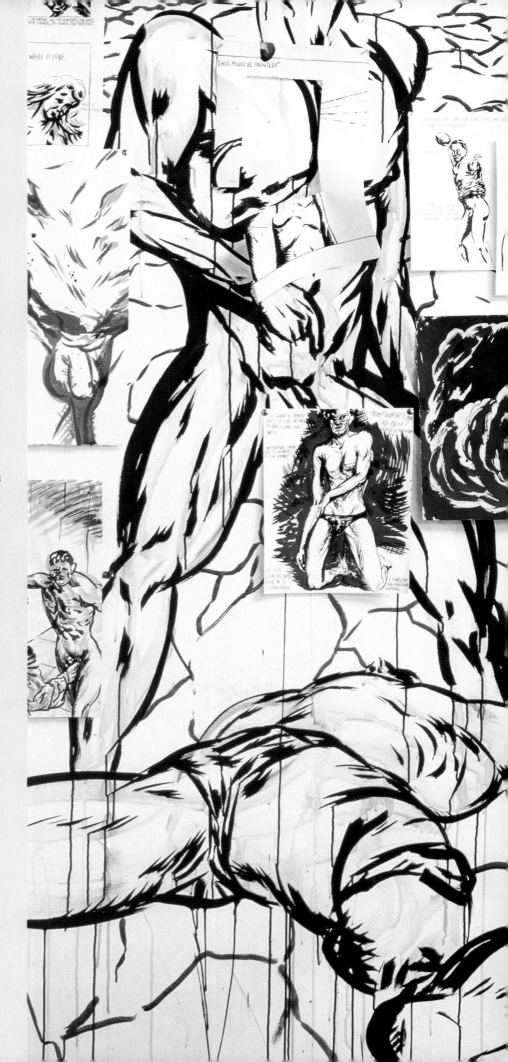

Contents

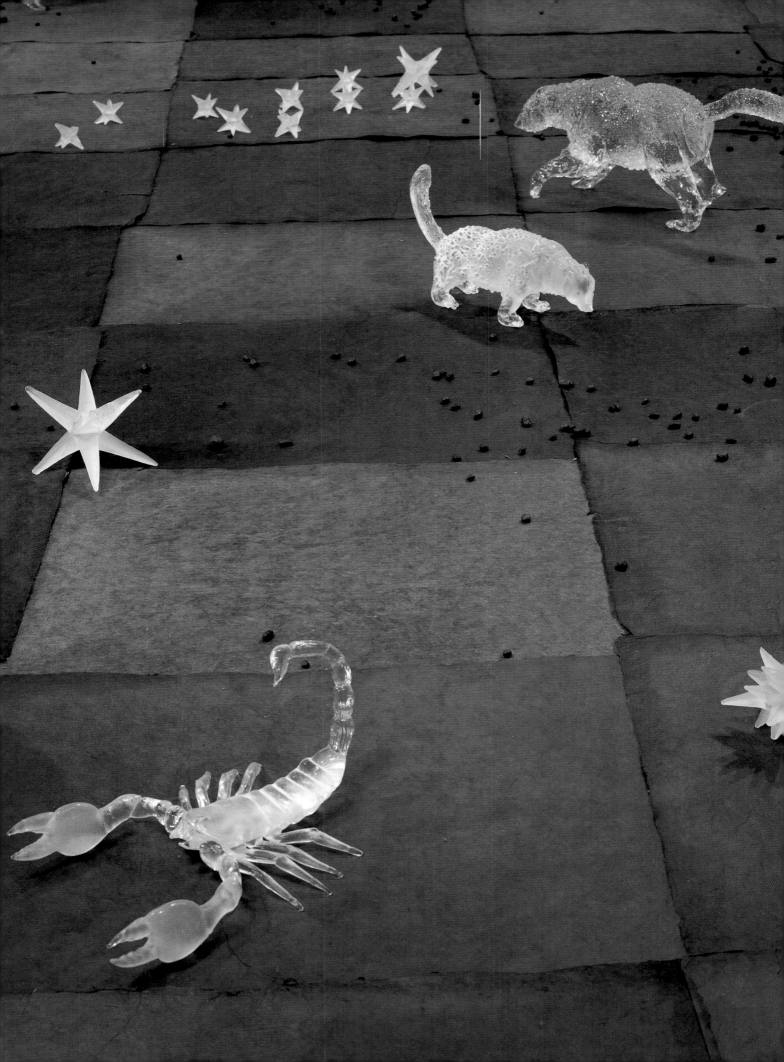

Acknowledgments

It is with great pleasure that I prepare these acknowledgments in anticipation of the publication of this volume and the opening broadcast of Season Two of the television series, *Art:21—Art in the Twenty-First Century*. Once again, I extend my thanks to Art 21's diligent and dedicated staff, without whose creative vision this second season would not have been possible. I am grateful to Series Producer Eve Moros Ortega; Associate Producer Migs Wright; Assistant Curator and Web Producer Wesley Miller; Production Manager Alice Bertoni; Director of Education and Outreach Jessica Hamlin; and Development Associate Sara Simonson for all their contributions to the project.

I extend my thanks to Margaret L. Kaplan, Editor-at-Large, Harry N. Abrams, Inc., who has been a strong advocate for the publication of the companion volumes for Seasons One and Two. I am also grateful to Glenn DuBose, Senior Director of Fiction and Performance Programming, Public Broadcasting System, and to Dorothy Peterson, Project Development Officer, Corporation for Public Broadcasting, for their steadfast encouragement and support; to Consulting Director Charles Atlas and Producer Catherine Tatge; Editors Joanna Kiernan, Kate Taverna, and Steven Wechsler; and to the directors of photography and film-crew members who provided invaluable professional expertise. In addition, I would like to thank Art 21's full-time interns, Daniela Leonard and Morgan Soloski.

Neither this volume, nor the television series, education programs, or website would exist without the generous support of Art 21's funders: the Corporation for Public Broadcasting and the Public Broadcasting Service; the National Endowment for the Arts; Agnes Gund and Daniel Shapiro; the Allen Foundation for the Arts; Bloomberg; the Jon and Mary Shirley Foundation; the Non-Profit Finance Fund; JPMorgan Chase; the Andy Warhol Foundation for the Visual Arts; the Horace W. Goldsmith Foundation; NYFA's New York Arts Recovery Fund; the Peter Norton Family Foundation; the New York Times Company Foundation; the Dorothea L. Leonhardt Foundation; and the Elizabeth Firestone Graham Foundation. I would also like to acknowledge the extraordinary support and involvement of the Art 21 Board of Directors, its distinguished Advisory Council, and the Art 21 Education Advisory Council.

I owe special thanks for the provision of images reproduced in this volume to 303 Gallery; Ace Gallery; James Cohan Gallery; Galerie Chantal Crousel; Dunn and Brown Contemporary; Ronald Feldman Fine Arts; Marian Goodman Gallery; Paul Kasmin Gallery; Lehmann Maupin; Luhring Augustine Gallery; McKee Gallery; PaceWildenstein; Pace Prints; The Project; Regen Projects; Brent Sikkema; David Zwirner Gallery; and to the Bowdoin College Museum of Art; Magasin 3 Konsthall Stockholm; the Modern Art Museum of Fort Worth; the Museum of Fine Arts, Houston; the Seattle Art Museum; Wardell Photography; and David Woo. For their gracious assistance with this publication, I would like especially to acknowledge Nathalie Afnan, Catherine Belloy, Anders Bergstrom, Cathy Blanchflower, Julie Chiofolo, Monika Condrea, Genevieve Devitt, Talley Dunn, Nina Elköf, Jeanne Englert, Juliet Gray, Michael Jenkins, Catherine Ann Johns, Laura Latman, Meghan LeBorious, David McKee, Simone Montemurno, Steve Oliver, Ruby Palmer, Sarah H. Paulson, Shaun Caley Regen, Julie Sears, Niklas Svennung, Jonathan Turer, Wendy Weitman, Pamela Whidden, and Zachary Wollard.

I am grateful to my sister Marybeth Sollins for providing and developing the concept for this volume; for her editorial skills, guidance, and supervision of the production process; and for her thoughtful editing of my essay. Assistant Curator Wesley Miller worked prodigiously with the galleries and artists to select the images for the book, and assisted with tireless enthusiasm in the painstaking detail-work involved in all phases of the project. His suggestions concerning image selection and layout have been invaluable. I would also like to acknowledge Art 21 research interns Lila Kanner and Jeremy Zilar, who assisted in compiling information for this volume. To Russell Hassell, the designer who has created yet another splendid and beautiful publication for Art 21, I extend my admiration and gratitude. Once again, he has brought his vision and talent to bear on a difficult project and has designed a book that reflects Art 21's spirit and philosophy.

To each artist in the series I send my heartfelt thanks for sharing so much time with us, and for their generous and open participation in the series and its ancillary education projects. I owe special thanks, also, to Agnes Gund for her wisdom and help in forming the television series; to Susan Dowling—my lifelong friend, co-creator of the series, and co-Executive Producer of Season One—for her continued support as an advisor and creative participant; and to consultant Ed Sherin for his unflagging encouragement and advice.

In closing, I dedicate this volume and Season Two of *Art:21—Art in the Twenty-First Century* to the memory of my husband Earle Brown (26 December 1926–2 July 2002). His unwavering belief as a composer in the imaginative and communicative potential of art serves as a continuing inspiration.

Susan Sollins
Executive Producer and Curator
Art 21, Inc.

Inspiration at Eye Level Susan Sollins

The television series that this volume accompanies has been an adventure for me, as I was neither a filmmaker nor a television producer at its inception, having instead spent my professional life as a curator of contemporary art. As such, the thought of using public television as a venue for the presentation of contemporary art and artists was an irresistible challenge, especially because the reach of most traditional exhibition venues of contemporary art is small in comparison to that of television. Although my knowledge of filmmaking at the inception of this

Elizabeth Murray in
her studio
Production stills,
2003

project was slight, the parallels between organizing exhibitions and creating a series for television were many—including the need for coherence of concept and programmatic content. Now, having completed two production seasons of the television series, I have acquired some of the skills of the filmmaker but retain the collaborative bias of the curator, placing the highest value in dialogue with each artist in order to convey his or her ideas to the public. The world of the 'tele-gallery' created in the television series is boundary-free, infinitely accessible via computer, video cassette, and broadcast, and allows interaction and communication through its website on a scale far greater than normally possible in a traditional

gallery space. If proselytizing and advocating for contemporary art and artists is my curatorial mandate, as I believe it is, then this tele-gallery provides opportunities for that activity on a grand scale.

What we lack in the tele-gallery is the direct effect of the art object on the viewer; what is gained is immediate access to the artists as well as an understanding of the scale of each work, which cannot be experienced or reproduced through any other means except presence in the gallery itself. The tele-gallery also affords us the ability to pass through a kind of time-portal that allows us to supersede the limitations of looking at art works side-by-side as in a three-dimensional gallery space and, instead, to create unlikely and intriguing juxtapositions of works of art or artists. Since the medium of television frees us from the physical gallery space as well as the curatorial 'rules' that govern juxtapositions of objects, we can also discard the canon of likeness of form, medium, or style as an organizational motive in favor of a segment-to-segment interplay of ideas conveyed by the works of art and the models for creative thinking provided by the artists.

Television is a medium that condenses time; it provides us with rapidly paced visual and aural stimuli and has accustomed us to receiving constant parallel streams of information. We expect and demand from television, and from our computers, an experience that offers information and entertainment simultaneously, without lapses of intensity. Television viewers, like surfers on the Internet, are easily distracted and

constantly eager for fresh experiences and more excitement. It is an anomaly, then, that even in today's climate of media barrages of information and entertainment, the producers of most 'serious' television programs continue to rely on the talking head and traditional narrative format—standbys of the hour-long unit of passage through prime-time programming. It was the consideration of those aspects of television as well as an analysis of the requirements of today's television audience that led to the form of the current series, dividing the hour-long program into three or four segments, each about an individual artist. It is the consummate Warholian joke. Though no formula demanded it, the internal logic of the television format led to the allotment of approximately fifteen minutes per artist, thus equalizing the artists by allotting the amount of time Warhol predicted as necessary for fame. This gesture was not intended to diminish any one voice, but to provide a broader understanding of each of the artists through a cumulative juxtaposition of the ideas and works of several.

As I began working on the series more than five years ago, this was a leap of faith, a gamble that a different television form could be created to enhance subject matter that had heretofore been considered too challenging, if not intrinsically unsuitable, for nationwide prime-time broadcast. The deliberate elimination of the omniscient talking head—the interpretive, mediating voice of the narrator—allowed the revelation of the artists' voices. Those intimate voices have been prodded to strive for clarity through curatorial interviews and the editorial process, both in the broadcast series and in this volume, but the ideas, reflections, and discussions of working processes

come directly from each artist. There is no equivalent here of the didactic wall-text that serves in the museum context to mediate between artist, art work, and viewer.

The rejection of a lengthy film or hour-long television presentation of a single artist in favor of four segmented hours profiling several artists of varying ages, backgrounds, stylistic proclivities, and interests reflects the philosophy and mission of the series—to demystify contemporary art and make it accessible, inspirational, and enjoyable for a diverse audience nationwide. The segmented hour democratizes the artists by virtue of placing them in close proximity to their peers; the elimination of the narrator allows each artist to speak directly to each viewer. Instead of presenting the artist as a heroic, if not exalted, remote, and godlike, figure isolated by the eye of the camera and the voice of the interpreter, I have placed each artist in a variety of contexts—including those of community, family, work, and beliefs—that are familiar to us all.

Once the viewer 'meets' the artists in this series (who inevitably seem more like you or me, but with heightened sensibilities and sensitivities), the Romantic notion of the artist as an isolated genius is no longer plausible. Our longing to know the maker of the art trumps the outmoded, distancing notion of hero worship. As a result, the television series sets out a new model and a new, more human pantheon in which the 'gods', the

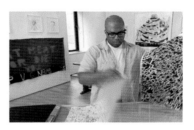

Trenton Doyle Hancock at James Cohan Gallery Production stills, 2003

Tim Hawkinson at home in Los Angeles Production stills, 2003

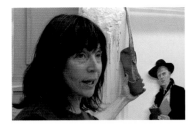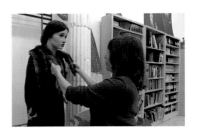

Eleanor Antin
in her studio
Production
stills, 2003

makers—those who have allowed their own creativity to flow—look us directly in the eye rather than observing from on high.

The new model of the artist revealed here is a figure who takes on the metaphorical Sisyphean task of pushing the boulder up the hill over and over again. The boulder is large: it represents an insatiable desire for knowledge, work,

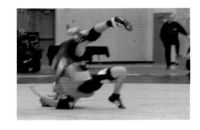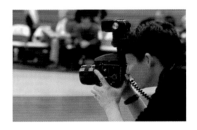

Collier Schorr
at a West Point
wrestling match
Production
stills, 2003

and the discovery that comes from the discipline of work. These artists never cease pushing the boulder: they work and work; they grapple with ideas; they think, study, and read; they seek out craftsmen or experts as teachers in methods that can enhance or advance their work; they pose and solve problems; they follow instinct, intuition, and curiosity. They

Kiki Smith at the
Johnson Atelier
Production
stills, 2003

are explorers. These artists redefine—or perhaps reject—the 'rules'. The heroic artist of the past seems, in retrospect, to have been a model of moral authority—a voice of certainty—that no longer exists in our culture, while the current model questions how to think and live.

The artists in this series, then, function as heroes of the everyday world, as people who vault over the mundane to find revelation, knowledge, or communication with others through art making. They exist very much in the present. They are, in general, immersed in family: parents, siblings, and children attend gallery openings; mothers, spouses, and partners assist in the making of art work; parents provide research skills; children are free to come and go in the artist's studio and to express opinions about the parent's work; and at least six of the artists in the current series have an artist-parent as role model.

Familial religious and cultural traditions —rather than being negated—re-emerge in the work, transformed. Eleanor Antin's political satire and her proclivity for performance stem from Yiddishkeit, her eastern European Jewish cultural background, while Trenton Doyle Hancock's visual and literary narrative, based in Biblical creation myths, constantly rolls through his mind's eye. His is a personalized creation myth, based in the lessons he absorbed as a child in the Texas church where his step-father was minister. Gabriel Orozco's analytical thought processes are filtered through the lessons of his Marxist education, which began in the private school chosen for him by his leftist parents in Mexico City. Janine Antoni and Kiki Smith have roots in Catholicism: for both, the figure of the Virgin Mary carries significant meaning and is a constant and rich source of imagery and allusion. For Paul Pfeiffer, the connections between art, religion, and human consciousness are significant: the titles of his works often come from the Bible or from religious paintings of the past. Religion can also

be seen as a touchstone in the work of Tim Hawkinson, especially when he uses sounds that derive from the Protestant hymns of his childhood in his large-scale installations.

Other themes and topics such as home, domestic concerns, sports, popular culture, political satire, performance, myth, alienation, identity, instability, and spirituality return again and again in the works of all the artists in the series. There is also dialogue and a kind of inspirational interchange between artists of different generations and across centuries about process and methods of operation. Kara Walker refers to the anonymous, itinerant silhouette artists of the late eighteenth and early nineteenth centuries, to Thomas Eakins's surgical theatre paintings, and to the tradition of history painting. When I interviewed Vija Celmins, we met at the Metropolitan Museum of Art where she examined and discussed her responses to works on paper by Morandi, Seurat, Dürer, and Goya, and the *Mont Sainte-Victoire* paintings of Cézanne, all the while wishing that there were time to take the film crew to see Jasper Johns's prints. Several artists in the series, including Raymond Pettibon, Elizabeth Murray, Walton Ford, and Trenton Doyle Hancock, revere and have found inspiration in the work of comic-strip artists. Both Walton Ford and Martin Puryear cherish the work of John James Audubon. Ford also refers to Bosch, Breughel, and Goya. Do-Ho Suh tells us of his own moment of revelation, as a student newly arrived from Korea in the 1990s, when he first saw Barnett Newman's paintings at the Museum of Modern Art. Until then, he had only known the work from books and reproductions, and so his first direct experience of both their scale and color was completely fresh and transcendently moving. Other artists of Newman's generation— Pollock, DeKooning, Gorky, and Guston— are important to Elizabeth Murray. For Collier Schorr, inspiration struck when she stumbled on a book about Andrew Wyeth and his model Helga. From this unlikely

encounter, Schorr developed a new body of work based on the resemblance between Helga and her own young German friend and model, Jens. This led her to re-explore the many poses of the model Helga and to transform the meanings of male and female with respect to both artist and model—another example of the slippery impermanence of life explored by many of the artists in this series.

In Gabriel Orozco's life, impermanence in permanence is also a factor: he lives in several countries but has no fixed place of work in any of them. In his work, he challenges rules by re-thinking games or re-making the contemporary icons of our culture. His is the work of a classicist, in the manner of the clear logic of his thinking, yet he remarks the accidental. His innate curiosity leads him to question assumptions and to apply a rigorous logic to the making of each work. In doing so he finds formal clarity—a peg in impermanence. Do-Ho Suh travels light: in a Duchampian gesture, he intends a recent work, *Seoul Home, L.A. Home,* to fit in a valise so that he can carry it—and his memories—with him wherever he goes. Kara Walker's cut-outs also have a quality of impermanence. She, too, can travel light: the cut-outs can be carried easily from place to place, to be re-installed as

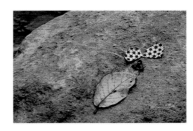

Gabriel Orozco
at home in Mexico
Production stills,
2003

Vija Celmins at
the Metropolitan
Museum of Art
Production stills,
2003

a new exhibition space dictates. Tim Hawkinson questions ideas about time and permanence in his work, *Slug*, in which a single gear makes a complete revolution only once in 10,000 years— an idea which, once grasped, transforms the sculptural object that contains the gear into the conceptual realm. Rather than addressing time and impermanence, Martin Puryear's major sculptures

Martin Puryear at the Paulson Press Production stills, 2003

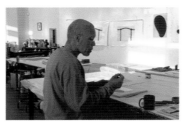
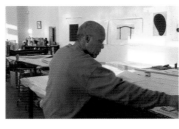

inherently speak to us of time and permanence. There is a sense of the ancient made new in his work: humanism breathes through his forms—forms that refer to archetypes, albeit archetypes that we cannot quite pinpoint or locate. And in works such as *Confessional* or *Meditation in a Beechwood*, there is an almost overt reference to a spiritual realm or to religion, topics that Puryear prefers to skirt in discussion but that are nonetheless powerfully present for the viewer.

charge, a quiet melodrama, a disquiet.

Meanings are often contradictory and layered. When Janine Antoni 'walks the horizon' in her video work, *Touch*, the act itself expresses the peace of the sublime coupled with an anxiety or inherent instability in the implied fall that could come, at any moment, as she balances between insubstantialities: air and water, sky and ocean, heaven and earth. As Kara Walker explains in reference to her reading of *Gone with the Wind*, she wants simultaneously to be the heroine Scarlett O'Hara and to kill her. Walker's works, like those of Collier Schorr and Do-Ho Suh, are also characterized by formal beauty and convey a sense of disquiet in their questioning of historic givens. Suh speaks in the series, and through his work, of the dehumanization caused by militaristic societies; Schorr, though at least two or more generations removed from direct experience of World War II, explores topics of twinship and opposition as they relate to German and Jew. And although humor and satire are potent weapons in Raymond Pettibon's arsenal, his targets are social injustice and issues of the political realm. His personal unease is palpably present. Charles Atlas frequently works in the tradition of the portraitist but uses neither paint, canvas, nor still photography, having instead discovered the structural possibilities of video and filmmaking early in his career. The theme of loss and desire is paramount for him, while considerations of humor, time, and narrative—all of which are treated in the television series and this volume—coexist in his work. For this reason, Atlas's pieces appear in this series as mini-videos which he created for each of the four introductory host 'opens.' Illustrations of his work appear in this volume as a separate section.

Kara Walker at the Tang Museum Production stills, 2003

Puryear's work shares a stillness and calm with that of Vija Celmins, but even in this realm of quiet, contemplative beauty there is a sense of alienation, the dislocation of the outsider looking in, that also resonates in some of the work of their younger colleagues. In Puryear's work there are many instances in which a mysterious form will not allow entry: you can look within, but you cannot enter. At times, one form is caged by another.

Walton Ford in his studio Production stills, 2003

Although formally different, there is in the work of both artists a ghost of something remembered, something haunting and ambiguous. In the case of Celmins's spider-web image, there is an emotional

Perhaps the disquiet I find in the midst of what I also see as works of considerable

Do-Ho Suh
at the Seattle
Art Museum
Production
stills, 2003

formal beauty is colored by the time in which I write, when Americans are at war in Iraq despite worldwide appeals for diplomatic engagement and restraint. If we do indeed sense that our society is in decline, that we approach the end of an era of American domination of the world, then we can see evidence of its foretelling in Eleanor Antin's recent *Pompeii* series; in Walton Ford's satiric, yet elegant commentary on nineteenth-century British colonialism; in Paul Pfeiffer's use of media and sports images to convey a sense of the loss of the soul in a moment of success; and even in the way that Elizabeth Murray's painterly forms, exuberant and joyful as they are, rap at us with an incessant instability as they cling to the wall.

Murray is essentially a painter's painter. Of her own work, she says, "You can't let your intellect get inside too much . . . with the kind of work that I do. If the intellect gets in . . . it takes away all your courage to just move into it." By this, I believe that Murray means that she is in constant search of the pure moment of communication between heart, mind, and hand when idea and form merge and sing—in contrast to the more common state of mental and spiritual disruption that is so familiar to all of us. And in Kiki Smith's work themes of death and morbidity are as constant as those that celebrate life and rebirth. The intrinsic instability and fragility of her works on paper counter the permanence of the sculptural work she casts in bronze. In a continuous process of renewal, Smith filters myths and mythic beings through her contemporary outlook and makes them real again for herself and us. Her working process, although often involving collaborators and assistants, also serves for her as a form of meditation and as an anchor to the realities of life.

In the future, when we look back at this series as an archive, it may be that we will find a story contained in it that is not the story we thought it might tell. For the element of story or narrative is implicit in all of the program hours, either directly in the work of the artists or indirectly through the unfolding of their personal histories. The 'story', after all, is what drives our culture twenty-four hours a day. For the news junky it is the unfolding of the current event; whether accurate or not, the story unfolds bit by bit—about a fire, a murder, a war, or the peccadilloes of a politician or public figure. For those who prefer softer or more crafted stories, there are television soap operas and the new 'reality' shows. The societal stream of consciousness that enters our minds and imaginations through the never-quieted voices and powerful visual imagery of television permeates our lives and culture. Other enduring and powerful forces, religious, mythic, and historic—and the desire to understand oneself and one's place in the world—are also at play in our cultural stew. And many of these derive from or feed into the story-telling realm. From the campfire to the television screen, we have held human interest by communicating with one another through words and images, by looking into the eyes of those surrounding us, by telling stories, by talking about ourselves, by solving problems together, and by making art. And so, it seems, in this age-old and simultaneously contemporary process—presented here via television and the printed word—artists are telling us their stories and, in doing so, telling us the story of art.

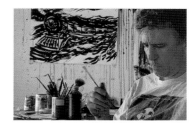

Raymond Pettibon
in his studio
Production stills, 2003

Paul Pfeiffer at
the MIT List
Visual Arts Center
Production stills,
2003

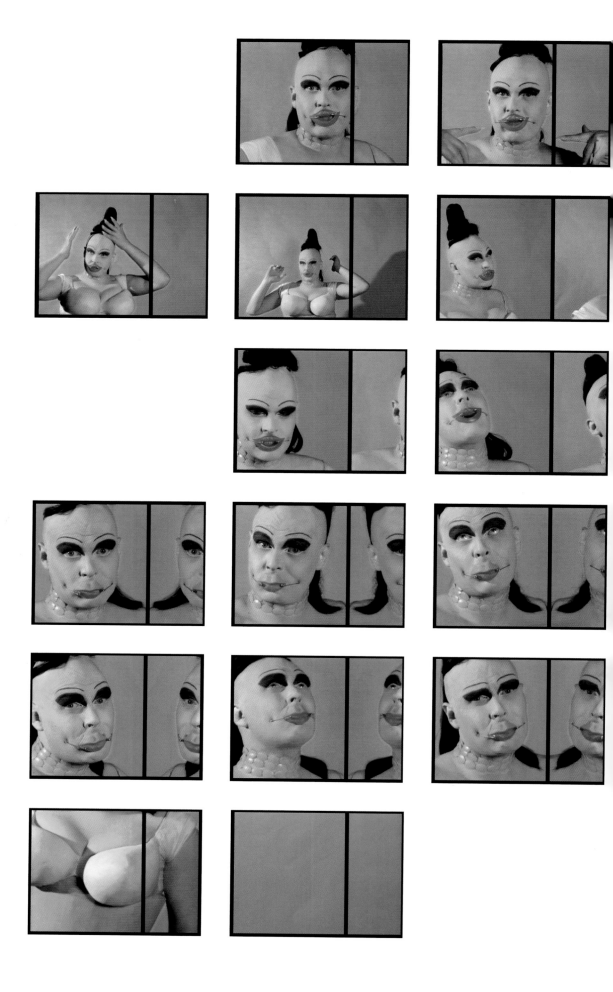

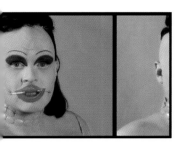

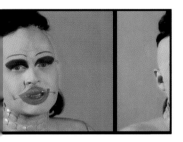

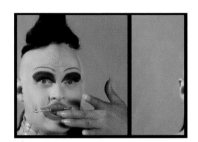

Charles Atlas

Charles Atlas created an opening segment for each one-hour program of the PBS television series. The images in this chapter are examples of his video installation work.

Why is there always irony in my work? It's just who I am. If I really let myself, if I don't have any really strict rules, the more I work on something the funnier it gets. It's kind of ironic humor, just kind of distanced. I find a lot of things funny. . . . I have sometimes made a conscious attempt to try to see if I could do something really straight. And I can, but I don't feel like I've gone as far as I can with it. You know, I feel like I am there on a formal level, but somehow part of me is missing.

I really work from the dance world, not being a dancer myself—but I'm very sensitive to time issues and how you fill time in various ways and with rhythm. All of my films, even from the very first film I made, have movement and rhythm. I'm really interested in time and the experience of time. . . . How long is the present? What is future?

Teach, 1992–98, with Leigh Bowery
Video installation, dimensions variable

Charles Atlas

Martha, Martha, Martha, Martha, Martha, 2000
Video installation, dimensions variable
Components: five video channels, black-and-
white and color, sound; 20 minutes; Five video
monitors with speakers; five DVD players; sync
box; architectural space, and specified lighting
Collection of the artist

Because We Must, 1989
Michael Clark, choreograpy
Videotape, color, sound, 53 minutes

I really wanted to develop a story idea, and had written the whole story around the piece *Because We Must* that was a theatre piece that Michael Clarke had done. So I'd written a story around it —a backstage story—about trying to solve a murder, in which the police had taken us backstage and people are coming off for their exits and having to answer questions. I really wanted to do something like that. But I had to drop the whole story idea and make another kind of piece. So I kept some of these backstage elements and then turned it into this other kind of piece that was more like a dream. . . . It starts in a normal theatre, and by the end you're in a video space completely. It was a very difficult piece to do, and I wasn't sure I should go ahead with it. The situation in Michael's company at that time was that there were a lot of drugs, and I really thought I had to reflect that reality. I thought if I could start with him throwing up that would really say it all for me. . . . And that's what I did. And then, they didn't want to put it on television. But you know, I wanted to reflect reality. I just can't do something that would have been dishonest. So in some way I felt that I was still making a piece that was real.

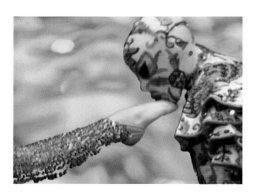

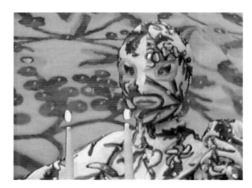

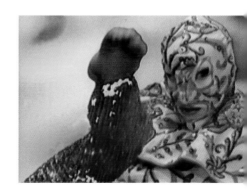

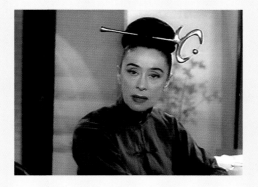

There was a monthly performance event called *Martha* @ Mother which started out at this tiny club down the street, on a really postage stamp-sized stage. The host and creator Richard Move impersonated Martha Graham.

The project was really to expand the notion of dance. Everything from gesture and facial expression to the sort of non high-art versions including burlesque and striptease and body dancing. So I had a lot of shots from burlesque movies and weird films and fetish films . . . and shots of children dancing. It makes me laugh to cut between Shirley Temple and a stripper.

I use references to everything, to Pop, just things that I find compelling to watch. The spirit of all this work was really stuff that I find either funny or beautiful that I wanted to share with people. And that was the spirit of that whole body of work. I wanted to make myself laugh. I could tell when I was editing if I was having a good time because it made me laugh.

It went everywhere, from folk dancing, shots of African dancing, to Lord of the Dance, to the running theme of Martha. I used everything I could find of Martha Graham and then found all these other clips where other people used the word Martha in film, which was a big project, and edited them into the whole thing so it was always funny . . . finding Marthas in different films . . . people saying things about Martha, using Martha Stewart.

Charles Atlas

TOP
Rainer Variations, 2001
Video montage, color, sound, 40 minutes
Yvonne Rainer and Richard Move as Martha Graham

CENTER
As Seen on TV, 1987
Collaboration with Bill Irwin
Film and videotape, color, sound, 25 minutes

BOTTOM
Blue Studio: Five Segments, 1975–76
Collaboration with Merce Cunningham
Videotape, color, silent, 16 minutes

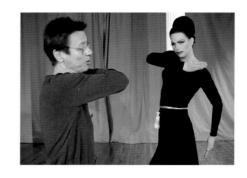

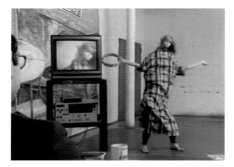

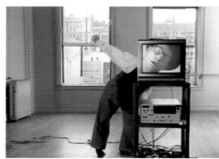

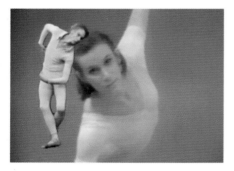

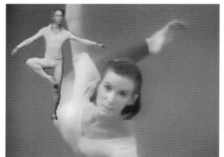

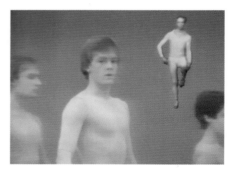

A lot of people start out, if they're dance people, with classical ballet . . . and they kind of figure out that modern is also interesting. For me, it was just the opposite. I never understood classical ballet, never liked it, and I always understood Merce Cunningham's work and loved it. I learned video and taught it to Merce. I had made films before that but didn't have access to video. But when we got started, it was a way to distinguish dance documentation . . . actually making pieces with dance and video where they were equal elements in it, although it was very much about the dance.

They were collaborative pieces. We had to agree on every part. And it was about making dancing vivid. It wasn't about doing elaborate video tricks anyway, but I often say that I had the great fortune of working with people whose work I loved and wanted to show and share. I know how to compensate for what's not there . . . but it just never was appropriate—certainly not with Merce. There are other people who start with the effect and try to make something with the effect. We never worked that way.

If anything came first, it was the camera space and set-up. If it was a multi-camera set-up, where would the cameras be? How would they play? Where was the overlapping space? Where was it going to be possible to make a cut? If it was a moving camera . . . we made the camera shot first because that determines the space, and then you made the movement that fit in that space. . . . Because if you're making a dance and you know it's going to be performed on a stage, you know the space. You know it's usually a rectangle. But there's no point in working that way if you're working for a camera unless the choreography already exists. It pushes you in a different way to work on something that exists, but it is never really as good for me. That's the way a lot of television works. They look at something, and they say, "Oh, that's a masterpiece. Let's make a television version of that" or any kind of art. It may be a practical way to work, but it results in a certain *kind* of work. So I wanted to try to do new work for television. But I would *create* the work.

Charles Atlas

The Laugh of Number 12, detail, 1994
Installation at Fort Asperen Foundation,
Amsterdam, Holland

The Laugh of Number 12 was a group installation piece. It was a curated piece that was done at a spiral fort outside of Amsterdam. We divided it into three sections, by height, and the theme of it was the tarot number 12, the upside-down hanging man. We made a collaborative figure that hung in the middle and then we each had a floor to deal with as we wanted to. I made my floor very controlled, like a walking performance in a way. You could only go through it in one way, so it was a bit like a fun house, but with these images (it was still in the period of the 90s) mostly about sex and death. I used found objects and put them together as sculpture elements and then I made the videos. Most of them had to do with video, but there were maybe two pieces that were just light and objects. Everything moved. I had motors on a lot of things and it started where you walked in and saw yourself upside down in a reverse mirror.

Where did the shoes come from? I went around to flea markets, and the old shoes were really cheap. And I asked the people I was working with. . . . And it was built up so that the surface was just shoes. It ended up having a connotation I'd never thought of . . . a strong suggestion of concentration camps. It wasn't really something that I intended. I really took as my area of interest the world of the foot fetish, and so I got into that and shoes as an aesthetic world that was very enclosed with rules, lots of interesting rules.

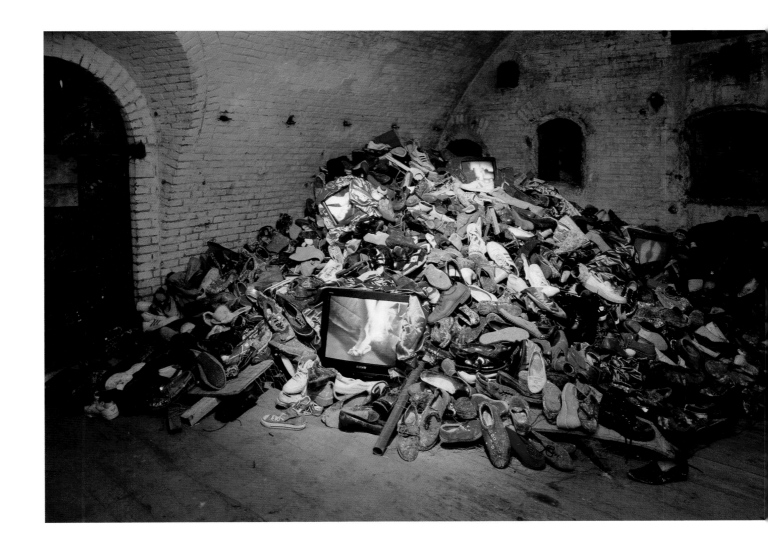

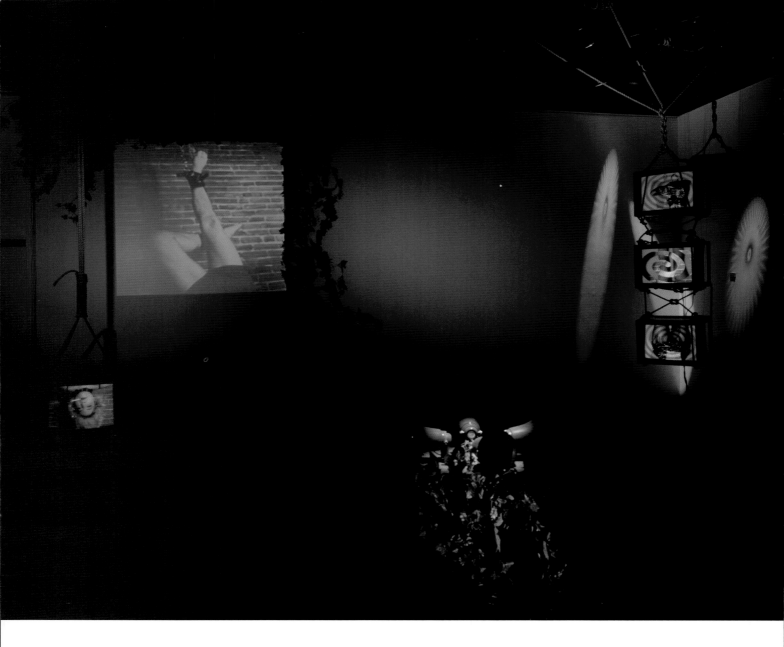

Charles Atlas

The Hanged One, 1997
Video installation, dimensions variable
Components: 15 laserdiscs, color, sound and
silent, variable running times; 15 laserdisc
players; 3 video projectors; 12 video monitors;
audio amplifiers; speakers; rope; rotoscopes;
sculptural elements; specified lighting
Installation view at the Whitney Museum of
American Art, New York, 1997

The number 12 is the upside-down hanging
man. He's hanging by one leg and he has
his legs crossed at the knee. It's a contem-
plative position . . . it's an in-between
moment of waiting for some spiritual thing
to come. It's not bondage in the way that
someone else binds you. It's self-enforced,
and it's not unpleasant. It's sort of a waiting
moment. He has this little smile on his face.

There are specific rules in drawing the
tarot figures. I am not into the mysticism
of the tarot or the mysticism of numbers,
but I took it as an aesthetic system with

rules that were very interesting to explore
because I don't normally make those kinds
of rules for my work.

At the Whitney, I had space and I had
rooms, and the rooms were very suggestive.
It was a new kind of project for me. I'd done
video installation before, but just video. And
so to have a space to work with was great.
Because of my relationship to my work I
don't really make things and try to find a
way to show them. I find a situation where
I'm going to have a show and do something
for that.

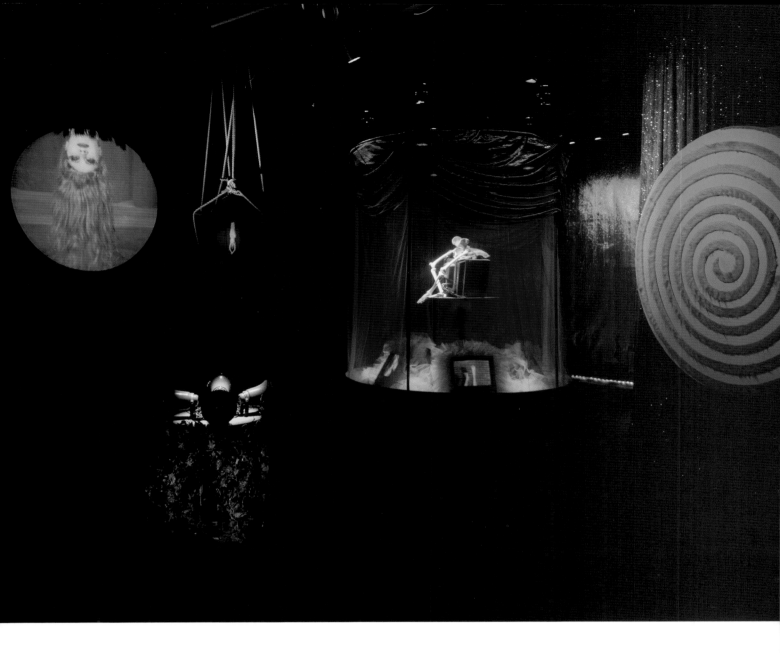

Trenton Doyle Hancock

Kiki Smith

 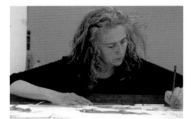

Do-Ho Suh

Kara Walker

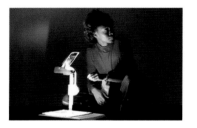 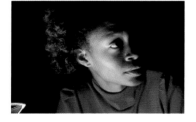 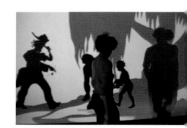

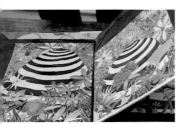

Stories

Trenton Doyle Hancock

Many aspects of my work, in a very direct way, are about recreating my childhood—not just childhood in general, but my childhood. I'm just beginning to get to a point where I realize I'm not a child anymore. And the further away I get from being a child, the more I think the work is going to be about me recreating, or trying to rediscover, what my childhood was about.

I have this kind of intense, extensive catalogue of information that I've found from my childhood that is a parallel project to what I'm doing in my studio, which is also about me going back and finding textures and personalities and reinserting them into the stories that I tell.

The desire to recreate my childhood, or to come to a different or better understanding of what that time period meant for me, comes from not wanting to ever forget that those things happened. A lot of people just block that stuff or it becomes unimportant. Or grown-up problems become way too important.

I guess I should explain a little bit about what *Mounds* are. Mounds are these half human-half plant mutants that came to life about 50,000 years ago when an ape-man jacked off in a field of flowers, and up sprang these creatures called Mounds. The first Mound, which I have come to know as *The Legend,* was not only the first to be revealed to me but also the first to ever exist. The Legend outlived many subsequent Mounds by hundreds and sometimes thousands of years. . . . I had been able to see death edging toward The Legend for almost a year but was powerless to stop it. Ultimately, The Legend succumbed due to injuries sustained during an attack by a band of vicious Vegan rebels. No amount of wobbling could have stopped these guys. They wanted it too bad. I guess our last hope would have been *Torpedoboy* but, by the time he got there, The Legend was leaking mound-meat in about sixty-two places. *Painter* and *Loid,* in true Painter and Loid fashion, scrounged around in the naughty bits and struggled for possession of the remaining soul. The Legend is succeeded by thirteen other Mounds and leaves nations to mourn. The Legend asks all of his friends to indeed *rememor* with *membry*.

Trenton Doyle Hancock

Rememor with Membry, 2001
Acrylic on canvas, 54 x 66 inches
Collection of the Whitney Museum of
American Art, New York

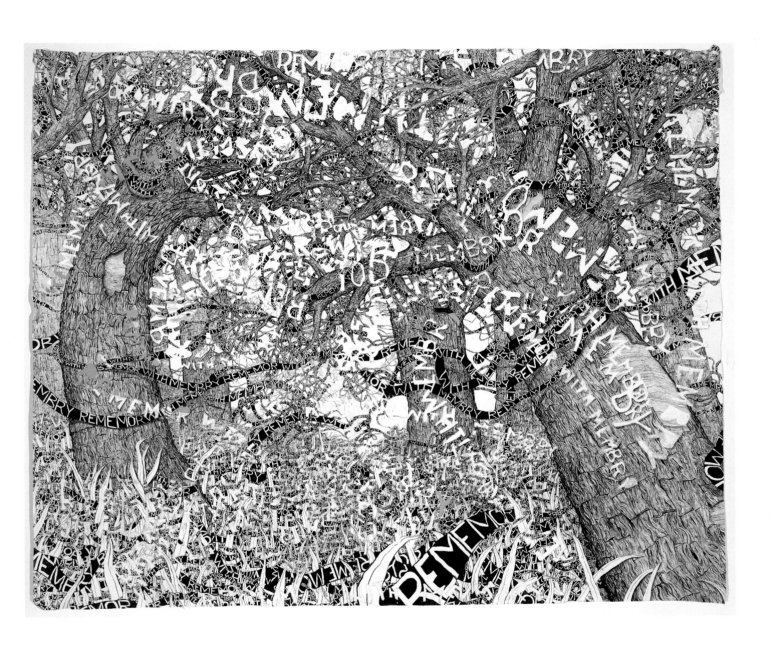

Trenton Doyle Hancock

BELOW
The Legend is in Trouble, 2001
Mixed media on canvas, 104 x 120½ inches
Collection Kenneth Freed, Boston, Massachusetts

OPPOSITE
Painter and Loid Struggle for Soul Control, 2001
Mixed media on canvas, 103 x 119 inches
Collection of the Jack S. Blanton Museum of Art,
University of Texas, Austin, Texas

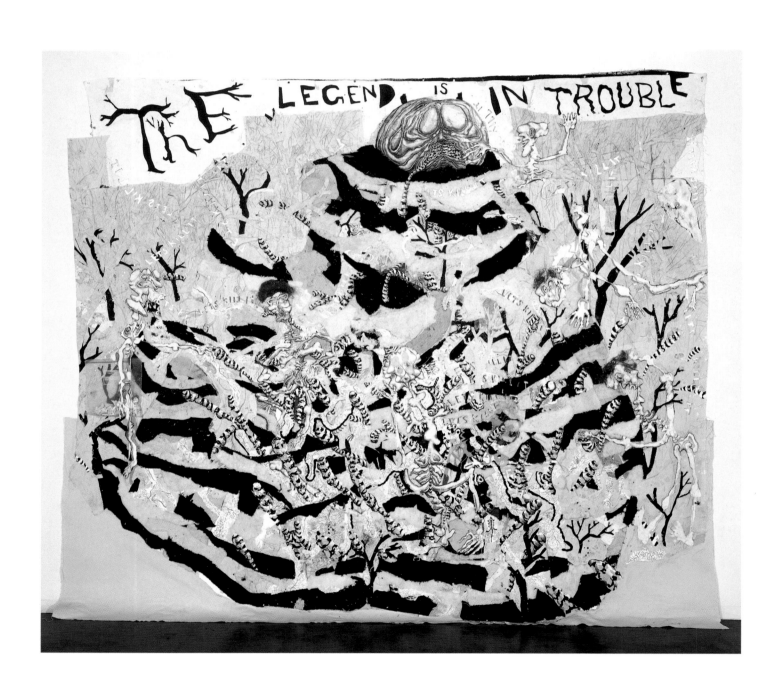

Painter is a mothering type of energy, synonymous with color, so it would only make sense that her energy would be all the colors, a rainbow of colors. With her array of colors, her spectrum, she represents hope and tolerance Whenever bad things happen she can present us with a layer of color over the top of things to give something else to hope for. Any time you see color within the paintings, that's Painter's presence. I've always been drawn to color, but it has to be necessary—to have some sort of meaning—if I'm going to use it.

If there's no reason for color to be there, the piece will just end up being black and white. And that's Loid, a father type of energy. Loid is just this love that I have with both the lyrical nature of the spoken word and also the way language looks when it's written. Loid can convey something you fully understand or can be totally abstract. It's what language has the capability of doing—either including you or excluding you. Loid is devoid of emotion; there's no real range. It's either black or white.

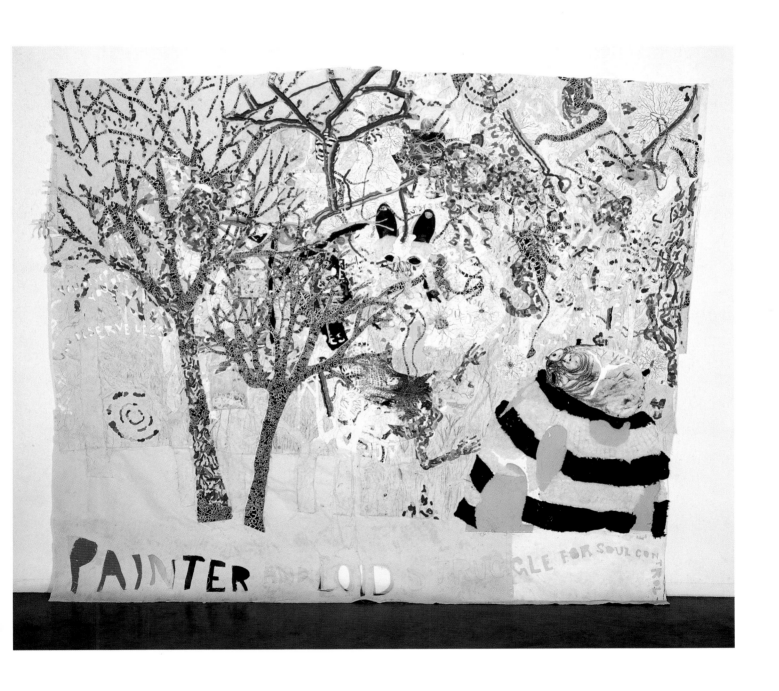

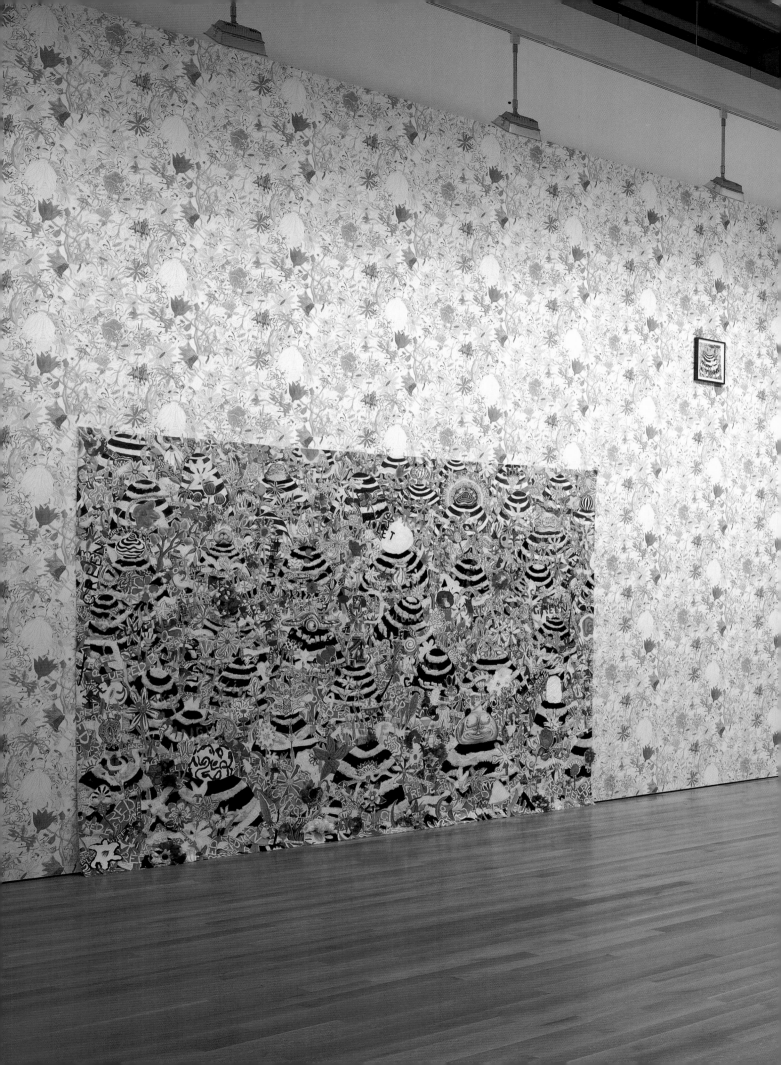

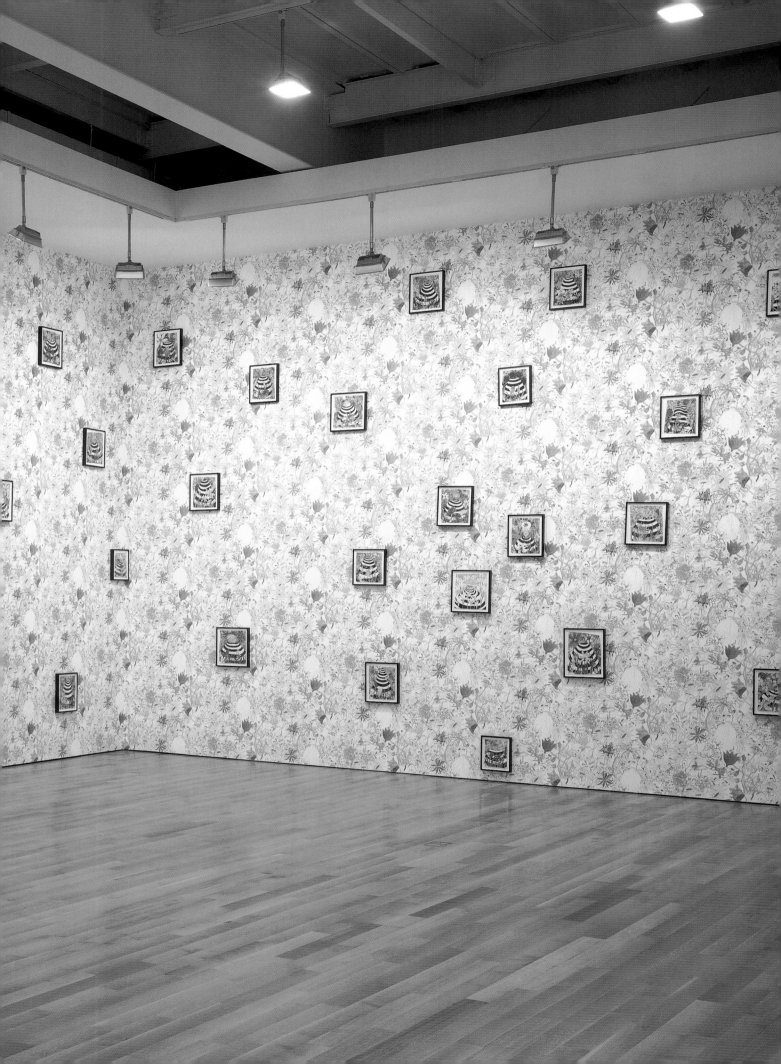

Trenton Doyle Hancock

PRECEEDING SPREAD
For a Floor of Flora, Installation at James
Cohan Gallery, New York, 2003
Left: *Choir,* 2003, mixed media on
canvas, 96 x 132 inches
Right: *Flower Bed,* 2003, wallpaper,
dimensions variable

LEFT TO RIGHT

Esther, 2002
Graphite and acrylic on paper,
11 ¼ x 10¾ inches
Collection Lewis Manilow, Chicago

I See Things, 2002
Graphite and acrylic on paper, 11¼ x 11 inches
Collection of Stuart Ginsberg, Chappaqua,
New York

Kos Good, 2002
Graphite and acrylic on paper,
10¾ x 11½ inches

I, I, I, I, Etc . . . , 2002
Graphite, acrylic and ink on paper,
11½ x 9¾ inches

I came up with the idea of having a story as a kind of framework to plug elements into, to let the characters have a place to exist and to grow, and to give context to the different sensibilities that the characters have. So, in essence, the story is the glue that holds everything together.

The characters exist as vehicles for a certain sensibility or a certain color scheme. Each character has his or her particular way of moving through space or through time. And instead of having one character that's multifaceted, I thought it might be more interesting to delegate

responsibilities to different characters.

The idea of having a story or a narrative be so essential to my work probably came from my need to have something that I feel is my own. That's how I put information together. I tend to give gender to inanimate objects. And I tend to animate things, like the cup I'm drinking out of or the pillow I'm sleeping on. These things come to life once they're in the same space as me. So it's only natural for me to adopt something, some kind of form or framework that lends itself to animating things. The idea of

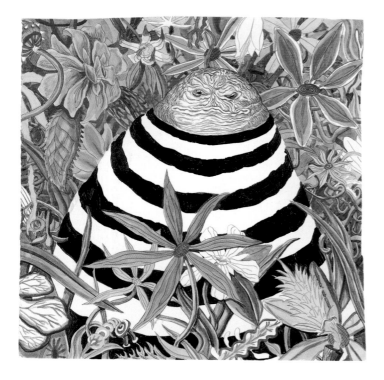

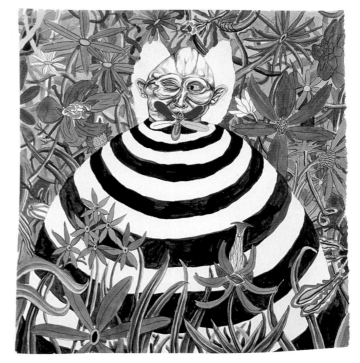

narrative is also important because of how information is passed down. I'm always trying to find the story behind anything that I'm looking at.

At times, I feel as if the story is ahead of me and I have to catch up with it. At times I'm the one who's in control. When it starts feeling too good, that I'm in control of everything, I know that I have to let loose and let something new come in . . . where I don't know what I'm doing again.

Having a story to go by, creating a story as a guideline, is just a way for me to have a reason to make stuff or to have some sort of jumping-off point for meaning . . . as opposed to willy-nilly just doing anything because there is a multitude, an endless multitude, of things that you could draw from outside your studio to create art. I need some sort of grid, a guideline to go by. Therefore, that's what the story is about for me. When you look at art history, all artists, in a way, have a story to go by. Some may call it a muse; some may call it an idea. I just call it a story.

Telling a story is just my personal way of leaving something behind.

Trenton Doyle Hancock

Bye and Bye, 2002
Acrylic and mixed media on canvas, 84 x 132 inches
Collection of the Museum of Fine Arts, Houston, Texas

In *Bye and Bye,* we have The Legend, or the remains of The Legend, in the forest, and all of the animals from the forest and the ocean and the ponds and the sky are coming together to grieve and give their eulogies.

The words 'bye and bye' are cut out of the piece because I just wanted another layer of information. It's always interesting for me to extend painting a little bit further from myself than it has to be, to make it just a little harder than it has to be. All of the letters cut out of this piece are glued back in different places, so you have this recession of space and this built-up space. Then, when you come up to the painting you experience it on several different levels.

Trenton Doyle Hancock

LEFT
Studio Floor Encounter with Vegans 2, 2002
Graphite and acrylic on canvas, 31 x 31¼ inches

RIGHT
Studio Floor Encounter with Vegans 5, 2002
Graphite and acrylic on canvas, 31 x 31¼ inches

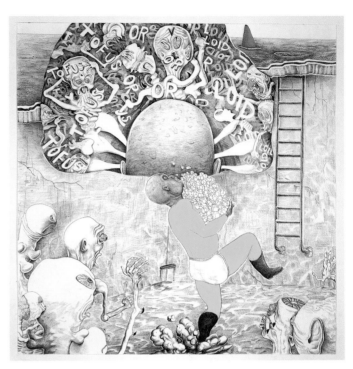

I took the words 'studio floor' and made anagrams. I came up with about fifty different words, and all of them led back into the story. It was very strange. The word 'Loid' appears . . . the word 'tofu'. It was so weird.

Torpedoboy is the protagonist, and we are taken step by step through his adventure. I'd been drawing Torpedoboy for several years and his face was kind of nondescript. Then, it was as if all of sudden things came into focus. I was suddenly okay with letting people know who Torpedoboy actually was. He looks like me, he is me. I even have an outfit, a Torpedoboy outfit that I wear while I'm painting. In a way, it's as if when I go into the studio I have to get into character. Torpedoboy's uniform is pink and yellow, one of the most obnoxious color combinations that I could think of. It's very loud, and that's what he's all about. His ego is his force field. That's just how he takes on the world.

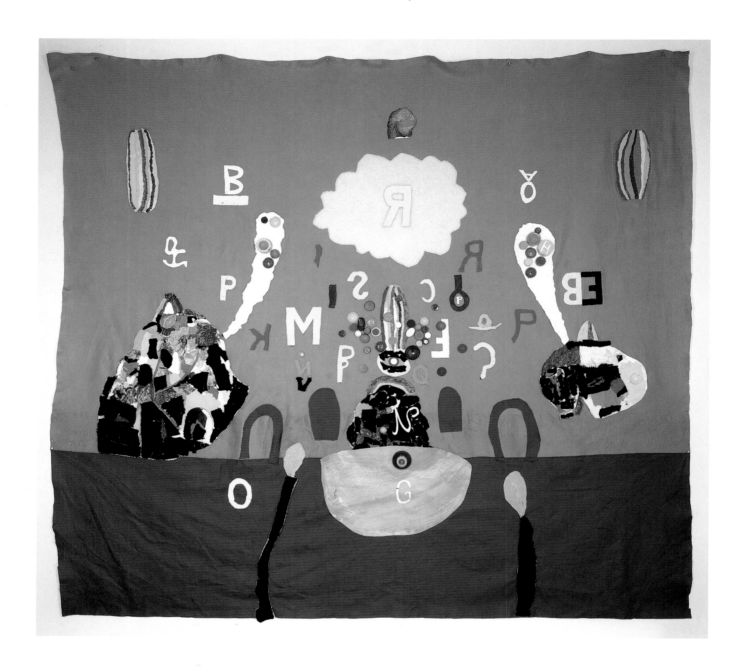

Trenton Doyle Hancock

Ferroneous & the Monk, 1999
Mixed media on felt, 102 x 114½ inches

I like to play with language, word-play and puns, alliteration and onomatopoeia, poetic devices within the work. Since the writing aspect of the work has become so much more important, I see fit to draw upon all those elements to get things done. I like to pick language that has a certain kind of cadence, and words that have double meanings, or maybe words that, if you take a letter away, will be an opposite. I shift letters around, and sometimes words explode and it's about each individual letter. And sometimes they become hybrids and form a new letter altogether.

Ferroneous & the Monk is what I call a dream flash. That's how Mounds dream—in big colorful landscapes filled with floating objects and symbols. Mounds are rooted in the ground. They can't really move. So in their dreams they're very mobile. They can go anywhere. All over the place!

Trenton Doyle Hancock

Sturdi of Loo, 2002
Mixed media on felt, 69¼ x 72½ inches
Collection of Michael E. Thomas, Dallas, Texas

I wanted to do a body of work that focused on the garbage and pieces of paper and scraps of canvas I had lying around on my studio floor, and where those scraps could ultimately lead me. What they led to was a body of work that at first glance seems disjointed—as if each element has nothing to do with the next. But on further scrutiny, you realize that it's all interconnected. This is very important for me because I feel I have made a leap from my journals to the gallery space. In my journals I have scrawled writing, or printed writing that I've found, next to rather intense representational drawings. And those might be butted up against some childish cartoon drawing, as well as someone else's writings and drawings. All of these things, in journal form, just make perfect sense together for me. There's no hierarchy. Everything is just evened out.

The paintings are filled to the brim with all kinds of color, the whole spectrum—bits of canvas that have opaque colors painted on them, different colors of felt and fur, and other bits of colorful trash. These paintings are like an explosion, like a rainbow exploded . . . what I call color flashes, which are sent by Mounds both living and dead. Color is the thing we wish we could all dream in. It just adds something else, this other level of existence. When you do see all these colors it actually means something . . . it's this morsel of something. I think about the story of Noah and the Flood . . . and God making the rainbow appear—his promise that there will be better things to come.

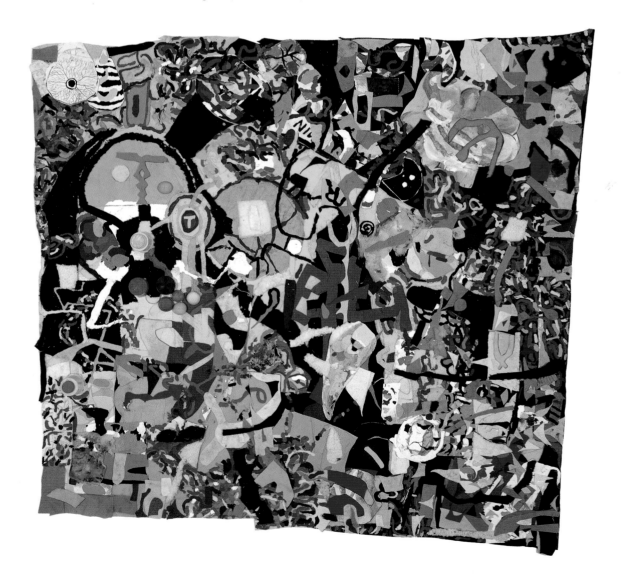

Kiki Smith

The thing about making things is that you have a proof. You know you have some proof every day that something has been accomplished, that something's different. And you know if you can make something as that proof, it's like a lot of power. I'm very attached to needing a proof of something, that there has been a change . . . not just to think about it, but to have a physical manifestation of that change.

It's one of my loose theories that Catholicism and art have gone well together because both believe in the physical manifestation of the spiritual world, that it's through the physical world that you have spiritual life, that you have to be here physically in a body. You have all this interaction with objects, with rosaries and medals, but it believes in the physical world. It's a 'thing' culture.

It's also about storytelling in that sense, about reiterating over and over and over again these mythological stories about saints and other deities that can come and intervene for you on your behalf. All the saints have attributes that are attached to them, and you recognize them through their iconography. And it's about transcendence and transmigration, something moving always from one state to another. And art is in a sense like a proof: it's something that moves from your insides into the physical world, and at the same time it's just a representation of your insides. It doesn't rob you of your insides and it's always different, but in a different form from your spirit.

I really love printmaking. To me, it's endlessly fascinating. The thing that I like the most is doing hard grounds and working with needles, because the needle is always the same size. So I think I got into this thing of scratching, which is just like obsessive, repetitive motion. But it can mimic hair. And you just work really slowly; you build things up very slowly. I have to make about a million proofs of everything. I don't know, it's just a repetition, like a meditation. You come back to something and then you leave it, and then you come back again and you leave it, and each time it changes. And sometimes you have to wait for new information inside yourself to be able to finish something, to find out how it should go. You don't know how to finish it. But it's just this scratchy, scratchy motion that I like best. And then . . . you just see what happens. It's like a mystery, and you're trying to figure out how to rein it in or something.

Kiki Smith

Wolf Girl, 1999
Etching on paper, 20 x 16 inches
Edition of 20
Published by Thirteen Moons

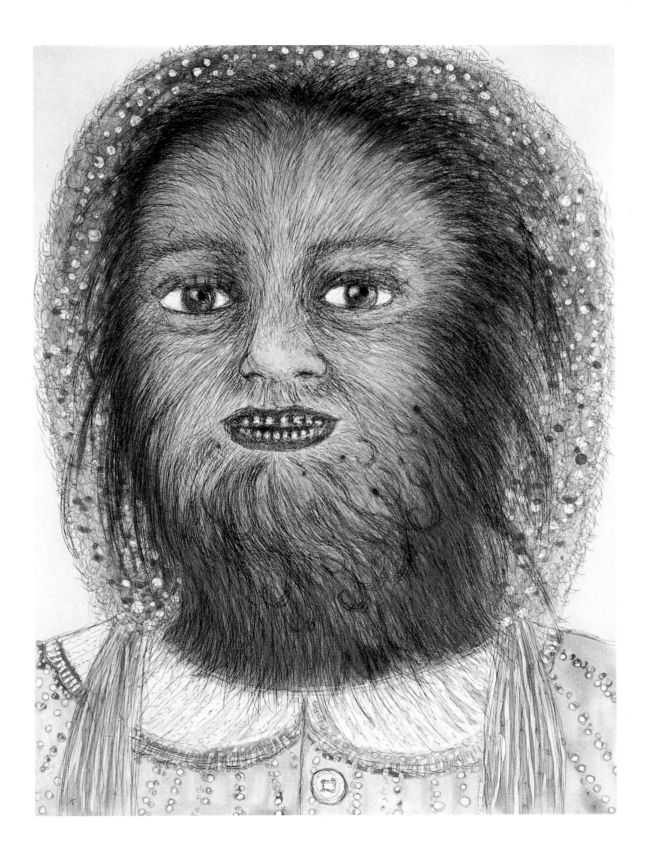

Kiki Smith

RIGHT
My Blue Lake, 1994
Photogravure and monoprint,
42½ x 53½ inches
Trial proof, edition of 41

OPPOSITE
Rapture, 2001
Bronze, 67¼ x 62 x 26¼ inches
Edition of 3

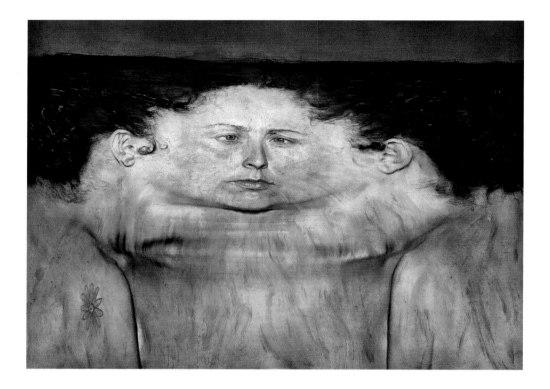

I think art is just a way to have an opportunity to think about things. I don't have any place that I'm trying to make it go. I'm not trying to control it at all. It's like standing in the wind and letting it pull you where, whatever direction, it wants to go . . . and things start telling you what you're supposed to pay attention to. It really just comes in you and tells you, "Pay attention to this and make this." I have lots of things where my work just said, "Make it like this." And then it's like you're a faithful servant. I make this meditation or give myself to this work.

Rapture. Maybe it's narrative or maybe I like non-linear narratives. In the Louvre I saw a picture of Genevieve sitting with the wolves and the lambs. I had stopped making images of people for a couple of years; I just wanted to make animals. But then I saw that picture, and I thought, "It's really important to put them all together." So I drew my friend Genevieve as the

Genevieve, and then I made all these wolves (I didn't make lambs).

First I made a Genevieve where she's just standing next to a wolf. Then I made a wolf from *Little Red Riding Hood.* And then I made a *Rapture* where the woman is walking out of the wolf. And that came from a print I made of the grandmother, when she and Little Red Riding Hood get cut out of the wolf and they stand up. I was laughing, saying, "Oh, they're born of wolves!" It's a resurrection/birth story; *Little Red Riding Hood* is a kind of resurrection/birth myth. And then I thought it was like Venus on the half shell or like the Virgin on the moon. It's the same form—a large horizontal form and a vertical coming out of it.

So I just made it. I thought, "I just want to see what it looks like." And somebody asked me, "What does that mean? Why is she coming out of the wolf? What is this?" And you know—I can't quite say.

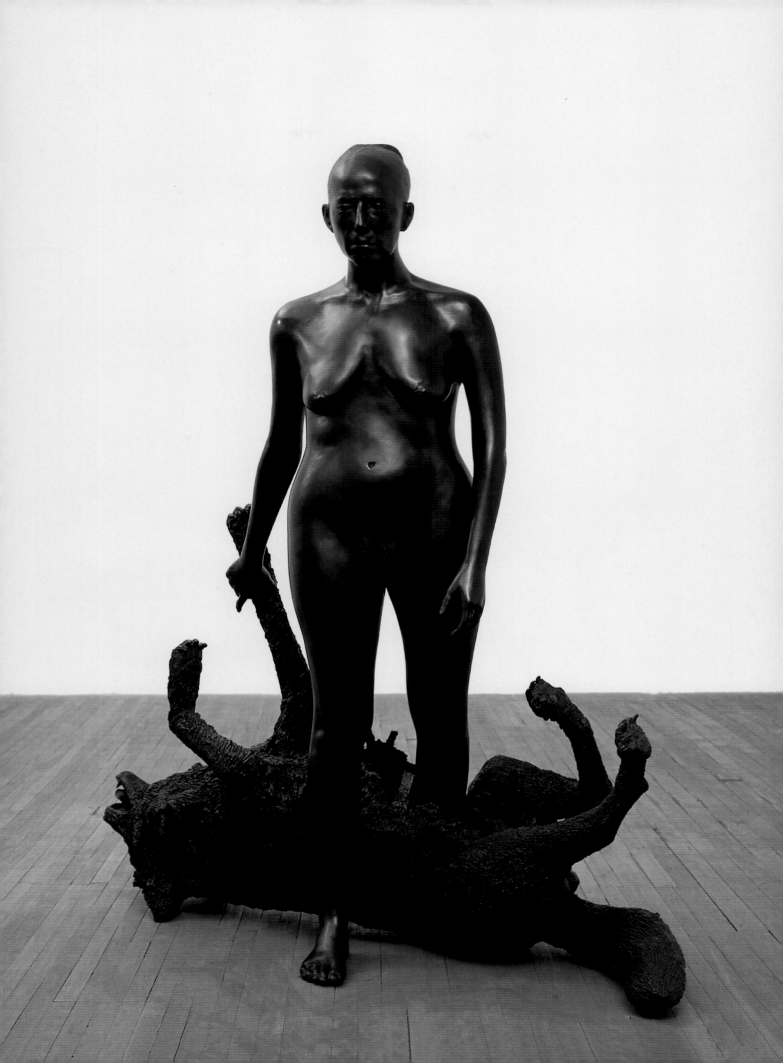

Kiki Smith

BELOW
Born, 2002
Bronze, 39 x 101 x 24 inches
Edition of 3

OPPOSITE, TOP
Lying with the Wolf, 2001
Ink and pencil on paper, 72¼ x 88 inches

OPPOSITE, BOTTOM
Wearing the Skin, 2001
Ink and pencil on paper, 72¼ x 88 inches

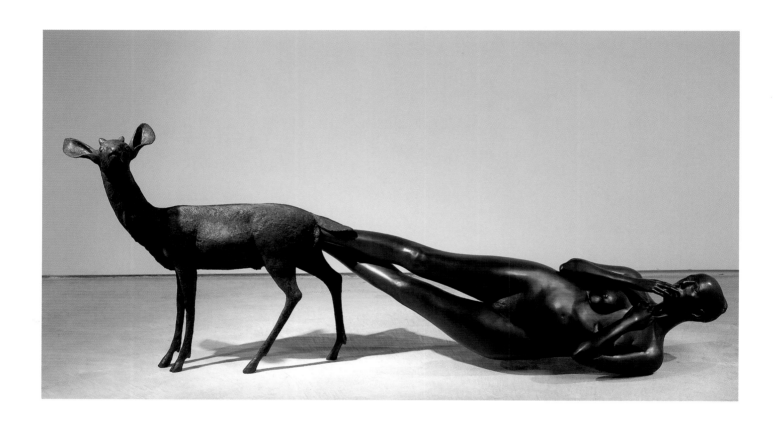

Then I made *Born,* a Genevieve being born of a deer. And I also have no idea where that came from. You can say that it relates to different mythological stories or something. Sometimes I'm making things and people will say, "Oh, that's Diana; oh, that's Daphne." But I don't know. It just pops into my head. My sister was saying the other day that our father taught us to trust our intuition. Our mother would also always say, "Believe your intuition; you always get in trouble when you don't pay attention to it." And I think that I always do that in my art. Sometimes I don't like where my art's going . . . but I always trust that that's what is appropriate for me to be doing. And so, all these stories can kind of intermingle, pass out of one door and in the other, and go into another kind of landscape. And if you make them like a kind of character, build them like a fiction character, they can be active in the world.

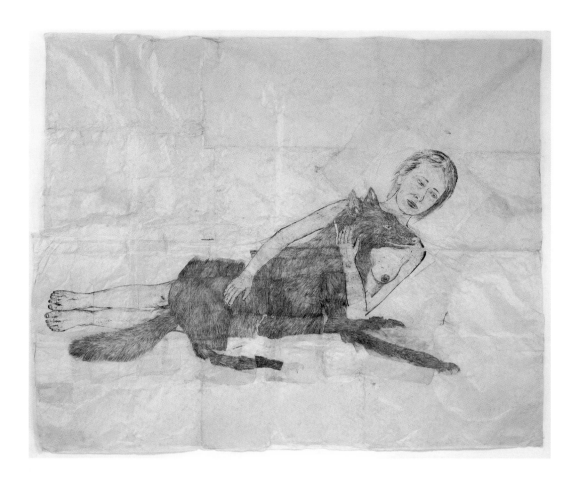

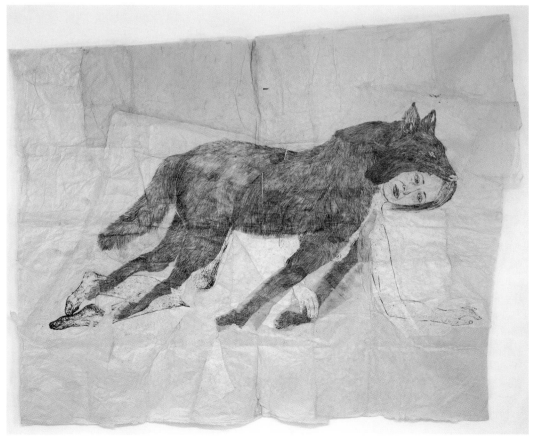

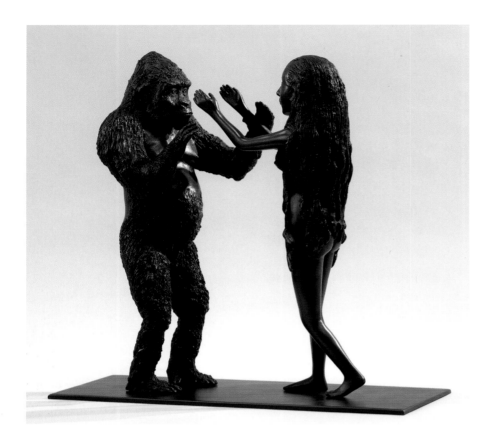

Last year I went to see Bill T. Jones's evening of dance, and one of his dances used a song about King Kong. It was just about King Kong looking for the woman, getting the woman, and all his tribulations. It was really sort of moving. But then I thought, King Kong and the woman are sort of the same size in real life. I thought of making a life-size sculpture, and then I thought that was too ambitious. But I made the sculpture of King Kong and the woman together.

The thing is that things sort of wander. In the early 90s I said, "I don't want to make humans any more." The world was in such a terrible state . . . it was only important to make things about animals and nature. But then I started thinking about how our identity was constructed around nature and animals, and how many metaphors we use in thinking about ourselves in relationship to animals.

And I just said, "It's good to put them together. That's what's important, to put them together and keep saying that's important to think about."

But then it strays into some other weird place. You only have about two seconds where you can say, "This is what I'm doing, this is what my work is about." Most of the time it's about much more. It's much more complicated and complex. You have all these contradictory things that don't go together, so many possibilities in your life all the time. You experience as much of that as possible, synthesizing that into things, into this other model that you can look at, see how it feels, and then re-evaluate it and make a new version. It's not so much that I have some linear, literal idea of what I'm trying to do in my work. I'm not trying to do anything in my work other than experience it and have fun.

Kiki Smith

ABOVE
King Kong, 2002
Bronze, 20 x 21 x 8 inches including base
Edition of 3

OPPOSITE
Peabody (Animal Drawings), 1996
Ink on paper
Installation view, *Landscape,* at the Huntington Gallery, Massachusetts College of Art, Boston, 1996

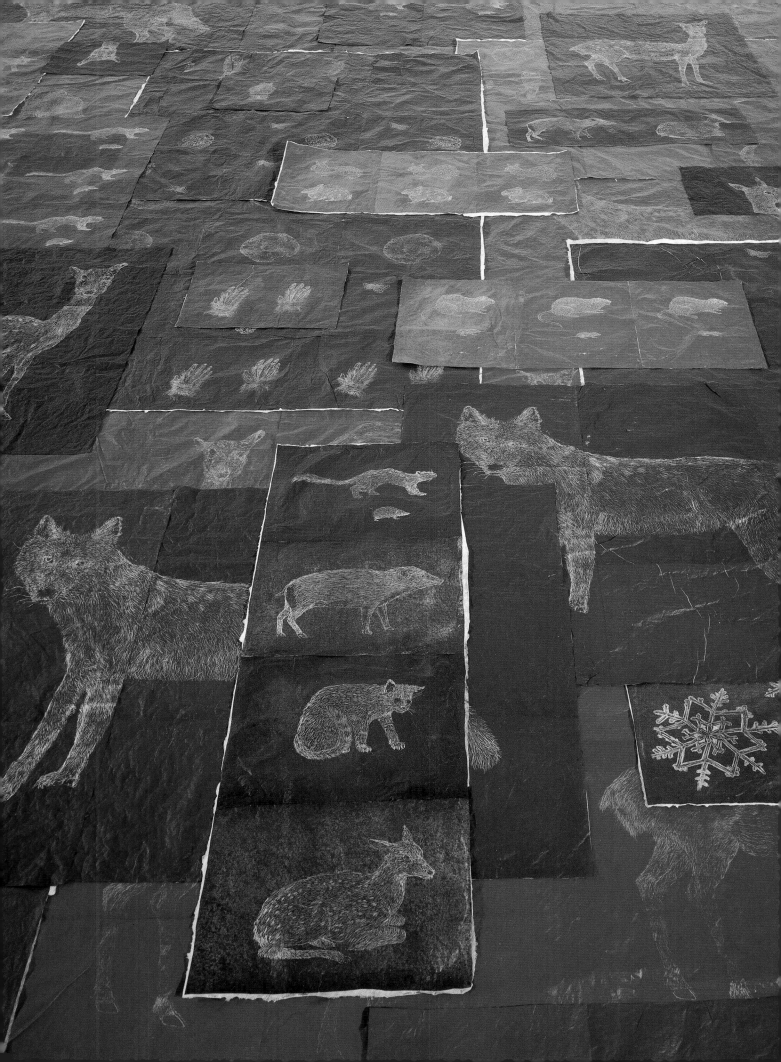

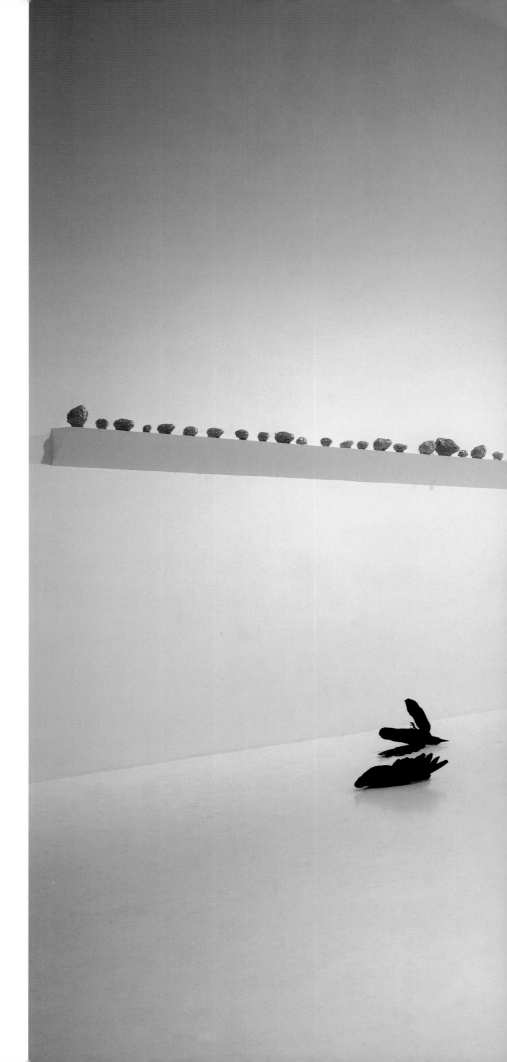

Kiki Smith

Kiki Smith New Work, Installation view
at PaceWildenstein, 142 Greene Street
Front: *Untitled,* 1995
From left: *Animal Skulls,* 1995;
Untitled, 1995; *Through a Hole,* 1995;
Ice Man, 1995; *Jersey Crows,* 1995

The most important thing for me is
looking at objects, looking at things
that people have made. I'm sort of
a private person, so my life isn't so
much about my social relationships.
It's more about looking at what people
have made, appreciating people
through what they have made or what
they do. So I need to look at things all
the time. You learn from things that,
maybe, you see once, and then it just
sort of resonates in your mind for long
periods of time, sometimes for years.
But for me, my suffering is that I see
that there are these really great forms.
They're holy in a way. They have incred-
ible power about them. And all I can
do is recognize it. And my ego wants
to be able to make one also. I want to
be able to make something in that
tradition. But it's really difficult, totally
different. It's an absolutely different
way of working, to will something or to
want something into the world, rather
than working from the listening version—
listening to your intuition. It has to be
a collaboration between listening and
your own interest, and then your own
access to making something.

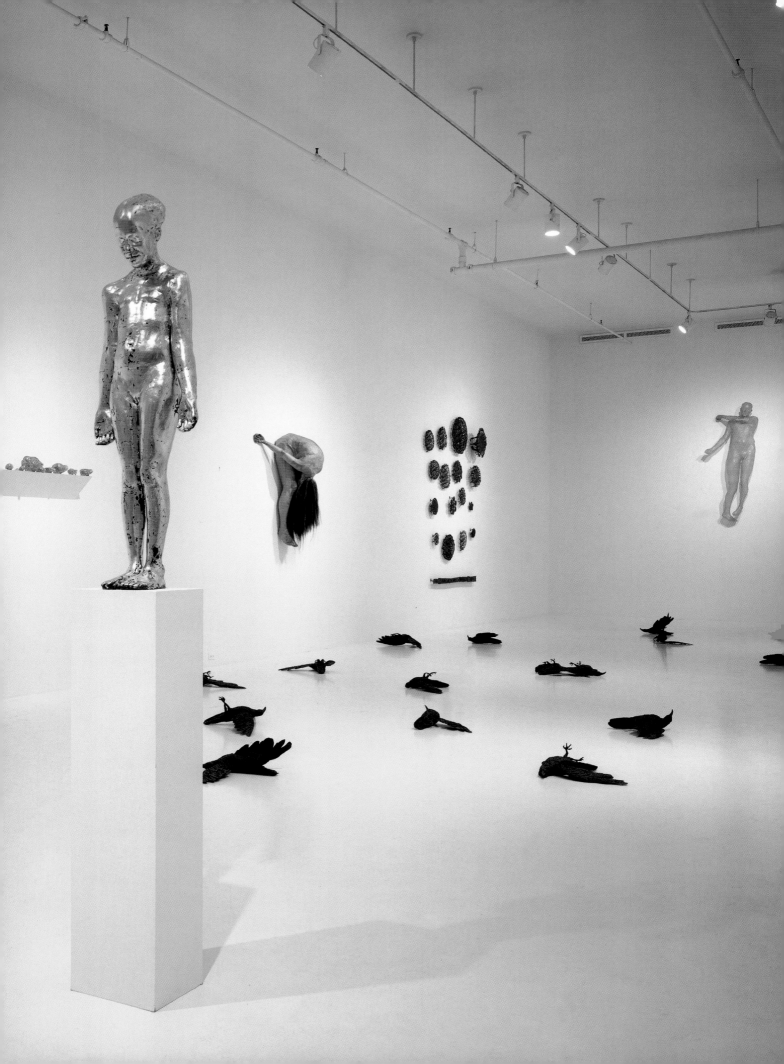

Kiki Smith

BELOW
Constellation, 1996
Glass, bronze, and blue Nepal paper, installation
dimensions variable
Installation view at Mass MoCA, North Adams,
Massachusetts

OPPOSITE
Constellation, 1996 (details)
26 various glass animal units, 630 bronze
scat units, and 67 glass star units,
installation dimensions variable

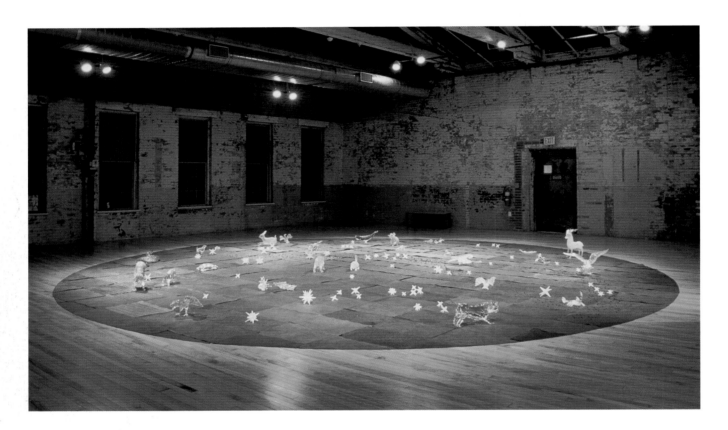

But I don't like things being so like a story. I don't really like a tight narrative. I don't want to make a tight narrative. I'm too jumpy or something. I don't want to be so declarative. I'd rather make something that's very open-ended that then can have a meaning to me, but then somebody else can fill it up with meaning.

You have to have a kind of physical devotion or dedication . . . to be stubborn and persevere until you get it right. That's why I like printmaking or working in sculpture because it's a generous way of working in the sense that you can go forwards and backwards. You can make a mark or, like drawing, you know you can make a mark and erase it, make it again and erase it. You can do it fifty billion times till you get it some way.

For me, what I like is that it's work. Ninety percent of it is that you have to come here and file out your bad mistakes and stuff like that, and just spend hours. And at the same time, the most pleasurable part of it is actually in the freedom. It's more like a meditation, or it gives you this enormous freedom. I want to have an experience, to struggle, to learn and try to do something. To me, that's the pleasure. Most of the things I have to just do over and over and waste enormous amounts of time. But that's my fun part. That's the part where I get to go out of my body and fly around the universe. I mean, that's when you get not to be conscious. You just sit and do this repetitive little motion over and over, and that makes you free.

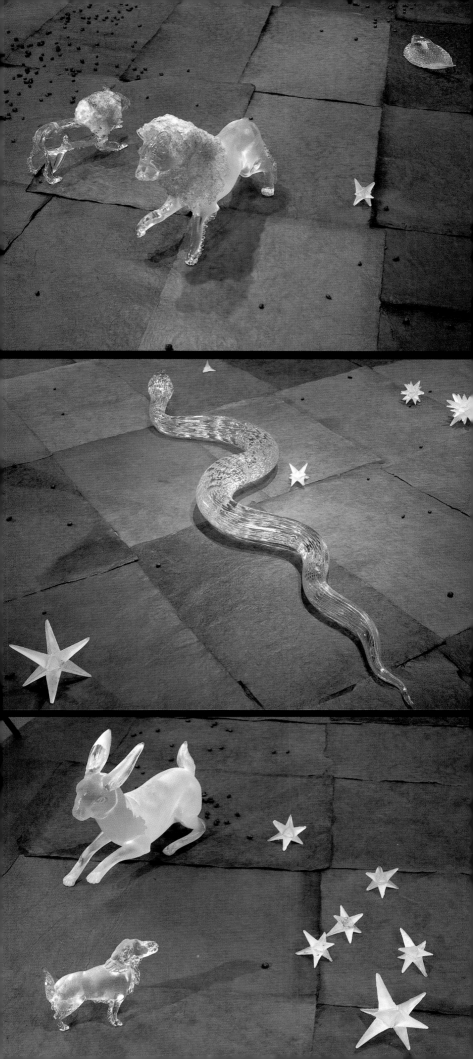

Do-Ho Suh

According to my fortune teller, I'm destined to move around. But I don't think I'm a nomad. I just live in an era when frequent travel is accessible. Going back and forth between New York and Korea is a normal facet of contemporary life. But one of the reasons that I don't feel like a nomad is that I have to go through an enormous, painful process of adjusting myself to the new environment every time I go back and forth. It's not something I do with pleasure; it's something I have to do somehow in order to get things going. But the bright side of this desperate sense of displacement is that it puts you in a very alert position about your surroundings. I think it gives me a space to have some critical distance to everything. It allows me to see things differently, I mean literal things that you wouldn't even care about, and then somehow in my work I can let other people see things differently. So traveling, living in different places, is an essential component in my work.

For me, making art is a by-product of life. I don't think I make art for just art's sake. It's a product or residue of my way of thinking and my belief system, and it just shows individual form.

Everything changes constantly; nothing is permanent. When I leave Seoul, I change. And while I'm in New York, Seoul changes. So every time I go back it's a new thing. I've been going back fairly often, so it's less and less. But I think if I stay in New York, let's say for three months, then Seoul becomes totally new to me. So it's a constant struggle. But the thing is that I didn't realize that for a while. It was like I just thought something was uncomfortable, and that slowly and gradually showed in my work. So that's what I meant when I said that making art is a residue of my life. I'm just slow. My work always comes late, from the first experience. I have to digest. Process-wise, I eliminate many things. I reduce things. Sometimes it takes six months and I just sit, just doing nothing, just think, and try to get to the essential idea. I don't want to add anything unnecessary. And that's how it works.

Often, people, even critics, think that my work is about individuality disappearing into anonymity. But it's not. I don't think anonymity exists actually. It's just a convenient way to describe a certain situation. It's our problem not to see certain individuals, or not to see difference or individuality. I just want to recognize them. Let's say if there's one statue at the plaza of a hero who helped or protected our country, there are hundreds of thousands of individuals who helped him and worked with him, and there's no recognition for them. So in my sculpture, *Public Figures,* I had around six hundred small figures, twelve inches high, six different shapes, both male and female, of different ethnicities.

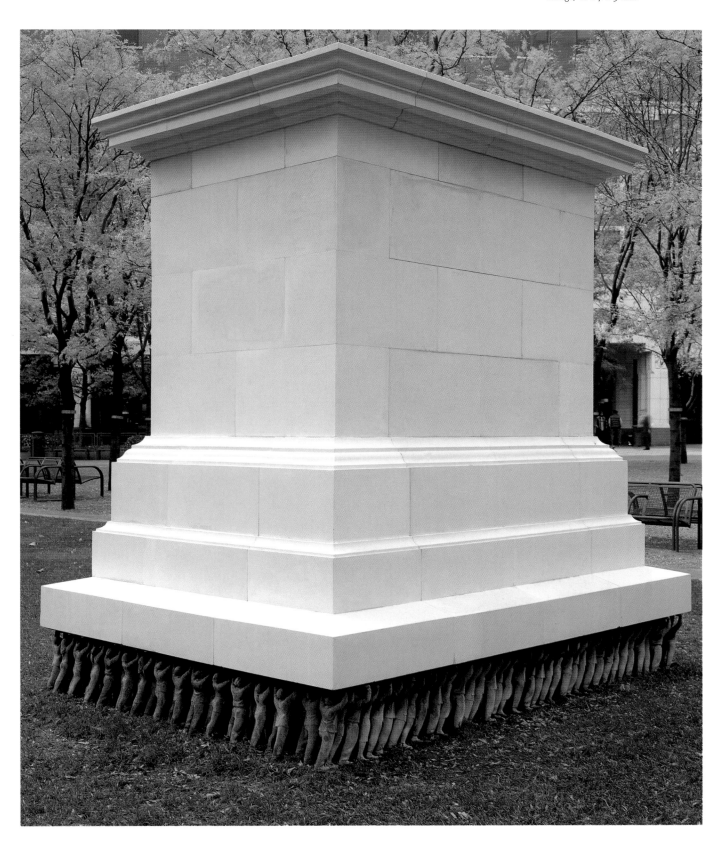

Do-Ho Suh

Public Figures, Installation view at
Metrotech Center Commons, Brooklyn,
New York, October 1998–May 1999
Fiberglass/resin, steel pipes, pipe
fittings, 10 x 7 x 9 feet

Do-Ho Suh

OPPOSITE AND RIGHT
Doormat: Welcome (Amber) with detail, 1998
Polyurethane rubber, 1¼ x 28 x 19 inches
Edition of 5

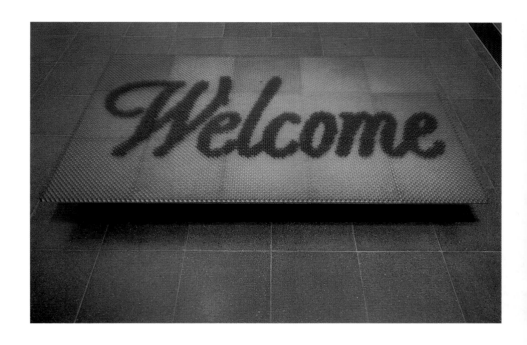

FOLLOWING PAGES
High School Uni-Form, 1997
Fabric, plastic, stainless steel, casters,
54 x 276 x 217 inches

I put a hyphen between *uni* and *form* in order to point out what the uniform does to you. Uni is one, and it's a form. And so my piece was sixty high-school uniforms together in one. I thought it was kind of interesting to manipulate the title like that, to point out what it's all about. It's a jacket of a high-school uniform, all in black with gold buttons and a priest-like collar. I have five rows in front and then twelve rows. Five by twelve makes sixty, sewn together shoulder to shoulder and back to back. It's on this hollow plastic mannequin on a metal frame that has casters, so you can move it around.

It's a funny thing. Koreans have this kind of nostalgia about the uniform. It's a funny thing because we hated to wear that uniform. It was very strict, and if you didn't follow it you were punished. But we tried our best to differentiate our uniforms from one another. So if you opened the jacket everything was different, modified, just a slightly different cut, but able to pass the strict regulation. It's the individual versus collectivity. That's the most obvious thing.

But I have to say that my work actually started from my interest in the notion of space, particularly this notion of personal space or individual space. And that's actually the result of contemplation on the idea of how much space one person can carry. Or what is the size of the personal space? What defines the individual versus individuals? For me it was just very natural to think about the interpersonal space, the space between people. And that's why this idea of individual and collective came in. I still think, for me, it's an issue of space.

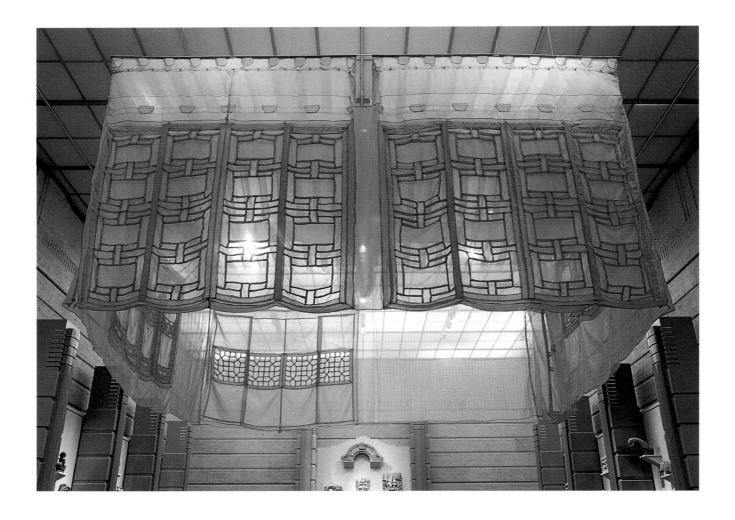

Do-Ho Suh

*Seoul Home/L.A. Home/New York
Home/Baltimore Home/London Home/
Seattle Home,* 1999
Silk, 149 x 240 x 240 inches
Collection of the Museum of Contemporary
Art, Los Angeles
Purchased with funds provided by an
anonymous donor and a gift of the artist

OPPOSITE
Installation view at the Korean Cultural
Center, Los Angeles, 1999

ABOVE
Installation view at the Seattle Asian
Art Museum, Seattle, 2002

My Korean house project was about
transporting space from one place to
the other, a way of dealing with cultural
displacement. I don't really get homesick
that much, but I've noticed that I have
this longing for a particular space and
just want to recreate it or bring it wher-
ever I go. So the choice of material was
fabric. I had to make something light and
transportable, something that you can fold
and put in a suitcase and bring with you
all the time. That's actually what happened
when I made *Seoul Home/L.A. Home.*

At some point in your life you have to
leave your home. And, whenever you go
back, it's just not the same anymore. So
I think it's something that you carry along
with your life. I just didn't want to sit down
and cry for home. I wanted to deal more
actively with these issues of longing.

Home is something I carry with me.
But I think that the process of making
the work has a really important meaning
because, in order to make that piece, you
have to measure every inch of the space

of the original. And you really get to know
it. And you often find the little marks that
you made when you were a kid and that
brings back all the memories of your child-
hood. When you go through that process,
this space becomes part of you and you
really feel like it's a part of you. It's in you,
and you can actually leave home without
any kind of attachment. I would say it's
one way of dealing with homesickness.

And I think that by measuring and
scrutinizing and investigating everything
possible you really consume the space
and it becomes part of you. Now you feel
like it's in you and you feel comfortable.
That's why I did my first site-specific
installations, and I did the same thing
with my Korean house project. But once
you take that piece down from its site and
transport it and display it in a different
place, the idea of site-specific becomes
highly questionable and refutable. That's
what I was really interested in because I
think this notion of home is something
you can repeat infinitely.

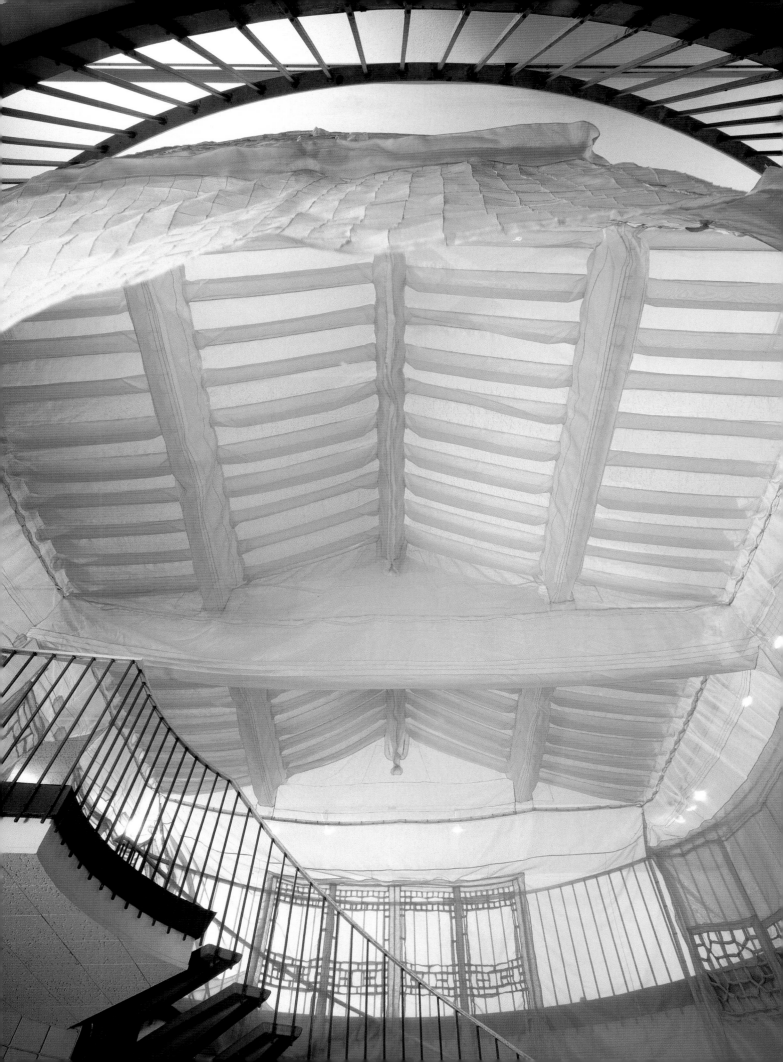

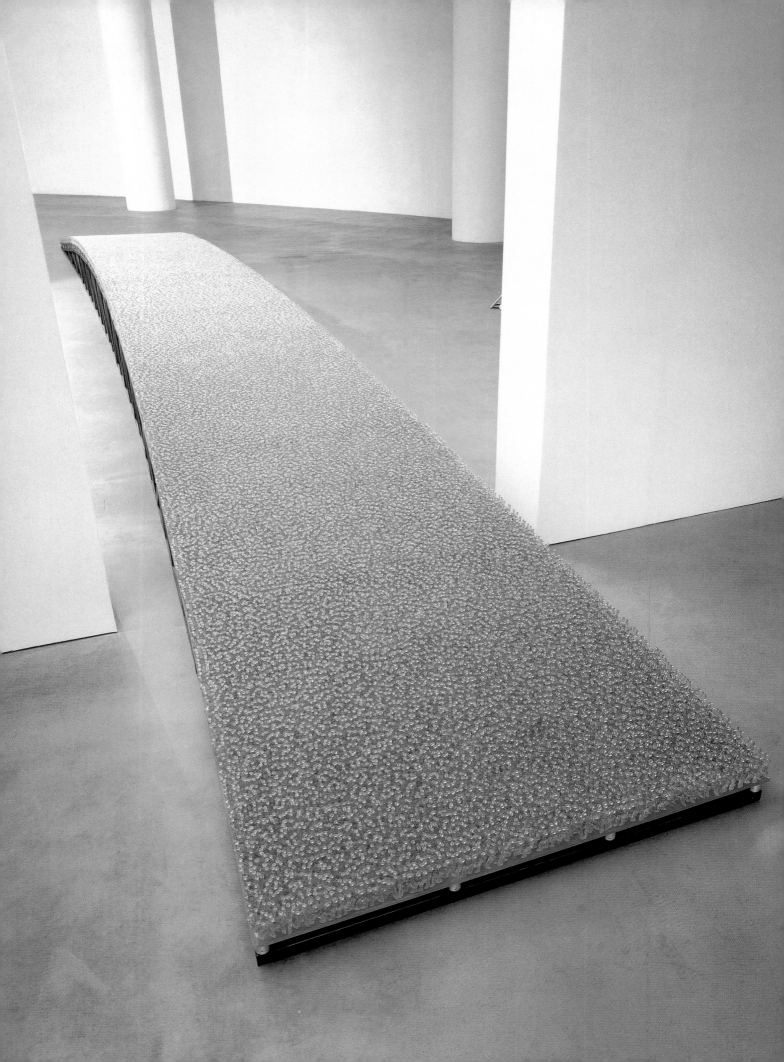

Do-Ho Suh

When I first came to the United States my response to the new environment was often physical. I often felt that I was living in somebody else's body and I felt like I was dropped from the sky and granted this new body. I had the same mind, but I didn't know how long my arms were. And everything was awkward, so it took me a long time to adjust myself. Every corner of the street was strange and foreign, so you have to create a new relation to this new environment. And I couldn't really articulate that intellectually at that time, but I responded with a gesture—a kind of bodily gesture. And it was just measuring the space. Measure everything and come up with something really minimal in its physicality, and just subtly insert that in the space and try to highlight those spaces. And I picked spaces like non-spaces—a corridor, a hallway, a staircase, an entrance. The space that you use to go to your destination —transient, transitional space. I think it's got to do with my experience of coming from a different culture and life as a kind of transient.

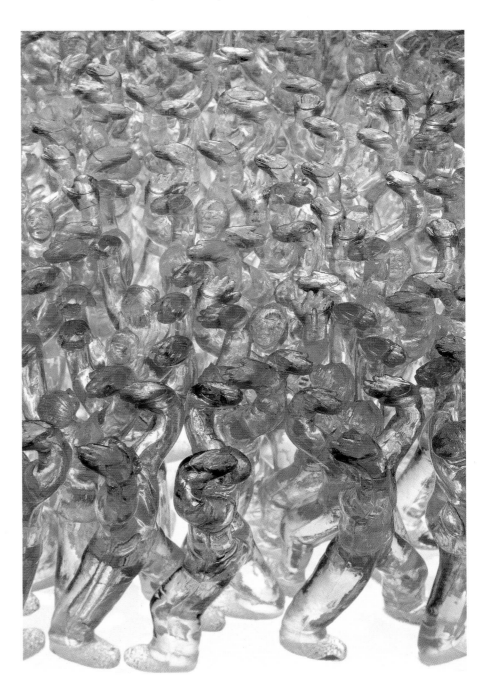

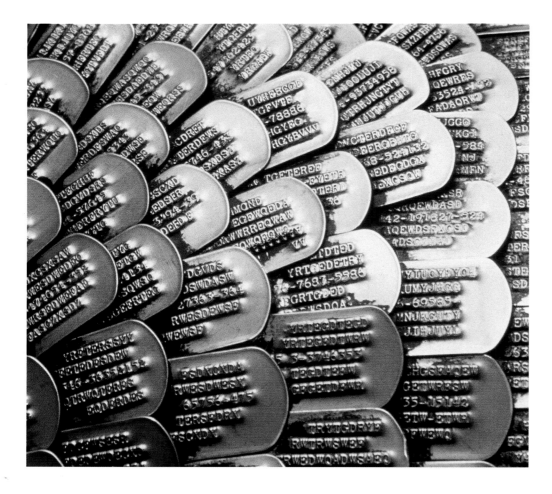

Some/One evolved from my first sculpture, *Metal Jacket*. I had a dream one day after I finished *Metal Jacket* that I wanted to turn it into some kind of larger installation. The dream was quite vivid. It was night, and I was outside a stadium, approaching it from the distance, and I saw a light in the stadium. And so I thought, "There's some kind of activity going on there." And as I approached, I started to hear clicking sounds, like the sound when metal pieces touch together. It was like there were thousands of crickets in the stadium. And then I entered the stadium. I walked slowly, but I went into the stadium on the ground level. And then I saw this reflecting surface and I realized

I was stepping on these metal pieces that were military dog tags. And they were vibrating slightly, vibrating and touching each other. The sound was from that. From afar I saw the central figure in the center of the stadium. It tried to go out of the stadium but it couldn't because the train of its garment, which was made of dog tags, was just too big. It was just too big to pull all the dog tags. So that was a dream and the image that I got. After that I made a small drawing about this vast field of military dog tags on the ground and a small figure in the center. Obviously I could not create the piece exactly as I dreamt it, but that was the kind of impact I wanted to create through that piece.

Do-Ho Suh

OPPOSITE AND ABOVE
Some/One, with detail, 2001,
Installation view at Korean Pavilion,
Biennale di Venezia, Venice, Italy
Stainless steel military dog tags,
nickel-plated copper sheets,
steel structure, glass fiber
reinforced resin, rubber sheets
Figure: 81 x 126 inches diameter,
overall dimensions variable
Edition of 3

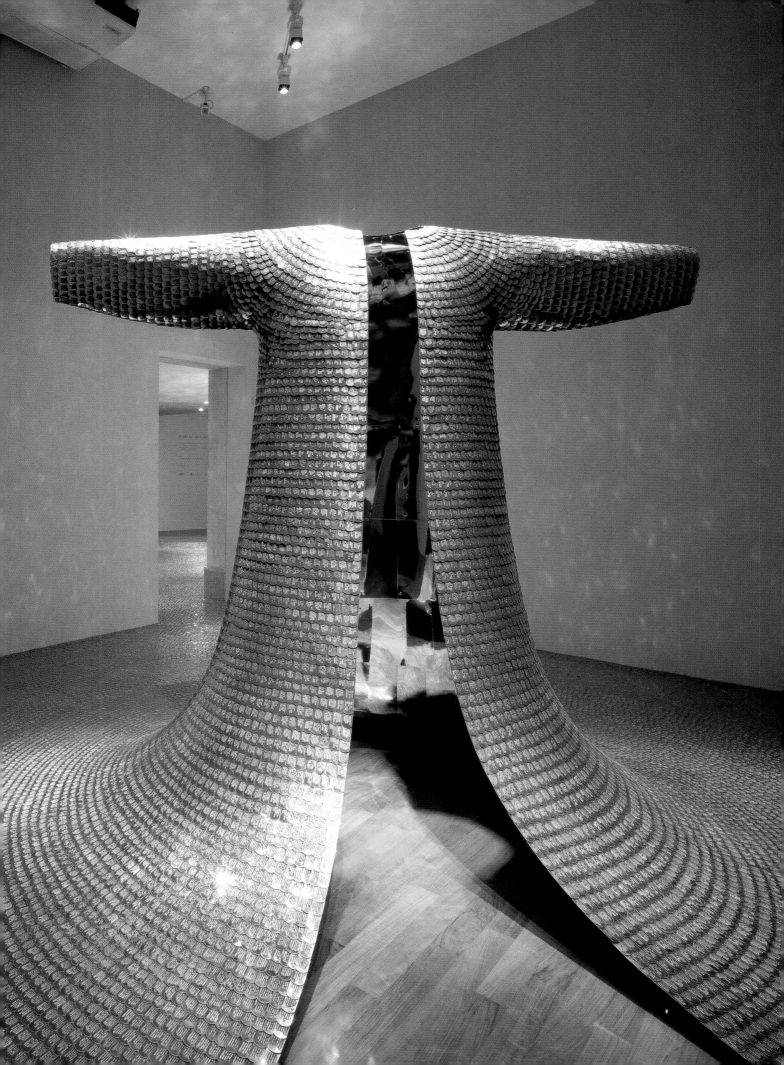

Kara Walker

Making things in shadow form suggests to the viewer, "You can look at me this way, but perhaps you'll see something else." It's a very passive kind of gesture, but within that I generally hope to create something tense, and a recognition of something very specific and very pointed about the viewer's relationship with the piece and the piece's relationship with me and my relationship with the viewer.

The silhouette, initially, was just an iconic thing. I responded to it. It seemed a little bit kitschy and hearkening back to some quiet, innocent period. I was looking at miniatures and early American painting and genre paintings, and silhouettes would occur in between the pages of these historical works. I responded to them in a number of ways. I recognized their beauty . . . this handmade quality, and began to love the self-promotion surrounding the work of the silhouette artist. They would have to show up in different towns and advertise in sometimes very overblown language describing their incredible skills . . . being able to cut accurate likenesses in less than a minute . . . or ten seconds. I was looking at racist paraphernalia, iconography, and then at these accurate versions of middle-class Americans. I began to associate the silhouette itself, the cutting, with a form of blackface minstrelsy. Here we have these mainly white sitters or a few slaves who were documented in silhouette—but for the most part white sitters whom I identify as middle class because upper class would require a full-fledged oil portrait and that's what I had already ruled out for myself. "No oil painting here, not going to ape the master that way."

One thing that got me interested in working with silhouettes, but then working on the large scale, had to do with two sorts of longings. One was to make history painting in the grand tradition. I love history paintings. I didn't realize I loved them for a long time. I thought that they were ridiculous in their pompous gesture. But the more I started to examine my own relationship with history, my own attempts to position myself in my historical moment, the more love I had for this artistic, painterly conceit, which is to make a painting a stage, and to think of your characters, your portraits, as characters on that stage. And to give them this moment, to freeze-frame a moment that is full of pain and blood and guts and drama and glory. It just became all the more relevant to my project. And my project is about many things . . . but it's also about trying to examine what it is to be an African-American woman artist. It's about how you make representations of your world, given what you've been given.

Kara Walker

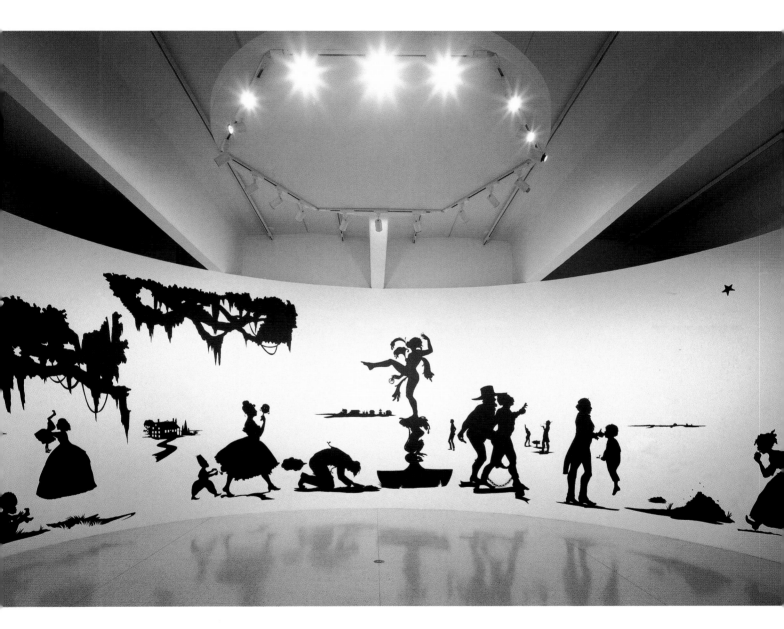

Kara Walker

Beauty is just kind of an accident. Beauty is just a happenstance. Beauty is the remainders of being a painter. The work becomes pretty because I wouldn't be able to look at a work about something as grotesque as what I'm thinking about, and as grotesque as projecting one's ugly soul onto another's pretty body, and representing that in an ugly way. I have always been attracted to the lure, work that draws a viewer in through a kind of seductive offering: "Here's something to look at. Stay a while."

Kara Walker

BELOW
Untitled (Hunting Scenes), 2001
Cut paper and adhesive on wall
Left panel: 98 x 68 inches
Right panel: 103 x 63 inches
Collection of Centro Nazionale per
le Arti Contemporanea, Rome, Italy

OPPOSITE
Cut, 1998
Cut paper and adhesive on wall,
7 feet 4 inches x 4 feet 6 inches
Collection of Donna and Cargill MacMillan

I needed to set down the paintbrush for a while. There was something misleading about trying to paint at all because it's so seductive and it lures the artist into believing that every stroke is magical and every stroke is intelligible to an audience. And sometimes they can be. But mine weren't. I had done cut pieces and collage work, a few here and there, but it really came in this moment of catharsis. I was tracing outlines of profiles, thinking about physiognomies and racist sciences, and the re-inscribing of identity based on white male parameters, and minstrelsy, and that being the opposite—the shadow and the dark side of the soul. And I thought, "I've got black paper here." I was making silhouette paintings, but they weren't the same thing. And it seemed like the most obvious answer was just to make a cut in the surface of this black thing. I had this black paper, and if I just made a cut in it I was creating a hole. And it was like the whole world was in there for me . . . in this evisceration, and at the same time taking that hole and making something very complete and w-h-o-l-e.

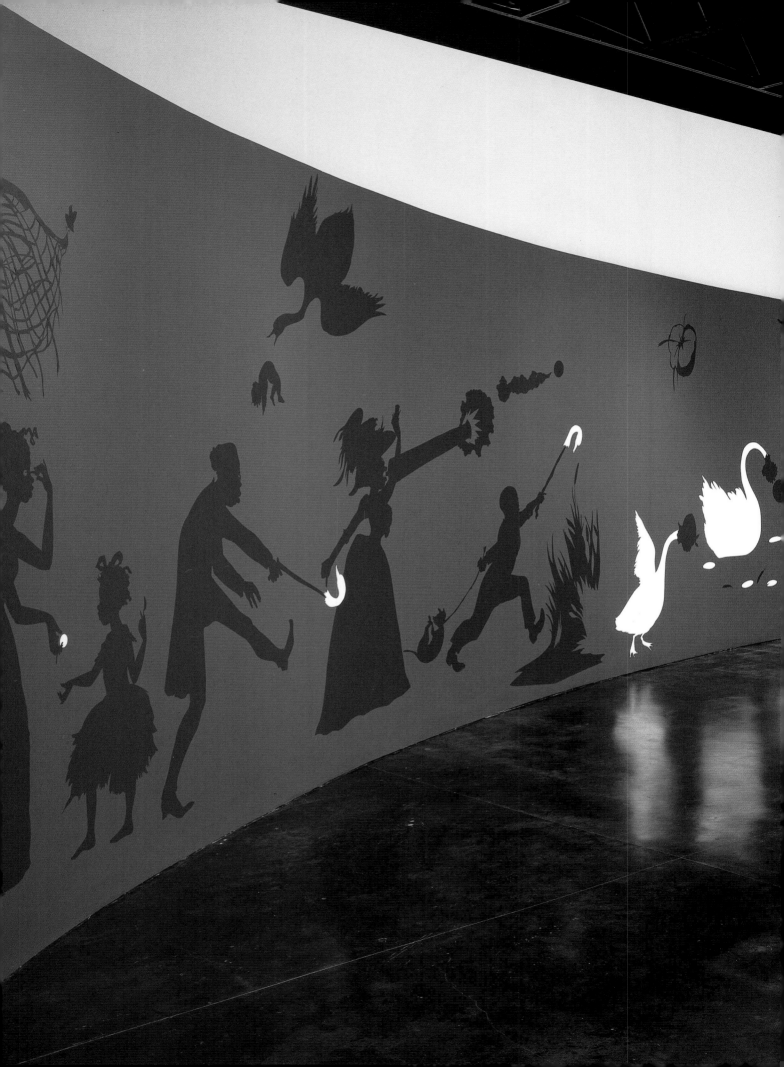

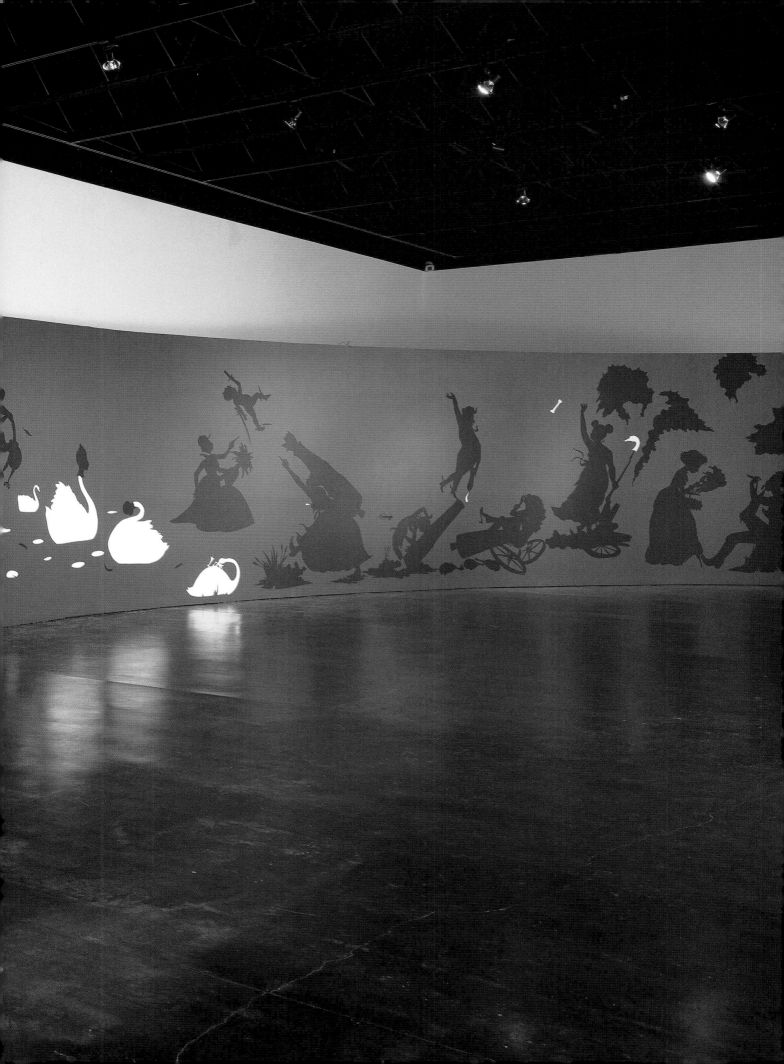

Kara Walker

PRECEDING SPREAD
No mere words can Adequately reflect the Remorse
this Negress feels at having been Cast into such
a lowly state by her former Masters and so it is
with a Humble heart that she brings about their
physical Ruin and earthly Demise, 1999
Installation view at the California College
of Arts and Crafts, Oakland, California
Cut paper and adhesive on painted wall, 10 x 65 feet
Collection of the San Francisco Museum of Modern Art,
San Francisco, California

BELOW
Insurrection! (Our Tools Were Rudimentary, Yet We
Pressed On), 2002, Installation view at the Solomon
R. Guggenheim Museum, New York
Projection, cut paper and adhesive on wall, 12 x 74½ feet
Collection of the Solomon R. Guggenheim Museum, New York

OPPOSITE
Mistress Demanded a Swift and Dramatic Empathetic
Reaction Which We Obliged Her, 2000
Projection, cut paper and adhesive on wall, 12 x 17 feet
Collection of Whitney Museum of American Art, New York

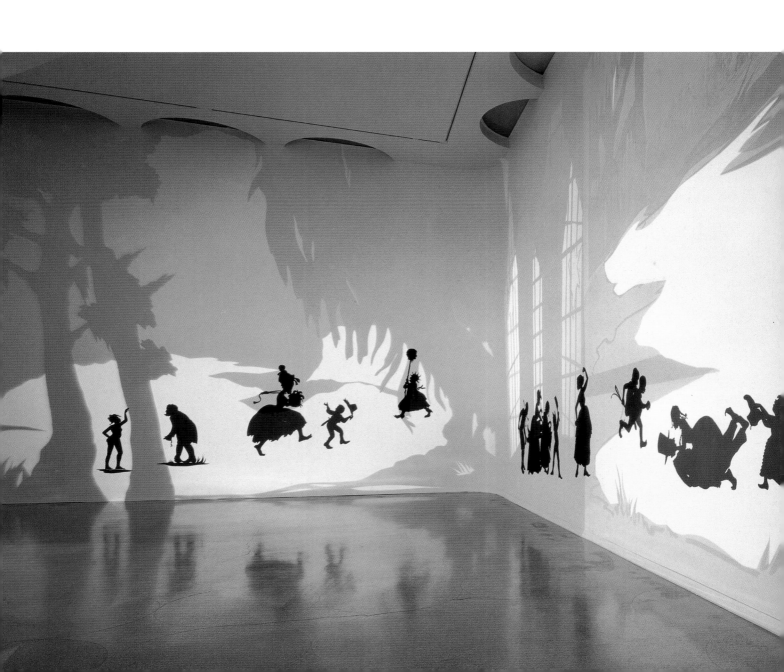

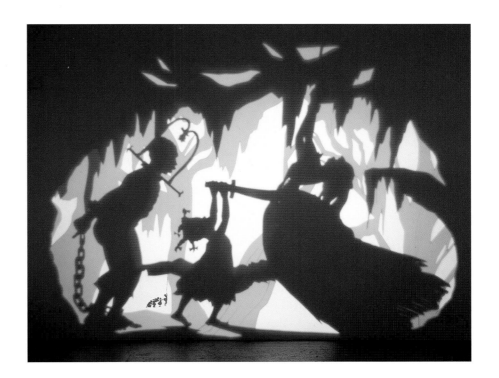

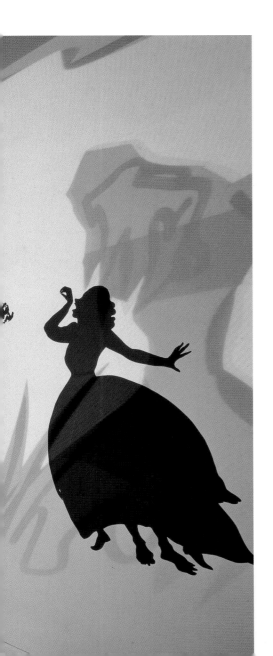

Insurrection! The idea at the outset was an image of a slave revolt in the antebellum south where the house slaves got after their master with their utensils of everyday life, and really it started with a sketch of a series of slaves disemboweling a master with a soup ladle. My reference, in my mind, was the surgical theatre paintings of Thomas Eakins and others.

Before I even started working with a narrative that circled around representations of blackness, of race, racial history, minstrelsy . . . I was making work that was painterly and about the body and the metaphorical qualities of the body. So I always think about this work, this history, in terms of the body. And in terms of this act of excavating that's been such a current and recurring theme, particularly in the histories of feminist artists, feminist writers, African-American people of color, investigating and eviscerating this body of collective experience . . . sometimes to the point of leaving nothing intact. I entered into this project, this idea of being a black woman artist, from the perspective of a person who has been presented with a pre-dissected body to work from. A pre-dissected body of information.

One of the things that's happened here with the work that I've done is that because it mimics narrative, and narrative is a kind of given when it comes to work produced by black women in this country, there's almost an expectation of something cohesive—a kind of *Color Purple* scenario where things resolve in a certain way. A female heroine actualizes through a process of self-discovery and historical discovery and comes out from under her oppressors and maybe doesn't become a hero but is a hero for herself.

And nothing ever comes of that in the pieces that I'm making.

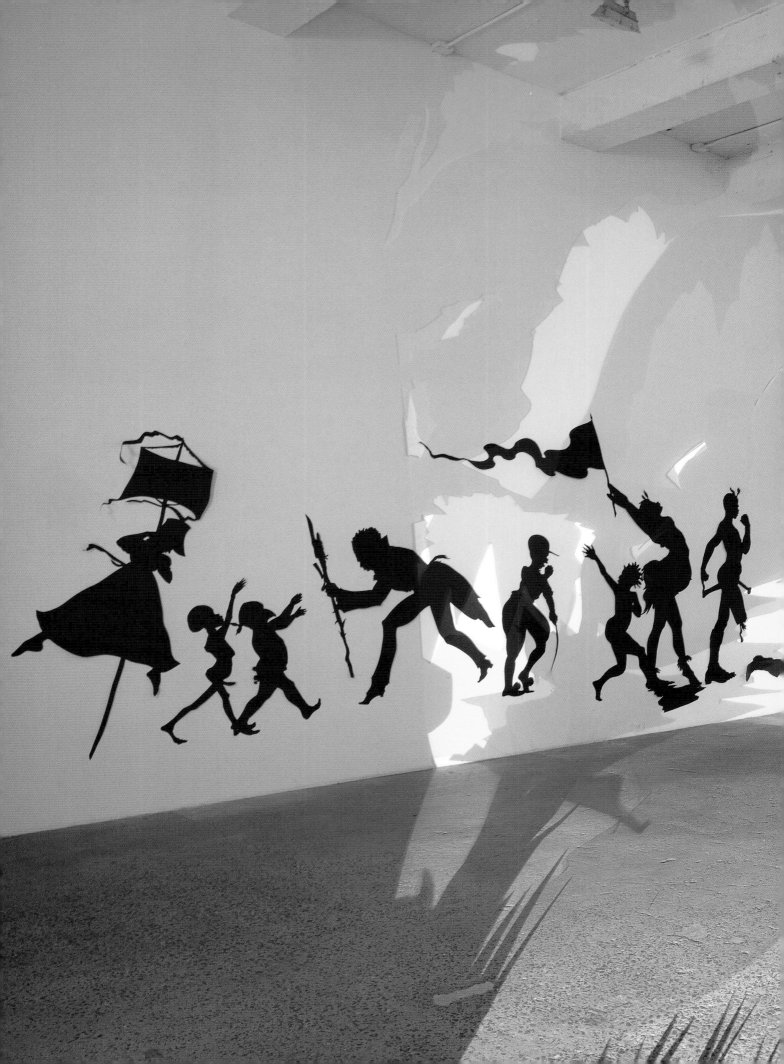

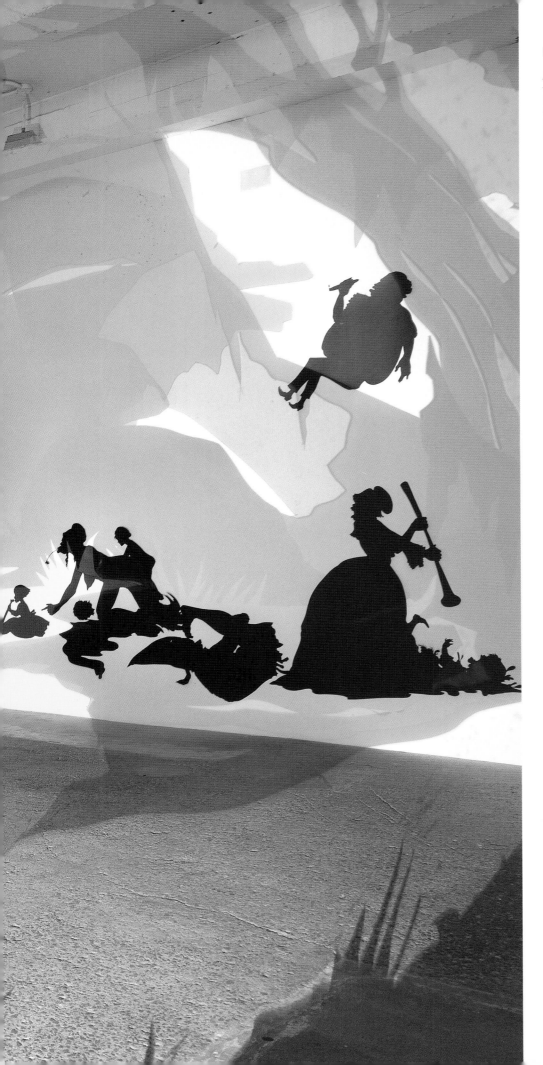

Kara Walker

Darkytown Rebellion, 2001, Installation
view at Brent Sikkema, New York
Projection, cut paper and adhesive
on wall, 14 x 37½ feet
Collection of Foundation Musée d'Art
Moderne Grand-Duc Jean, Luxembourg

Wall projections came about as one of
a series of steps to projecting one's
desires, fears, and conditions onto other
bodies, which all of my work has tried
to engage with using the silhouette.
And it also created a space where
the viewers' shadows would also be
projected into the scene so that maybe
they would become captured and
implicated, and implicated in a way that
is very didactic. Overhead projectors are
a didactic tool, they're a schoolroom
tool, so . . . in my thinking they're about
conveying facts. The work that I do is
about projecting fictions into those facts.

I'm more interested in what viewers
bring to this iconography that I'm
constantly dredging out of my own
subconscious. As I dredge, I'm often
surprised about what comes up and
what seems holding my own invention
and what seems connected to a series
of representations of the vulgar, paired
with blackness, that have already existed
and been regurgitated over several
hundred years. . . . I couldn't really name
these characters or caricatures. These
are phantom-like; they're fantasies. Just
the end-result of so many fabrications
of a fabricated identity.

Janine Antoni

Gabriel Orozco

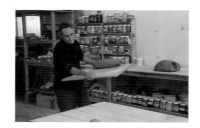 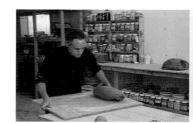

Collier Schorr

 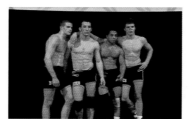

Loss and Desire

Janine Antoni

In the making process one has to try to leave space for the object to make itself. Making is a struggle between what you want the object to do and what the material wants to do. In my processes, which are so repetitive and take such a long time, I have time, too, to accept what the material wants to do. I have a great belief that there's inherent logic there. Rather than saying, "I have this idea. I want to communicate it through this object," it's more about a dialogue between me and the material, coming to it together.

Performance wasn't something that I intended to do. I was doing work that was about process, about the meaning of the making, trying to have a love-hate relationship with the object. I always feel safer if I can bring the viewer back to the making of it. I try to do that in a lot of different ways, by residue, by touch, by these processes that are basic to all of our lives . . . that people might relate to in terms of process, everyday activities—bathing, eating, etc. But there are times when the best way to keep people in that place, which for me is so alive and pertinent, is to show the process or the making. And it's always difficult to put myself there. It's a vulnerable place. It's very powerful. I think that the thing that is most dangerous about it is that I move the energy off the object and I try to put it on the process. But somehow it gets stuck onto me. This . . . is a tricky place for me, too. That's why I so often only work with the residue, and I'm sort of in the viewers' imagination when they look at the object. When I show myself doing these things, I know it will be riveting for the viewer, but I want it to be riveting for the right reasons, or for the reasons I'm interested in.

Gnaw, 1992
Chocolate, lard, lipstick and
display case, dimensions variable
Collection of the Museum of
Modern Art, New York

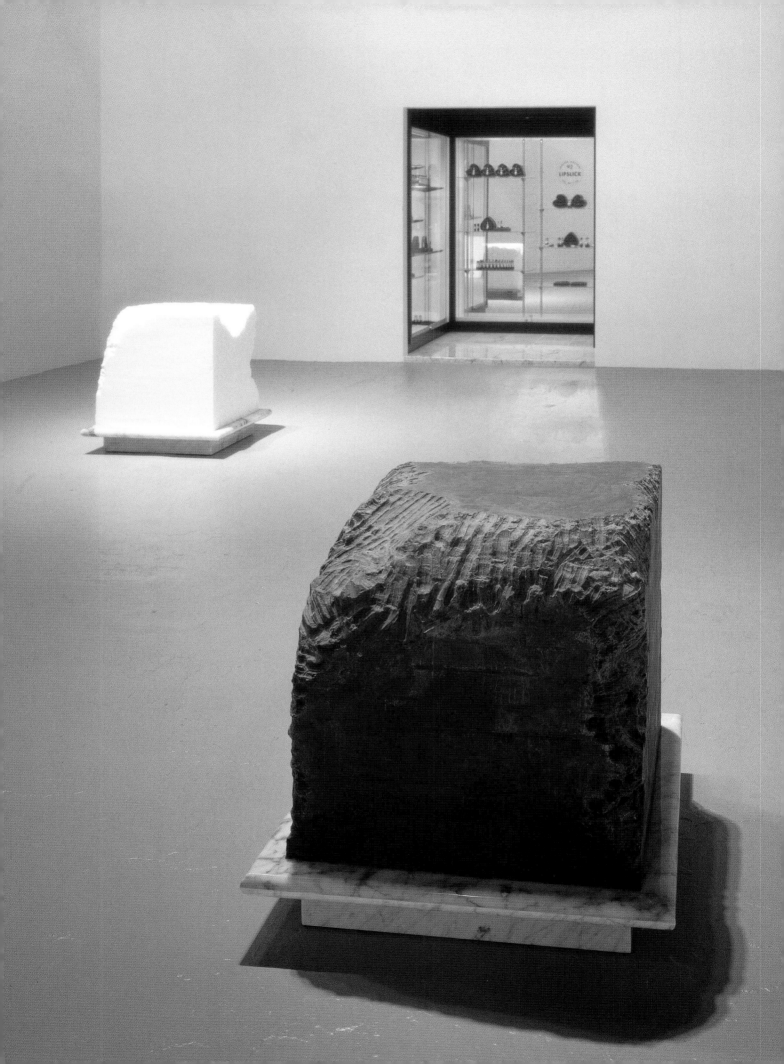

Janine Antoni

All of my objects sort of walk the line
between sculpture, performance, and
relic. Any time I use performance, it's
not so much my interest in performance
but my interest in bringing you back
to the making, the meaning of the
making. I'm interested in pieces existing
in different realms. So some people
will experience the performance, but
what I would really like is that the
sculpture will somehow tell the story.
I think of it like the viewer coming
in on the scene of the crime and piecing
everything together to understand
the work.

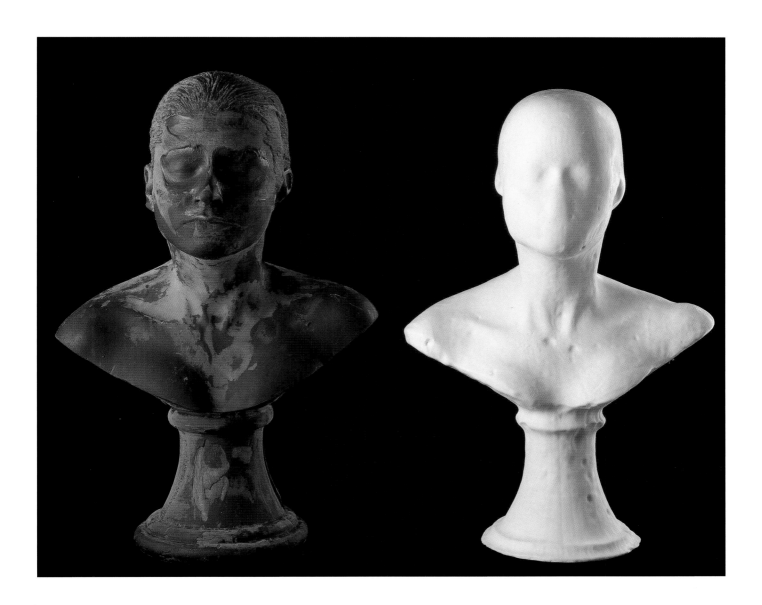

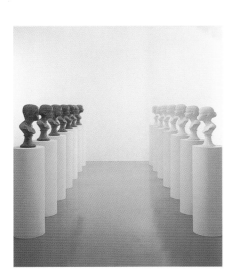

I wanted to work with the tradition of self-portraiture but also with the classical bust. I took a mold directly from my body . . . and I cast every little pore and wrinkle, even my hair. I started with an exact replica, and then I carved the classical stand. I made a mold, melted down thirty-five pounds of chocolate, poured it into the mold, and when I took it out of the mold I re-sculpted my image by licking the chocolate. I licked up the front and through the mouth up onto the nose, over the eye, and back up over the ear onto the bun and then down in the back, around the neck.

I also cast myself into soap. And I took the soap into the bathtub with me and slowly washed with it, and I transformed my image through that process. I had the idea that I would make a replica of myself in chocolate and in soap, and I would feed myself with my self, and wash myself with my self. Both the licking and the bathing are quite gentle and loving acts, but what's interesting is that I'm slowly erasing myself through the process. So for me it's about that conflict, that love/hate relation-ship we have with our physical appearance, and the problem I have with looking in the mirror and thinking, "Is that who I am?"

Janine Antoni

Loving Care, 1993
Detail of performance, Anthony
d'Offay Gallery, London
The artist soaked her hair in hair dye
and mopped the floor with it

I mopped the floor with my hair. . . .
The reason I'm so interested in taking
my body to those extreme places
is that that's a place where I learn,
where I feel most in my body. I'm
really interested in the repetition,
the discipline, and what happens
to me psychologically when I put
my body to that extreme place.

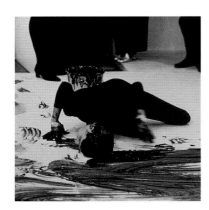

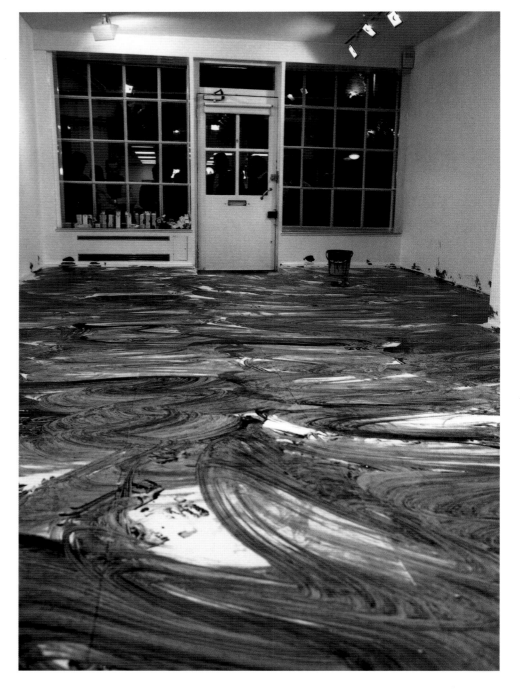

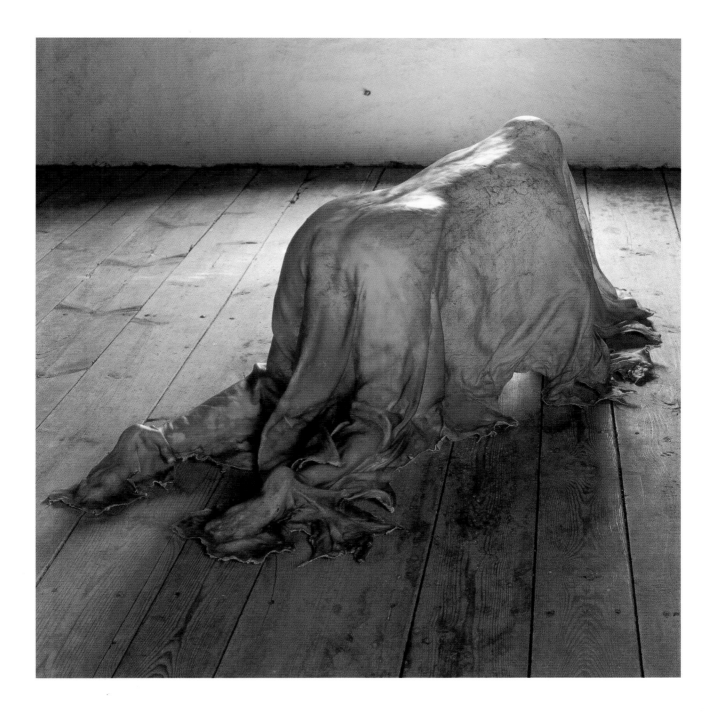

Janine Antoni

Saddle, 2000
Full rawhide (cow),
25²⁄₃ x 32½ x 78⁵⁄₈ inches

I got on my hands and knees and made a cast from my body in fiberglass. Then I got a full rawhide taken straight from the cow. It was still very pliable. I threw the hide over the mold, and in about twenty-four hours the hide shrunk about twenty percent. During that time I could sculpt all of the folds. They were almost like clay, totally malleable. And slowly I sculpted the folds as it was shrinking, trying to get the impression of the figure underneath. When I was done, it got very, very hard, and I removed the mold. It's completely hollow.

I think the startling thing for me was that I made a ghost of myself. When I'm with the piece I feel the absence, both of my body and the cow. It wasn't necessarily something I intended for the piece, to be so ghostlike. It's transparent . . . there's nothing underneath, although the shape so articulates the figure. It's a kind of push-pull that you feel, of such a presence of the figure. For me, the shocking thing was to realize that I've made a piece about the death of the cow, my own death.

Janine Antoni

Coddle, 1998
Cibachrome print and hand-carved frame, 21½ x 16 inches

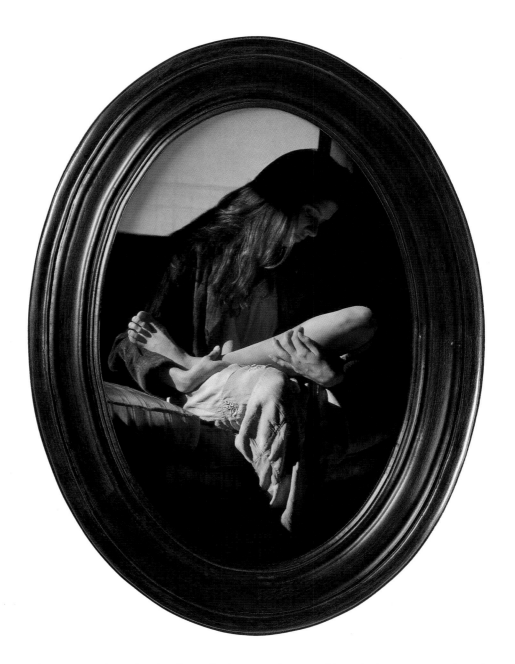

The structure that I develop for each piece is like a shell of meaning. Then I can let loose with the process. It seems I rarely start from the place of expression, but that the expression comes through the making. That structure is very comforting, but also helps me not to get lost in the process.

I certainly want there to be a part of the work that not even I understand; there is a place for that. But this shell or structure that I talk about has to be there for that mystery to exist. In *Coddle,* the structure—the already existing thing that I know and the viewer knows—is this painting of the Madonna and Child. We all know things about that kind of representation of maternal love that's come to us through art history. Then I can go from this objective place to a very subjective place. To hold my leg and look at it as something other than myself and love it is an interesting experience to give myself. There are a lot of things in that pose that seem charged for me. So here I am, literally holding myself.

I was reading a book by Jeanette Winterson, and the first line was "Why is the measure of love loss?" And I thought of this piece right away, because it's not only an image of Madonna and Child but it's an image of the Pietà. You know it's an image of absence. It's about what's not there.

Janine Antoni

Touch, 2002
DVD installation,
14 feet 8 inches x 13 feet 2 inches

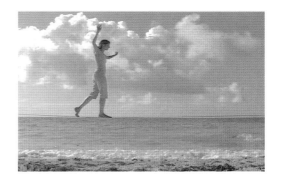

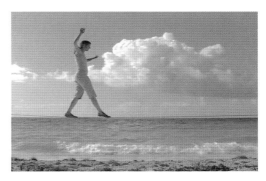

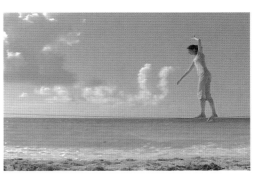

Touch is about that moment or that desire to walk on the horizon. And you can see I'm hardly balancing there in that place of my desire.

I started with this idea of why we would ever want to walk on a wire that's half an inch wide. It's crazy. What is that desire? When we look at the tightwire walker we think, "He's walking on air." And that idea just triggers the imagination. I thought, "If I could walk on air, if I could walk anywhere, where would I walk?" And that brought me to the horizon line. It's not a place; it doesn't exist.

My mother likes to say that she always encouraged us to travel. She had this Trinidadian expression that we come from behind God's back—that our island is so small that not even God recognizes it. So there was always this idea that you had to go out and see the world. And for me the horizon was out there. It's a very hopeful image; it's about the future, about the imagination. And so for me to walk in this place seemed very appropriate. It made sense for me to go back to this horizon, this ocean that I had looked at my whole life.

For me, it was really about, "What is that desire?" And just to be able to balance there for a second was a way of bringing you to the point of that desire. And then taking it away.

Janine Antoni

OPPOSITE AND FOLLOWING PAGES
Moor, 2001
Dimensions variable
Installation views, *Free Port,* at Magasin 3
Stockholm Konsthall, Sweden
List of materials appears on pages 84 and 85

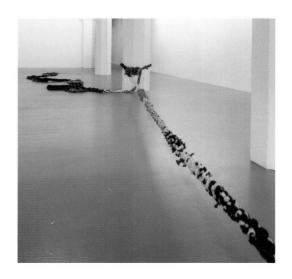

I asked my friends to give me materials to put into the rope. A lot of people gave me materials from friends who had passed away. Giving them to me to put into the rope is like giving them another life, another form. I wonder whether the viewer can uncover these stories through their experience of the object, whether these stories are somehow held in the material.

People looking at the rope begin by walking along it and noticing details, little buttons or a zipper, and then they come to the idea that this was something else before it was a rope. It was a shirt or something like that. Then they go to the material list and all of a sudden they realize what the rope is and they go back and view the rope in a different way. It's a slow uncovering of the story. Sometimes I like to think about objects or art objects as props to tell a story. So it's nice to use these materials that already come with stories, and somehow incorporate them into a story that I would like to tell.

When I look at the rope, I have a lot of my own memories. It's a piece that is sort of parallel to my life. When I was making the rope I started to think about it as a kind of lifeline . . . recording parts of my life and people in my life and I thought, "Wouldn't it be great if I could walk on the rope and walk my life again?" That idea brought me to the fact that I needed to learn how to walk the tightwire.

The first time I exhibited *Moor* was in Stockholm at Magasin 3, at the center of a harbor. The curator decided to do a show around the theme of the harbor. That's where the original idea for making the rope came from. I tied the rope to a column that was in the space, and then it went out the window, over the balcony, over a street, to a tiny little lifeboat that was floating at the center of the harbor.

The idea is that the piece continues. I'll keep adding to the rope every time I have an opportunity to exhibit the piece.

There is a connection to my mother and the work. I guess I could say that about most of my pieces. But I guess a rope is an umbilical cord.

At the beginning of the day we begin cutting up the materials and then we have to sew them together and twist them. If you look at the rope, it looks like it's braided together, but actually it isn't. What happens is we're twisting as tightly as we can in one direction. And then we're going to twist the strands back on themselves, and as we twist them back they release and create a kind of lock into each other. We work all day, sewing and twisting, and at the end of the day we take the big strands and we twist, let them go, and it's like the rope makes itself. It's a beautiful moment because we see all the materials mixing and of course we try to predict how they're going to mix, but it's always a bit of a surprise.

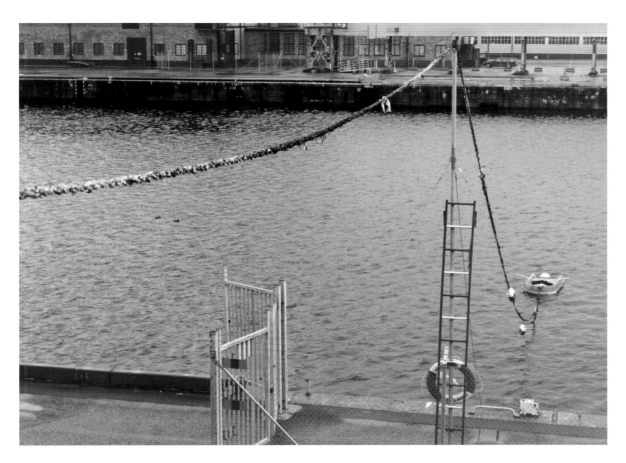

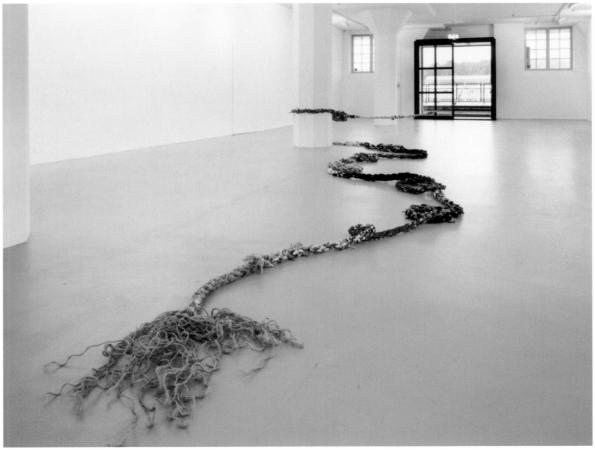

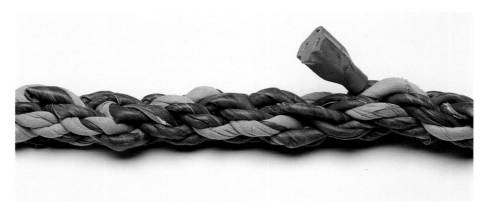

Fur from Judy's cats, Jay and Dee • Melissa and Mom's leftover tassel cords from *Unveiling* • Paola's chiffon scarf • Brian's green-flowered pillowcase • Brian's blue-flowered sheet • Melissa's plastic deli bags • Meg's aqua and white dragonfly skirt • Melissa's Barbeque Soy Chips bags • Linda's black velvet dress • Meg's green pajama top • Paul's left-over red, yellow, and blue flag material and pink raf-fia • Paolo's green and gray wool scarf • Paolo's vinyl belt and shoelace • Dave's blue-and-white robe • Dave's lamé boxers • Willie's electrical cord from his irons • Leather from Kevin's tightwire shoes • Beige baby hat worn by Louis and his son, James • Rebecca's Raggedy Ann doll's yellow-flowered apron • Marita's sister's handwoven pink fabric • Nora's blue handknitted scarf • Judith's blue and black rodeo shirt • Natalia's multipurpose fabric • Craig's aqua studio shirt • Robert's black scarf • Beverly's son's bedsheet • Maureen's ambrosia fabric given to her by Julie • Mom and Ana's blue flowered dress • Bob's orange University of Miami sweatshirt • Tamara's best friend, Barbra's white studio shirt • Kiki's tie-dyed clothes from her country house • Raffia from the straw bag given to Pat at our wedding • Brother Arnold's hand-dyed yarn • Dog hair from Habakkuk, Landon, and Jason • Piece of bell rope from the Shakers • Sister June's multicolor scarf • Mona's stained baby mattress cover • Michael's apron from the oval box shop • Sister Marie's kitchen apron • Sister Marie's red T-shirt • Fabric from Kazumi's childhood • Brother Wayne's sus-penders • Tony's suit • Boa France wore to Chen's opening • Zendon's socks • Lenny's T-shirt with Sabbath Day Lake logo • Sister Frances's scarf • Roland's favorite old tie • Nari's firehose • Yellow kite string and red electrical wire from Paul's studio • Julian's T-shirt • Danielle's work pants • Danielle's mom's blue patterned blouse • Courtney's laven-

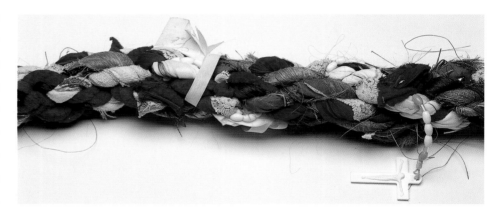

der shirt • Robin's pink silk dress • Tibetan prayer flag given to me by Jenny • Robin's metallic, flowered dress • Robin's father-in-law's Navy uniform • Daniel's plant specimens • Rosa's nightie • Beverly's bird nest mixed with orange and pink string • Lisa and Byron's Skowhegan T-shirts • Dan's yellow shorts • Martin's red handker-chief • Andreas's guitar strings • Paul's *Trans* edition, plastic hurricane flags • Jose's Barra do Sahy T-shirt • Dad's coconut husks • Joe's blue pants • Rosary beads found with Doug • Doug's grandmother's dishtowel • Elizabeth's grandmother's blue and white striped apron • My Mom's fall and hairnet • My Grandmother Gugu's slip • Red velour Christmas dress worn by my Granny Miana • Julie's multicolored fabric • Julie's green pants • Jenny's ribbon found on the beach • Gedi's wetsuit • Thomas's blue flour-sack pants • Gold trim for my Virgin Mary costume bought by Jody • David's blue striped Brooks Brothers shirt • Nina's interior decorating fabric • A rabbit fur belt

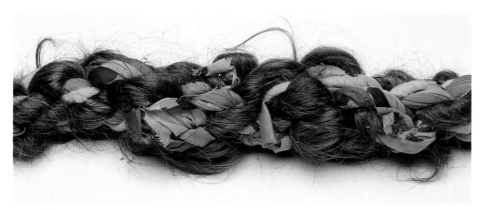

from the jacket my Mom bought me • Tove's black socks • Richard's green plaid shirt • Raffia from Pat's straw basket given to him at our wedding • Mattias's towel • Red plastic bag from Sina and Nina • Remnant from Nina's bridesmaid outfit • Sina's ex-friend's orange towel • Robert's blue rope • Robert's silk weather balloon fabric • Robert's rubber fish • Alan's glow T-shirt • John's gray nightshirt • Leis from Brian's birthday party • My brother Brian's favorite

shirt • Doug's industrial power cord • Grey fabric from Danielle's art project • Melissa's scarf • Melissa's skirt • Paul's navy shirt • Andrea's plastic curtains • Stuart's T-shirts • Pink feather boa from Codi • Chair upholstery given to me by my Mom • Mom and Dad's chenille bedspread • Dad's doctor uniform • Pat's shirt • Glenn's Uncle Donald's college sweatshirt • Mark's batik T-shirt from Indonesia • Mark's T-shirt • Byron's red turtleneck • Mary's phone cord • Mary's apron • Danielle's argyle sweater • Melissa's 100% vinyl jacket • Meg's triathlon bathing suit • Fur from Jody's cat, Hudson • Stockings I stole from my mother • Green button-down shirt of Paul's • More ribbon from Jenny • Dad's pajamas from the hospital • Hospital pajamas my mother bought me • Yarn given to me by Suzanne • Mom's hooded, orange terrycloth bathrobe • Robert's fuse • Dad's brown and white batik shirt • Blanket from Gabriel and Marina • Bob's boxers • Ambrosia fabric from the Bahamas • Paul's video connection cord • Brian's island shirts • 17 ties from Richard's father • Pat's hammock • Pat's camera obscura T-shirt, unlimited edition artwork • Doug's blue corduroy pants • Doug's High 8 video from the *Peripatetic North Watching Pack* • Paul's green turtleneck • Elizabeth's pink little girl's dress • Melissa's yellow embroidery thread • Haydee's brown T-shirt • Necklace that Paul bought me in Honduras • Mom's canary-yellow beach cover-up • Melissa's scarf • Melissa's polka-dot Carmen Miranda dress •

Meg's multilayered turquoise dress • Melissa's performance wig made from human hair • Meg's gold Mardi Gras beads • Melissa's burgundy ribbon • Brian and Paul's wool sailor pants • Mark's purple shirt • A Mickey Mouse shirt shared by Emmett, Ella, and Addie • Flower pajamas worn by Ella and Addie • Glenn's button-down pink shirt • Purple shirt given to Byron by Mark • Pat's khaki pants • Plastic rain hats that Jenny found • Dad's T-shirt commemorating the silver anniversary of the Bahamas • Gary's black banner from SITE Santa Fe • Mom's purple, blue, and white housedress • Pearl necklace my mother made and we both wore • Paul's blue and green sweater from Argentina • Sabina's green fabric • Gregory's tie bought in Sweden • Jenny's ribbons • Paul's paisley shirt from RISD days • Lisa's rose V-neck shirt • Lisa's late father's shirt, worn by Byron • Byron's purple patterned bathing suit • A fleece sweatshirt worn by Ella and Addie • Byron's tie • Striped leggings worn by Ella and Addie • Ella's star shirt • Melissa's plastic tubing • Danielle's angora sweater • Mark's plaid shirt • Unidentified pink shirt • Ana and Mom's blue patterned dress • Paul's paisley button-down shirt • Meg's transparent white gauzy/lacy negligee • Melissa's antique cream dress. • Meg's light blue Monster Truck T-shirt • Melissa's brown satin shirt • Danielle's work jeans • Doug's red wool cardigan • Sabina's

black and white dress • Gregory's purple shirt • Paul's orange shirt • Glenn's ochre sweater • Emmett's blue and black bathing suits • Michael and Donna's rock climbing rope • Byron's red tie • Byron's green shirt • Anissa's swimsuit • Byron's tie • Night shirt of Paul's • Douglas's plaid shirt • Pat's tie • Lisa's studio jeans • Byron's striped velour shirt • Glenn's brown sweater from Old Navy • Green T-shirt of Pat's • Danielle's red reversible jacket • Melissa's dental floss

Gabriel Orozco

The process of living and the process of thinking and perceiving the world happen in everyday life. I've found that sometimes the studio is an isolated place, an artificial place like a bubble—a bubble in which the artist is by himself, thinking about himself. It becomes too grand as a space. What happens when you don't have a studio is that you have to be confronted with reality all the time.

I try always to be intimate with the world . . . with everything I can, to feel love for it, or interest in it. To be intimate you have to open yourself, to be fearless, to trust what is around you, animate and inanimate. Then you start to change the scale of things, of the public and private.

I believe that a small action or a subtle gesture in life can change many, many things. There's no guarantee that the big building is going to be the best architectural work. A little house can be much better and more important. It's the same in art. We work, and the work is realized when it's in contact with the public. All my work is intimate because I do it for me, because I'm curious about something, want to experience something, or want to find out about something. But I am conscious that it's going to be presented to other people who might be interested. So it's always intimate and it's always public. I don't think it has to do with the size or the scale of the work. It has to do with a deep reason why you are doing that work. It can be a small piece or a big piece and meaningless . . . just as empty of real content as a huge public sculpture or a small drawing can be totally empty.

It doesn't have to do with the size or durability of the work because if it's a good idea, it's going to be there for a long time. If it's a bad idea, if it's in bronze, it's a bad idea. It lasts five minutes. I don't think it has to do with size or material. It has to do with space that you open for real communication and real thinking.

ABOVE
My Hands Are My Heart, 1991
Terracotta, approximately
6 x 4 x 6 inches

OPPOSITE
My Hands Are My Heart, 1991
Two-part cibachrome,
9⅛ x 12½ inches each
Edition of 5

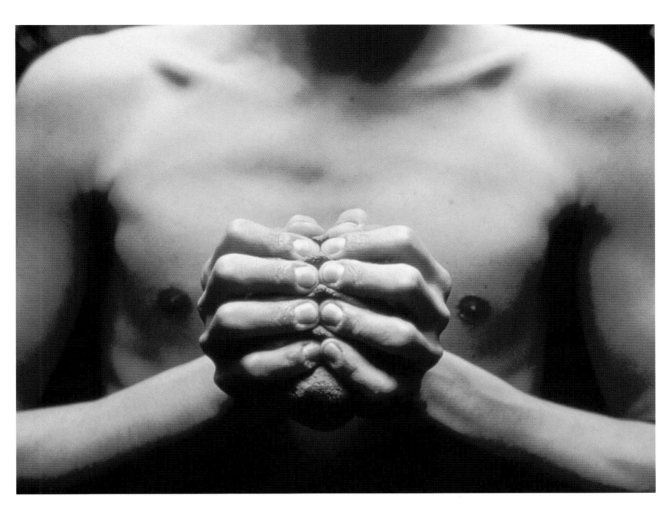

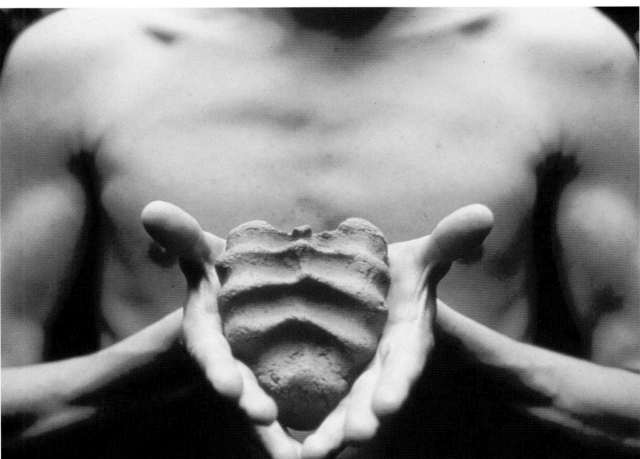

Gabriel Orozco

A lot of my work is about traces of human activity. I don't portray people. What I'm interested in is what people do—or what I do that can be done by anyone. I have the feeling that if I was doing a kind of self-portrait or portrait of a person in a specific culture, I would be limiting the work. I think it's more important to see the possibilities of human activity in everyday life.

When an object has a logic on its own, it starts to talk of many other things. It's not that it represents anything, but it represents . . . its own reason to exist, in a way, as a material—as clay, terra cotta, in relation with bricks, in relation with construction, with pottery, with many things, and the body. Then it's representing the movement that makes the shape. And then it can talk and express other things, suggest food, look like a fish, or something else.

Art happens in that space between the spectator . . . and the work. It's that space in between that finalizes the work of art. And in the case of the terra-cotta works, they are especially artistic—on the one hand very artistic, on the other . . . very hermetic.

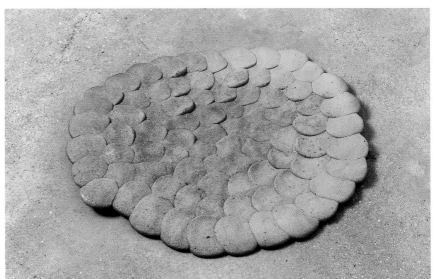

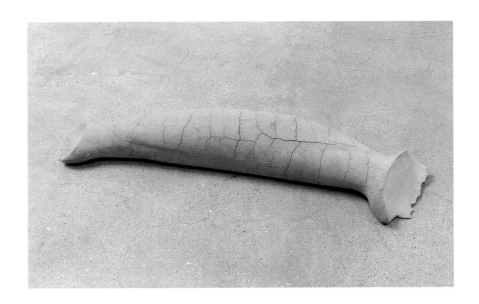

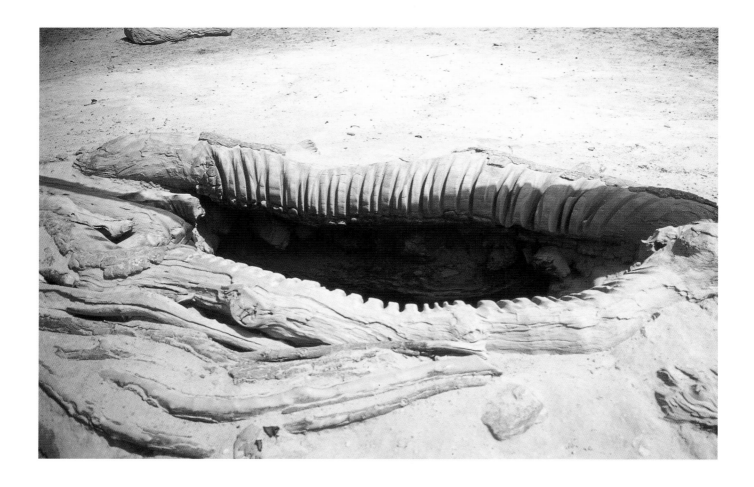

Gabriel Orozco

Well, 2002
Fuji crystal chromogenic archive
C-print, 33¾ x 46¾ inches
Edition of 3

Looking through the camera doesn't intensify experience. It just frames the object. It's much more intense without the camera. For me photography is like a shoebox. You put things in a box when you want to keep them, to think about them. Photography is more than a window for me; photography is more like a space that tries to capture situations. It's notational. I use the camera like drawing.

Gabriel Orozco

Standing Bicycle, 2002
Fuji crystal chromogenic archive
C-print, 33¾ x 46¾ inches
Edition of 3

A photograph might or might not become a work of art. In a way, it's irrelevant because I think photography is a necessity for documentation . . . for memory. First it's a necessity. Then, some of these photographs might generate enough thinking and contemplation to be exposed for consideration. But I don't take photographs thinking that they are going to be art. I take the photographs thinking that I need to keep the moment, because I need to look at it afterwards.

Gabriel Orozco

TOP
Pinched Ball, 1993
Cibachrome, 16 x 20 inches
Edition of 5

BOTTOM
Light Through Leaves, 1996
Iris computer print, archival water-based ink on paper
(500 gsm Somerset Satin 100% cotton rag), produced
by Cone Laumont Editions, New York, 20 x 30⅛
inches (image size), 22 x 32⅛ inches (paper size)
Edition of 60

I'm always drawing for projects, and writing. Making diagrams and measuring things. But also I like to draw as another way of thinking. And sometimes I think my drawings are like puddles. They're like water puddles. You have all this . . . paper and then you start to drop things in. And they are like a platform for accidents to happen.

Gabriel Orozco

Horses Running Endlessly, 1995
Wood, board: 34⅝ x 34⅝ x¾ inches;
knights 11¾ x 11¾ x 3½ inches each
Edition of 3

When you are playing chess . . . you always have to have the whole picture of the whole board. At the same time you have to fragment that into situations in present time. You have . . . the whole landscape, and you have to think in the big picture. And you have to think what is going to happen in the future in these areas on the board. And that is dialectical thinking between the big picture, the big scale, and the small, fragmented situations.

And if you think about what I'm saying in terms of my work and the planet, or my work and the landscape, it's exactly the same. You have a notion of the big picture of the world . . . and also the fragmentation of culture and the reconciliation or reconfiguration of culture and objects.

But go back to the chessboard. You have this fragmentation and then you have to act. You have to move things, and then you commit yourself with the movement. And then, reality is coming back to you. Reality means the other player. And it's coming back to you with a move that you probably expect. But it could be a surprise. That whole relationship between the board, the fragments of the board, the players, time, and concentration has been very important in my work.

Space is not an abstract thing. Space is a social thing. So when I do a drawing of the DS, a chessboard or an elevator, it's because I'm interested in the space. But I am aware that it's always social space and . . . trying to develop a new topography, a topology that can still be space. That is the mathematics in the real world. It's an equation, or a new speculation, with a real object like the car or the elevator, the ping-pong table or the billiard table, or the skull—a speculation related to space, topography, mathematics, and the logic of the object itself, transformed to make it clearer but, at the same time, something else.

It's not just a car. It's a special car. When I cut it and extracted the center and put it back together, the design in relation to speed and the body became accelerated. So I think that you are looking at a car in motion, and you can think in sculptural terms of the idea of trying to express motion, speed, time.

Another way is to deconstruct a cultural icon that is not just an icon, because it is also a machine that has a function, and to remake it on its own logic. It's a car that still works. It doesn't run, of course; the motor is gone. But in a way, you can go inside. You can feel speed.

It's a work that has so many levels: In terms of desire as a body, in a way, it's a rocket but it's also a feminine body. It's quite serious, but at the same time so funny. I think it's tri-dimensional, but at the same time it's bi-dimensional. When you see it in reality it looks like a photograph. It gets flat. You find a tri-dimensional object, quite a complex object, and when you cut it and assemble it again you are trying to flatten it. The funny thing is that you can keep cutting it and cutting it, and never ending. It's a kind of infinite process. From point A to B you have to first go to the half. To go to the half, you have to go to half of the half, and then to the half of the half of the half . . . so you never finish. It's another notion of the infinite.

Gabriel Orozco

ABOVE
Oval Billiard Table, 1996
Wood, slate, mixed media, 35 x 122 x 90 inches
Edition of 3
Collection MAC, galeries contemporaines des musées de Marseille

OPPOSITE
La D.S., 1993
Altered Citroën DS, 55⅛ x 189 x 44⅞ inches
Collection Fonds National d'Art Contemporain, Paris. En depot au MAC, galeries contemporaines des musées de Marseille

Beauty? I don't use the word beauty anymore. Never. It's not that the thing itself is beautiful. It's the relationship that you establish that makes something beautiful. And so the word 'beautiful' is not an absolute. It's a moment, I would say. It's more like a moment in which you look at something and you feel alive, you feel that you are enjoying something. And that is a moment of poetry, pleasure, revelation, thinking. It's that situation that is beautiful. But for that, and to find beauty, you need to be open and you need to activate the world. Then you generate beauty. Beauty is not something that comes to you. You have to do it. It depends on your culture and your energy, your openness, your generosity with the world that makes beauty happen.

When I did *Black Kites*, I was interested in how we perceive volume, how we perceive tri-dimensionality. I am interested in the pattern in the grid and how we perceive truth, always through filters of light, darkness, or many other things. It's not a pure vision; it's always there in

layers—cultural and physical layers. I was just trying to impose a homogeneous pattern on a very complex tri-dimensional object—a human cranium. So I did this drawing for six months . . . superimposing grids on top of the cranium, and getting into a lot of trouble making this drawing because I had to get into the eyes and then describe the object with a bi-dimensional structure, i.e., drawing.

The black and white is a cancellation and a revelation. Everything that is black somehow makes the object disappear. And all the things you leave in white, which is the natural color, reveal the object. So half of the object is disappearing, half of the object is present. This, of course, is an illusion.

That should be the work of an artist, that everything looks easy in the making. It is not an issue that something is complicated or expensive to make, but that the work in its easiness opens up an immense landscape of possibilities, of understanding, and you can really get into this landscape and work and work and work.

Gabriel Orozco

ABOVE
Cats and Watermelons, 1992
Cibachrome, 16 x 20 inches
Wendy and Robert Brandow

OPPOSITE
Black Kites, 1997
Graphite on skull, 8½ x 5 x 6¼ inches
Collection of the Philadelphia Museum of Art: Purchased with funds contributed by the Committee on Twentieth-Century Art

Collier Schorr

Gender, religion, nationality are all in flux in my work. They build on each other, on the idea that you're not sure what you're looking at, what you are, what someone else is. The avenues to desire are skewed. I wanted to make work that spoke to as many people's desire as possible—maternal desire, fraternal desire, desire for romance, for youth.

When I first started making work I wasn't an artist; I was a writer. I made artwork because I had something to say. It was the late 80s, and if you had something to say and you were an artist you could still make something. So my entry into the art world was, "I have some kind of political point of view and I'm going to join all these other people I know who have political ideas and talk about it in the work."

I moved from writing to sculpture to a brief interlude with painting and clay, wood, embroidery, and yarn. And then I started photographing.

There's not a single intention that I want people to walk away with when they look at the body of work. Rather, I want people to luxuriously stroll amongst the pictures and look with curiosity, and marvel at what we've done . . . that people from different places and different ages could go on this sort of journey together and make this collaboration, that is really equal parts history, fantasy, documentary, realism, appropriation. But it's not about a specific cause or identity struggle. It's about internationality and androgyny, costume design and military history, landscaping and geography. And that's quite different than earlier bodies of work that were very specific.

I think what happens with artists who are lucky enough to make work for more than a few years is that you bring along with you the concerns of your earlier bodies of work. But you're not so set on telling people what it is they're seeing. You're more relaxed, and you allow your audience to discover things themselves.

One of the roots of my work was that I always wanted to steal into my brother's life. I always saw myself as his older brother, but I was his sister and I wanted to do the things that he got to do but didn't seem to want to do as much.

I think I've tried to recreate those things. The androgynous part of the work comes from the fact that I can only imagine with a girl's brain. I'm creating a boy's world from the emotional center of a woman. Whenever they look soft it's because I don't really know what it is to be a guy. I only know what it is to be a girl. So I think that paints them with androgyny.

I'm not making something that's about the façade. I'm making something that's about removing security, removing the myth, and being left with something that is more human and approachable.

For me there is no progress unless you put things forward—unveil desire—unveil repression.

If you have a question, ask it.

Collier Schorr

BELOW
Jens F. (114, 115), 2002
Photo collage, 11 x 19 inches

OPPOSITE
Forest Bed Blanket (Black Velvet), 2001
C-print, 35 x 44 inches
Edition of 5

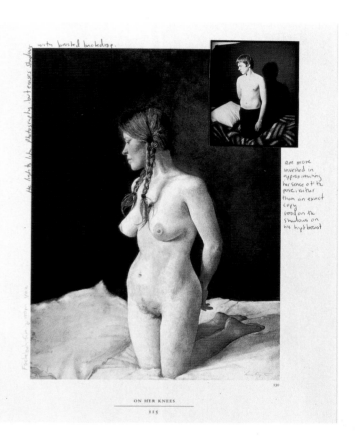

In the Helga pictures I set out to create a total portrait of a young man using Andrew Wyeth's Helga paintings as a template to explore how one defines someone in images using a description of femininity to describe a man, so that you start to wonder with the Wyeth portraits whether it is a feminine pose or an artist's pose. Is it Wyeth's pose, is it Helga's pose?

I've always had the notion in my work of trying to get very close to something, to create as little distance as possible between the viewer and the subject.

We end up with two kinds of mirror images—one that's very much about photography and the way artists express ideas with the camera rather than drawing, and the notion of a photographic sketch-book, drawing made of photography. It

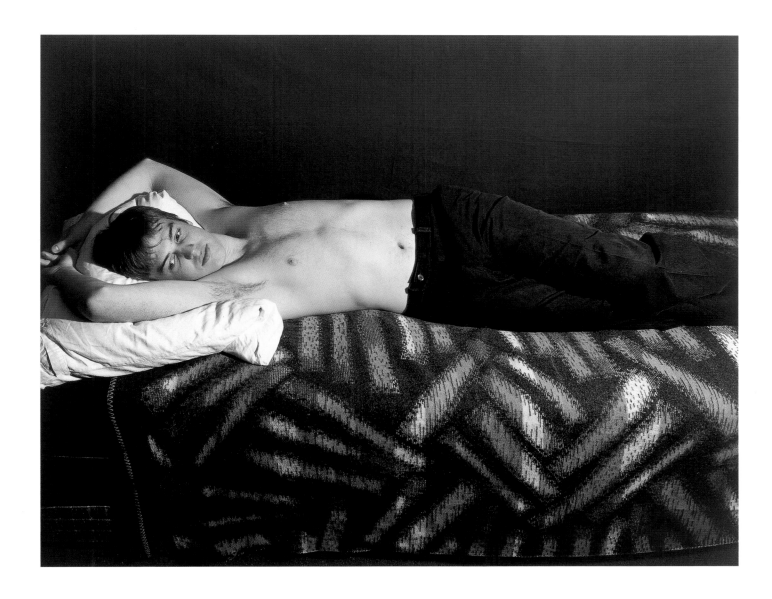

was very important to show that when you look at photography you're seeing edited things, and when you look at my Helga project you're seeing everything, as many moments as possible.

You're seeing pictures of Jens when Jens was Jens, pictures of Jens once he's in the middle of transforming into Helga, or Jens as he fails in capturing a pose.

Having a boy play a girl (and when I say "play a girl" I don't mean that he is represented as a girl, because he is represented as a young man) is complicated. He knows he's looking at photographs of a girl and copying those poses. So the audience sees him as a man, but he can only see himself as a woman, because that's the model he's looking at. It was a really interesting exchange.

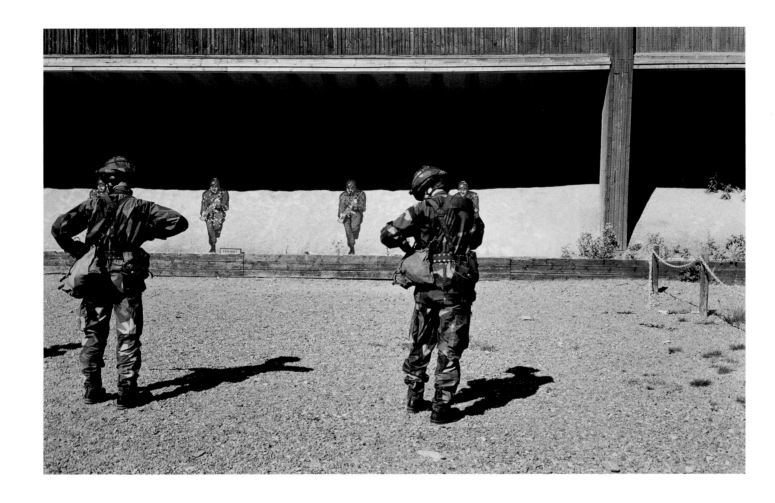

Collier Schorr

ABOVE
Shooting, 1997
C-print, 15½ x 23 inches
Edition of 5

OPPOSITE
*Matthew
Occupation
Barbarossastrasse,* 2001
C-print, 44 x 35 inches
Edition of 5

The first soldier pictures I took were of Herbert and his friends. They all collected army stuff and they would go on campouts, play army, and raid each other's bunks. I was really surprised to find that all the army stuff was American and that they were dressing up as Americans, in a territory that was in fact occupied by American soldiers.

So my first pictures were really to put them in their German landscape and have them play out this occupation that I was watching from afar.

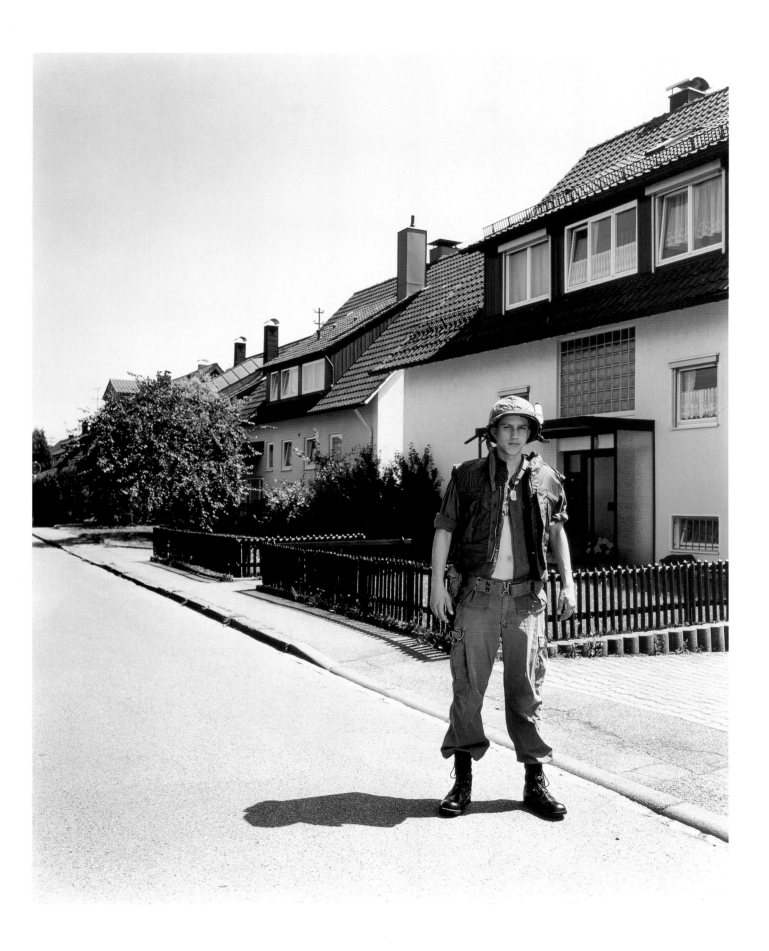

Collier Schorr

BELOW
Andreas
POW (Every Good Soldier
Was a Prisoner of War)
Germany, 2001
C-print, 39 x 28½ inches
Edition of 5

OPPOSITE
Swedish Soldier (Poster), 1997
C-print, 23 x 15½ inches
Edition of 5

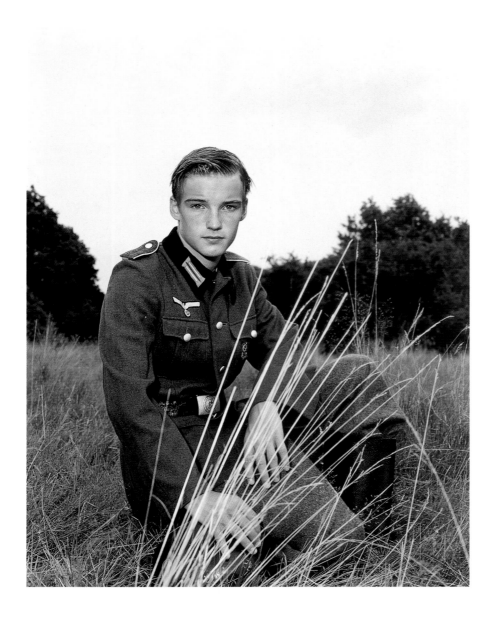

The work is about conflicting obsessions—twinship and opposition. It's about people who look the same but aren't, about boys that look like girls or girls that look like boys, or boys that look like athletes and aren't, or boys that look like soldiers and aren't. It's a metaphor for the Jew and the German—German Jews thinking they were the same as Germans and yet being so different—for the way in which Jews and Germans are so linked together because of the Holocaust. It was such an opposing situation, but they're stuck with each other. It happened to them together: the Holocaust is over and we're left with this strange relationship that goes on forever.

The pictures . . . don't always veer that far from snapshots that guys who served in the army would bring or send home. People don't send home pictures with their best friend's head blown off or body on fire. They send home pictures of arms draped across shoulders, smiling for the hope that one day they're going to be home. Those are the kinds of pictures that I was interested in making, and especially making them in Germany.

Some people fit into uniforms and are soldiers; some people don't fit into uniforms and aren't soldiers. Some pretend to be soldiers. I wanted to show that political causes change but soldiering is consistent. It's about putting young guys in scary places, asking them to die for someone else, to die for a cause they might not understand.

Collier Schorr

War is about losing innocence. And the war pictures were particularly about that journey. The earlier pictures were very bucolic, leisurely, soft. It was really about sunbathing as much as it was occupying a piece of territory. The later pictures, when the guys were older and some of them had been drafted into the army, became more critical—became more about being injured, or being vulnerable. It no longer was so much about sunbathing as it was about being out in the open and being a potential target. And I think that it was closer to me.

It became more specific . . . it wasn't so much the poetry of the fragile body but the poetry of the spirit, of the fragile spirit, a poetry of risk and devastation.

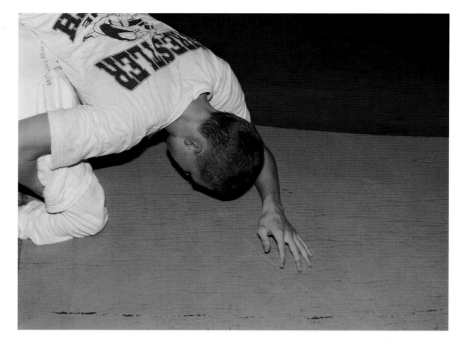

Collier Schorr

ABOVE, LEFT
America Flag with scratch, 1999
C-print, 20 x 16 inches
Edition of 5

ABOVE, RIGHT
At Ernie Monaco's THE EDGE, 2003
C-print, 16 x 20 inches
Edition of 5

OPPOSITE
Blow-Up, 1999
C-print, 19 x 14 inches
Edition of 5

I bring a certain fantasy to masculine adolescence. I don't know for sure what it was like, but I'm interested in preserving or recreating moments from it because I think they show a wider scale of emotion for men. So I love shooting wrestling, particularly in practice, to see two guys throwing some moves and then being careful that they didn't hurt each other. Pushing as hard as they can but then pulling back, making sure they're okay. Talking about it, how to do it better, giving each other advice. All that . . . is a rich part of masculinity that I think dissipates when guys get older because priorities change and they enter a different world.

I picked wrestling because for me it felt like what it was like to be in school, a struggle. I loved the way the guys looked . . . that they were shorter—my size—that they were doing something that made them small outcasts within the community. They were not doing a popular sport. It was a sport that people didn't watch, that was really difficult and demanded a lot of them, emotionally and intellectually. I was interested in defining what went on in a series of very tight moves, over

and over and over again, and picking apart personalities and relationships. I was interested that wrestling is a team sport and an individual sport about partnerships, working out with a guy who's your size, working through the moves together in a non-competitive way. It was a beautiful relationship that I had never seen before.

I can only approach it as a woman, but for me, from the outside, masculinity has been depicted in very black-and-white terms. There never seems to be a wide range of emotional definitions of men. In wrestling you see so many different emotions, so many different reactions and interactions.

I'm looking for introspection—for the moment before the guy goes out there, warming up—the moment when he comes off, either exhilarated because he won or devastated because he lost. I'm looking for anyone who's bleeding, who's been beaten up a bit.

The theme of twinship has always run through my work. It's about people who look alike. That was another reason I was drawn to wrestling—because wrestlers look a certain way.

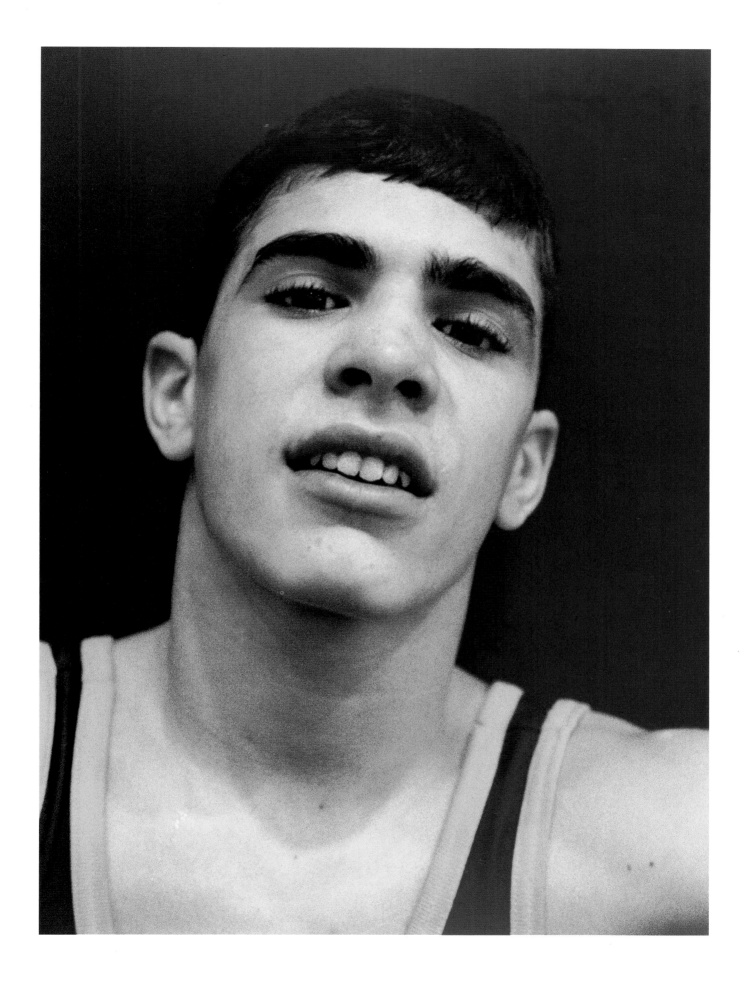

Eleanor Antin

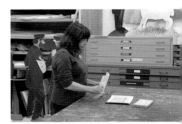

Walton Ford

Elizabeth Murray

Raymond Pettibon

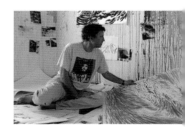

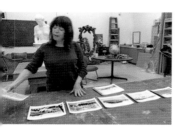 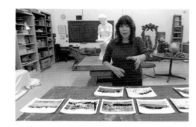 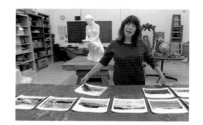

Humor

 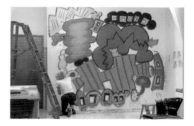

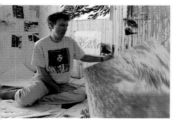 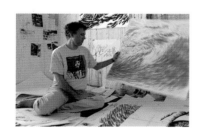

Eleanor Antin

I always tend to see the funny sides of things. To me, the richest experience is when it's laughter and tears together. And I know that sounds very Jewish, and perhaps that's part of the Jewish kind of humor I was brought up with. It's like endless humor . . . and at the same time it's "Oy!" I like it when it has those layers, that depth of richness, human experience, and suffering that it goes along with. And I think all my work— I mean, some of it—is just downright outrageous and funny obviously. But it plays, even that stuff that looks like the most obviously ridiculous. There is, I think, a relation to human experience that gives it more of a rich layer than humor on its own.

Essentially, I invent histories. And I invent them by coiling up their relations to the present. I used to have this fantasy —when I was a kid—that I would give up my life and die right then. I was always very melodramatic. If I could be invisible and I could be from the beginning of history, and for me that was Western history, I would be this invisible person who would be there when Keats was dying, when Marlow got killed, when Caravaggio was screwing with whomever he was screwing. All of these things would be happening and I would be there invisible, and I would know everything. It's a very Faustian image, especially for a kid. It was this passion, and it was always for the past.

I'm sort of a time traveler. I travel freely in the past.

You can find anything you want by going back to the past. You don't even have to look . . . the metaphors start erupting all over the place, the relationship with the present. Also, I've always loved the past because of its relation to the present that I could make as an artist.

From *Before the Revolution,* 1979
Installation at Ronald Feldman
Fine Arts, New York
Left: *Karsavina,* masonite figure on wheeled base, 54 x 30 inches
Right: *Nijinsky,* masonite figure on wheeled base, 58 x 15 inches

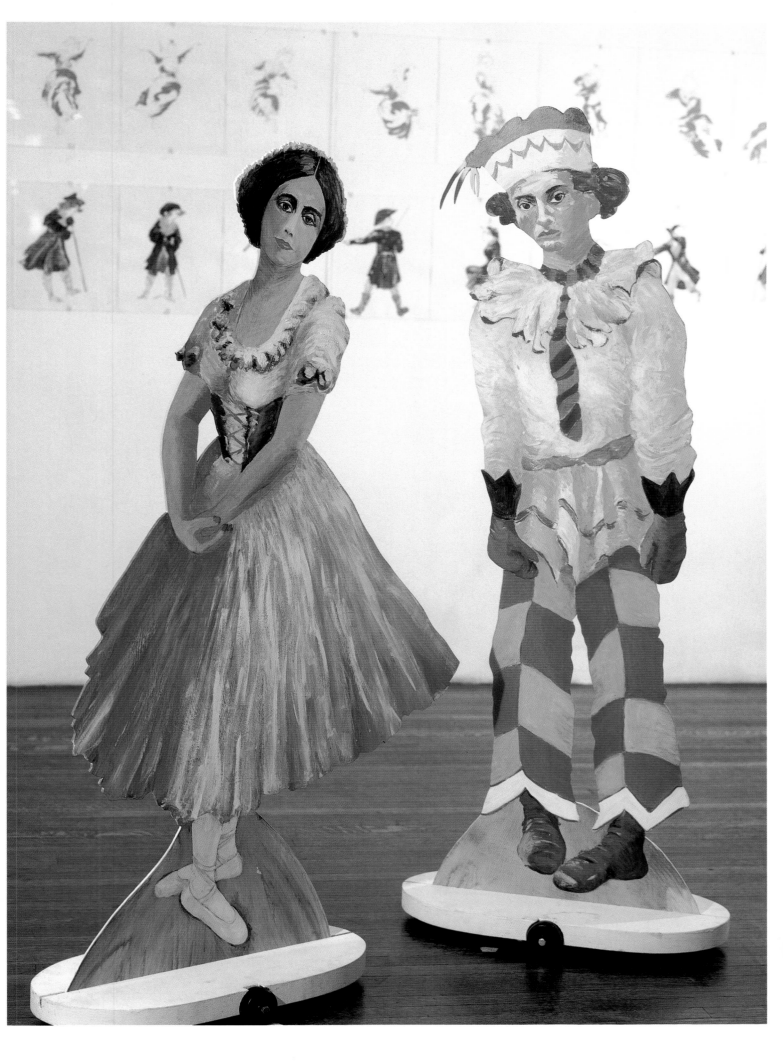

Eleanor Antin

TOP
Love's Shadow, 1985
16mm film, black-and-white, 2½ minutes

BOTTOM
The Ballerina and the Poet, 1986
16mm film, black-and-white, 2½ minutes

OPPOSITE
The Ballerina and the Bum, 1974
Black-and-white video tape, sound,
54 minutes (shot on location)

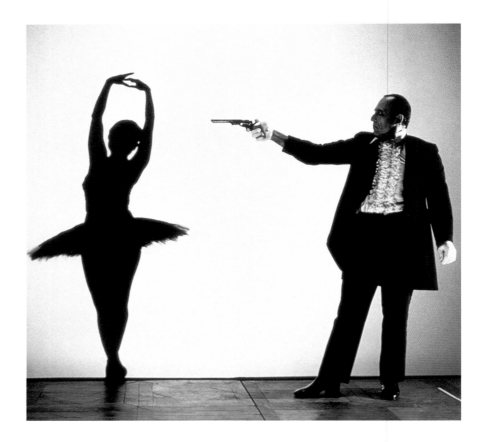

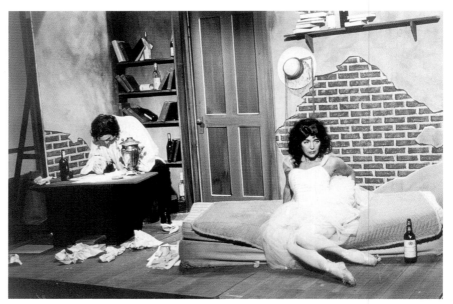

It's playing with high-art form. I adore the ballet, but in some ways it's a completely ridiculous art form. It is so stupid, but it can be very beautiful. And I dealt with it because of its interest to me as a classical art form that deals essentially with beauty. And then, of course, it's complex history with Diaghilev as the disseminator of modern art, modernism, as it were, in the popular culture. So I dealt with all sorts of complex concerns. But the form itself—I love it because it is pathetic and in its way ridiculous for people to walk around on stilts. It's foolish, and there is something beautiful and sad about it, and very mortal in a way. I love the mixture of things in it.

The Ballerina and the Bum was in the beginning days of video for artists. Practically all of the video, except for some works which were very funny like Bill Wegman's, were what used to be called self-referential works in relation to art, dealing with aspects of minimalism or whatever the particular artist was concerned with. Formalist considerations. Now people look at it and they could die of boredom, but actually some of it is still quite wonderful . . . various things that would be real live actions rather than theatricalized ones.

One of my major passions has always been narrative. I tell stories. That's what I love to do, and out of the narrative I like to deal with particular issues that interest me. I've always felt that narrative is as much of a human need as breathing. I'm not being facetious about that; I really believe that, because we do it. We're constantly—even if it's a one-sentence story —explaining ourselves and communicating in terms of putting material together that in some way has aspects of a story. And narrative is how we transform and change into different selves, into new places in our lives, move back and forth. Things happen to us.

So these are things that interested me. And alone, of everybody else I think, I was dealing with this story, *The Ballerina and the Bum*, in real time, transforming my real dreams of becoming a famous artist. I was a very young artist, going to New York and transforming this into the story of the ballerina who comes from California, hitches a ride on a freight train . . . with a bum who is living in the freight car, and together they dream of life and fantastic stories and the great things that will happen to them.

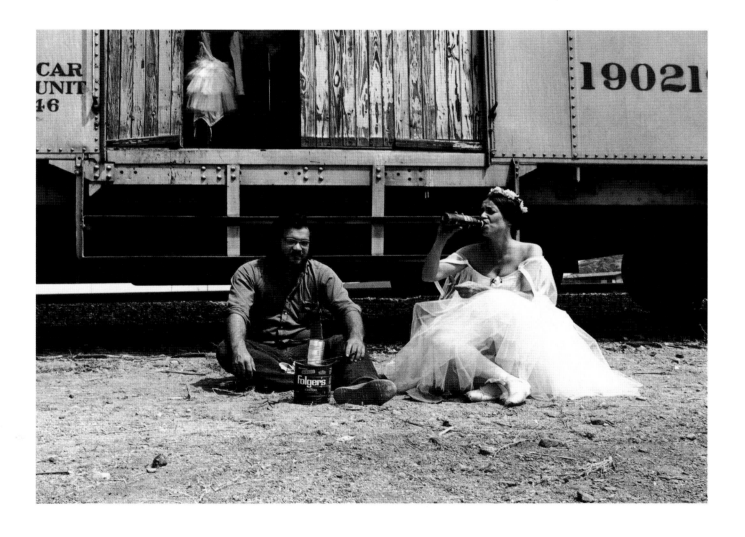

Eleanor Antin

OPPOSITE, TOP
Portrait of Antinova, 1986
Filmic installation, dimensions
variable

OPPOSITE, BOTTOM
Loves of a Ballerina, 1986
Filmic installation, dimensions
variable

ABOVE
From *The King of Solana
Beach,* 1974
Eleven black-and-white
photographs, mounted on
board with two text panels,
6 x 9 inches each

I used to think that I didn't have a self. I didn't have a self that was mine and I literally decided on being an actor when I decided, "If I don't have a self of my own I can borrow other people's, and so I'll be an actor." But I found the kind of stuff I was called on to do . . . was just stupid. I went back to my first love . . . which was writing, and then I left that. I was moving through all these different art forms. And it wasn't until conceptual art started coming in with its possibility for mixed media, for not being stuck with particular genres, that I could make use of all these talents of mine. Not because they were talents but because I liked them. I enjoyed playing with them.

Fluxus and Pop opened up all sorts of possibilities with collage, with borrowed imagery, with whatever. So I was just picking up from all over, like a scavenger, and transforming possibilities on my own. It was the art world that was so alive and exciting . . . and I think I was being fed by my milieu and, yes, I was in from the beginning.

Role playing was about feeling that I didn't have a self. And I didn't miss it. It's not as if I suddenly was this pathetic person without a self; it was just fine. I just borrowed other people's, or made them up. And it's something that continued when I started working with personas because it

was a very good way of dealing with a lot of the political and social issues that were of interest to me. And also particular intellectual interests that I had, like theatre and self-representation.

So I took on the King, who was my male self. As a young feminist I was interested in what would be my male self . . . he became my political self. And then, my most glamorous, wonderful woman self in those days was the Ballerina. I actually found that these characters had this marvelous quality of being like an onion. You know, you peel an onion and then there's more skin and you keep peeling and then you peel and you peel. Of course that's a romantic image because you're crying all the time you're peeling, you know, and I was sort of laughing most of the time.

But they did tend to 'unpack', and what happened is that they became richer and richer and more complex, especially Antinova. You know, in some ways if you look at Lichtenstein—he put everything into the Ben Day dots. That was a great art-making machine he had, a marvelous art-making machine. And I had a marvelous art-making machine, my personas. I never knew where it would go. I could always open up into something else, until I decided I didn't want to make art as somebody else . . . until I decided I really was me.

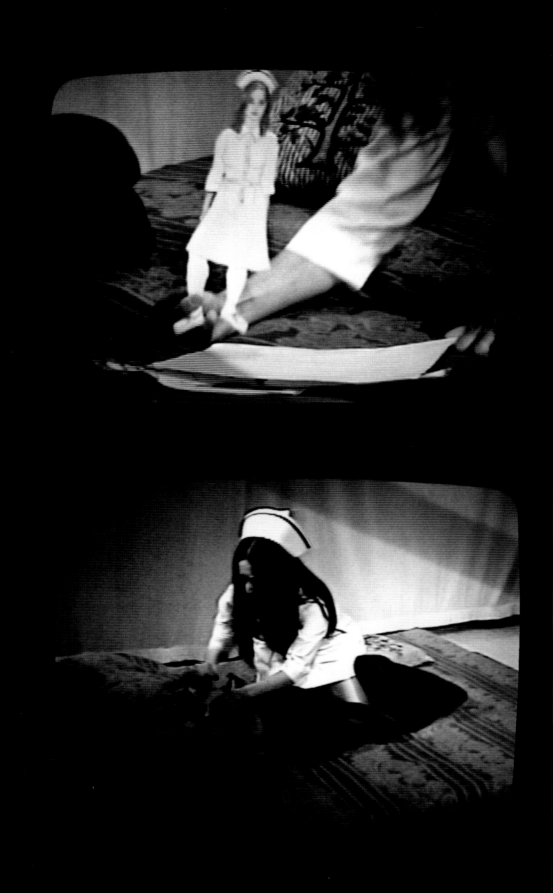

Eleanor Antin

OPPOSITE
*The Adventures of a Nurse
(Part I and Part II),* 1976
Color video tape, sound, 64 minutes

ABOVE, LEFT
The Angel of Mercy, 1977
*Eleanor Antin, Myself 1854
(Carte de Visite)* from
The Nightingale Family Album
One of 25 tinted gelatin-silver
prints, mounted on handmade paper
with text, 18 x 13 inches each

ABOVE, RIGHT
The Angel of Mercy, 1977
In the Trenches Before Sebastopol
from *My Tour of Duty in the Crimea,*
One of 38 tinted gelatin-silver prints,
mounted on handmade paper with
text, 30 x 22 inches each

There's the grand nurse, Eleanor Nightingale, who invented nursing as a profession for women . . . a rather complex and tragic tale. And the other is little nurse Eleanor, a sort of fantastical creature, a little paper doll who has love affairs and adventures, and goes from lover to lover cheerfully, being treated badly by one after the other, and then just picking up and starting again. It's very funny. It's playing with paper dolls the way I used to play with paper dolls all through my childhood.

I must say that even . . . when I was in high school and I no longer played with these but I still had them, on the days when I'd come home . . . depressed (you know, kids were always depressed about something), I'd play with my paper dolls. And somehow I'd continue the stories, and then afterwards, I would feel humiliated that I had done this, I had played with these paper dolls like a child. But it was so important, it let out

so much, you know. There's a richness in that kind of make-believe, which is— I guess—why I return to them. And even my big figures are in a sense cut-outs, only bigger.

Eleanor Nightingale discovers that by saving these men to go out and continue to be soldiers, they are going to kill other people and then finally be killed themselves. Where she had one corpse before, now she'll have two or three or four. So . . . nursing does not really solve problems. You need much more revolutionary ways to do this. However, she says, when you see a man you have to bandage him. And that is the human thing to do. It's not going to get rid of the problem; it is going to make life bearable and possible. That is the rather sad message of that piece, if there is a message. I mean, the whole thing is kind of loony. And then she gets a medal at the end which is, you know, great.

Eleanor Antin

TOP
A Hot Afternoon, from *The Last Days of Pompeii,* 2001
Chromogenic print, 46⅝ x 58⅝ inches

BOTTOM
The Artist's Studio, from *The Last Days of Pompeii,* 2001
Chromogenic print, 46⅝ x 58⅝ inches

OPPOSITE
The Golden Death, from *The Last Days of Pompeii,* 2001
Chromogenic print, 58⅝ x 46⅝ inches

Pompeii is a photographic sequence. It's directing a whole host of actors, placed in another historical period, and it deals with art, theatricality, and with what I think is our present-day situation. I was coming down the scenic route, looking at La Jolla, and there she was. The town was laid out on this incredible bay . . . like Pompeii, which isn't exactly on a bay, but it's filled with these beautiful, affluent people living the good life on the brink of annihilation. And in California we are slipping into the sea, eroding into the sea . . . living on earthquake faults. And we finished this piece two-and-a-half weeks before 9/11. . . . So the relationships between America as this great colonial power and Rome—one of the early, great colonial powers— were extremely clear to me.

Eleanor Antin

The Death of Petronius, from *The Last Days of Pompeii,* 2001
Chromogenic print, 46⅝ x 94⅝ inches

Walton Ford

I am doing the kind of research that legitimate natural history artists do, but I do it in a very lazy way compared to them. I don't want to ever pretend that I'm like one of those guys. There is another level to this sort of natural history-art thing that actually doesn't interest me, but I do a kind of imitation of it.

I think it's like John Lurie. He said something like he plays fake jazz, and everybody howled at him for that. But I think I make a sort of fake natural history art. It's similar. Don't look too closely!

Part of the reason I got interested in using watercolor is that I was interested in painting things that looked like Audubons. They were like fake Audubons, but I twisted the subject matter a bit and got inside his head and tried to paint as if it was really his tortured soul portrayed . . . as if his hand betrayed him and he painted what he didn't want to expose about himself. And it was very important to me to make them look like Audubons, to make them look like they were a hundred years old . . . like he painted them, but that they escaped out of him.

Walton Ford

BELOW
Ornithomancy No. 3, 2000
Watercolor, gouache, ink and pencil
on paper, 26 x 19 inches
Collection of the Bowdoin College
Museum of Art, Brunswick, Maine
Given in memory of John Stuart Fallow, Jr.,
Class of 1948, by Laura-Lee Whittier Woods

OPPOSITE
Ornithomancy No. 3a, 2001
Watercolor, gouache, ink and pencil
on paper, 38½ x 28 inches
Private collection, San Francisco

I often question the intersect between the message as perceived (as a political kind of "blah, blah, blah") and my urge to just make these pictures. Why do I feel the need to make these things? Why is it that you want to make them as disturbing as you can? Or as violent and out of control as you can? That just comes from some place that doesn't bear up under theoretical discussion. And all artists are like that. They get going and then they figure out—as they go—why, what it all means in a weird way, and how it all ties in.

The big, big thing I'm always looking for in my work is a sort of attraction-repulsion thing, where the stuff is beautiful to begin with until you notice that some sort of horrible violence is about to happen or is in the middle of happening. Or that it's some sort of interior monologue.

Ornithomancy No. 3

The Belted Kingfisher or Halcyon ~ Megaceryle alcyon

Walton Ford

RIGHT
The Orientalist, 1999
Watercolor, gouache, ink and pencil
on paper, 60 x 40 inches
Private collection, New York

OPPOSITE
The Forsaken, 1999
Watercolor, gouache, ink and pencil
on paper, 60 x 40 inches
Private collection, New York

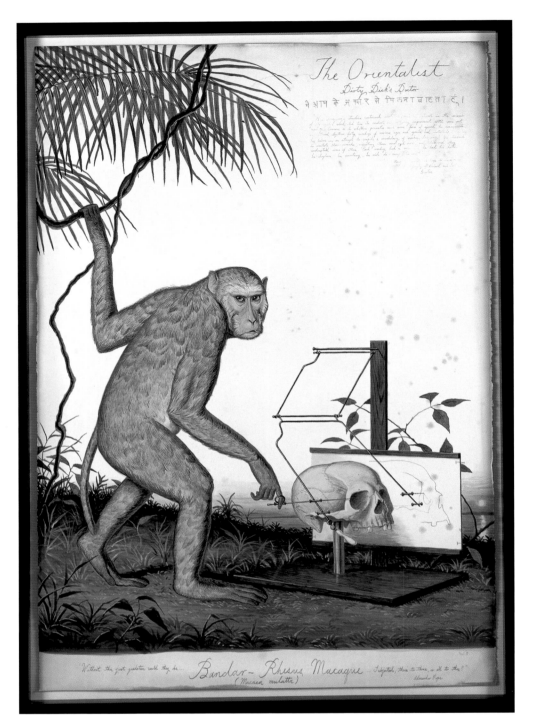

I have an ongoing project that has to do with Sir Richard Burton, the nineteenth-century explorer. One of the stories that stuck with me was about monkeys that he kept in his quarters when he was a young officer. A quote explains the paintings:

Curious as to whether primates used some form of speech to communicate, he gathered together forty monkeys of various ages and species and installed them in his house in an attempt to compile a vocabulary of monkey language. Each monkey had a name. He had his doctor, his chaplain, his secretary, his aide-de-camp, his agent, and one tiny, very pretty, small and silky looking monkey he used to call his wife and put pearls in her ears. He had a list of about sixty words before the experiment was concluded, but unfortunately the results were lost in a fire in 1860.

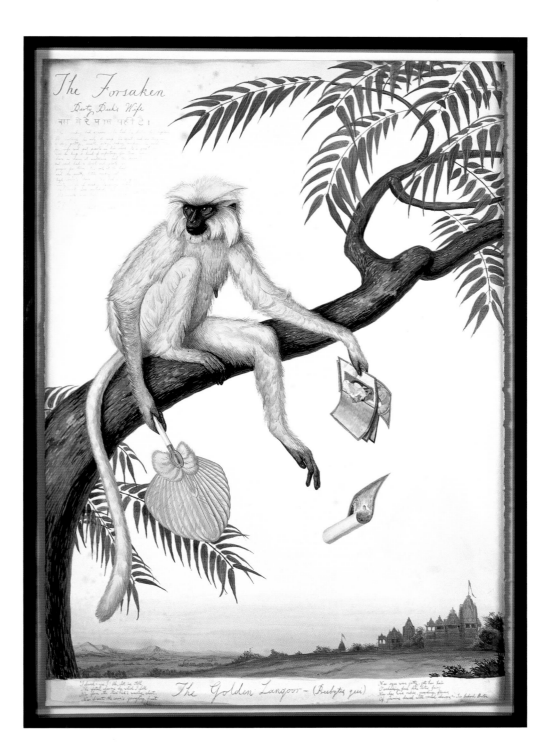

The Forsaken
Dirty Dicki Wife
बा मेरे माम पहाँ है।

The Golden Langoor – (Presbytis geei)

There is just some sort of sad humor in this idea. When I painted the monkey wife, I painted her individually and I named it *The Forsaken*. And my idea is that what Richard Burton did as part of his colonial enterprise was to actually learn languages. When he would go to a new place . . . he would have a woman set up house for him and become his mistress. And he said he would learn the language that way.

So this thing with the monkey wife seemed to be perverse once you know that about him. I set up a fantasy that she was devoted to him, that she really loved him. And when he left she was a bit heartbroken no longer to be his wife. So she sits in a tree and she's got Indian miniatures that are erotic and she's got a fan, a pink fan, and she looks all heartbroken and bereft because she's been abandoned by her lover . . . which is how England would like to think the rest of the world felt about them, the sun setting on the Empire.

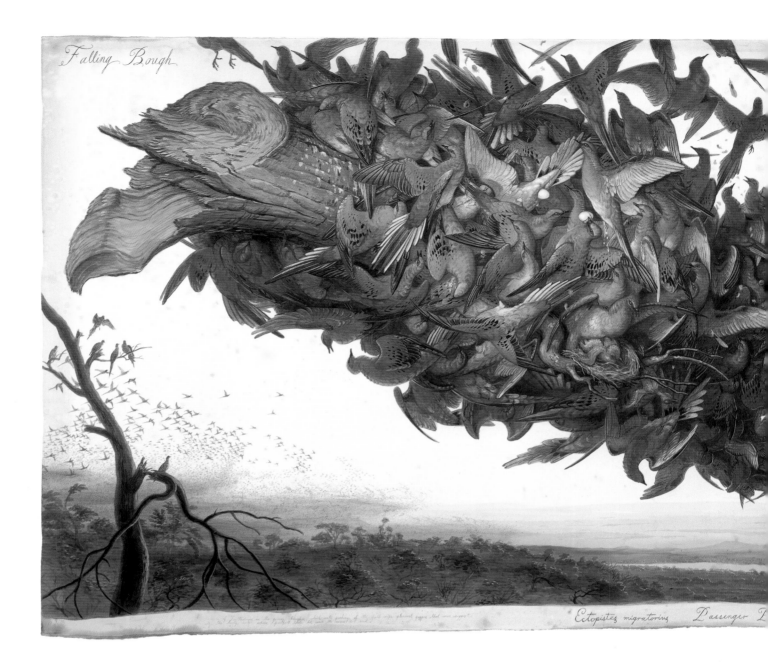

Falling Bough

Ectopistes migratorius Passenger P...

The passenger pigeons were the most numerous birds that ever lived in the history of the planet. It's almost disturbing how numerous—billions upon billions of birds. It was a fecundity that was almost disgusting. I started thinking about a blame-the-victim kind of attitude you could take to that . . . to make it seem like they had it coming, that there was this disgusting empire of birds and that it was corrupt like Rome . . . that it was bound to fall. So I invest the passenger pigeons with every kind of sin that I can imagine. And the bough, this gigantic branch, is falling under their tremendous weight. Meanwhile they go

about their bickering and their lusts and foibles and all the disgusting things that they are doing. I have a little squab being raped. He's like a little scandal unfolding among the pigeons. Gluttony, murder, and envy, all kinds of things are portrayed in that image. I'm sure it came out of seeing Breughel, the drawings where he depicted the Seven Deadly Sins and the Virtues as well.

The thing that tickled me about this picture was that I took this very grave, kind of frightening, hair-raising image, a picture about animals that are extinct. And I wanted to portray them as causing their own extinction by their bad behavior.

So it's a dark, dark humor, but to me it's amusing, and drawing these little sketches and making them progressively sicker makes me chuckle. This just feels sort of apocalyptic, but I am trying to put these silly pieces of behavior in it.

It connects most specifically to the darker side of the comic world . . . *EC* comics and *Mad Magazine* . . . R. Crumb and the underground comic artists. That was the stuff I grew up with, so this dark sexual humor, this weird sort of underbelly stuff informs this a lot. I think that there's almost no subject matter that you can't treat with some humor, no matter how

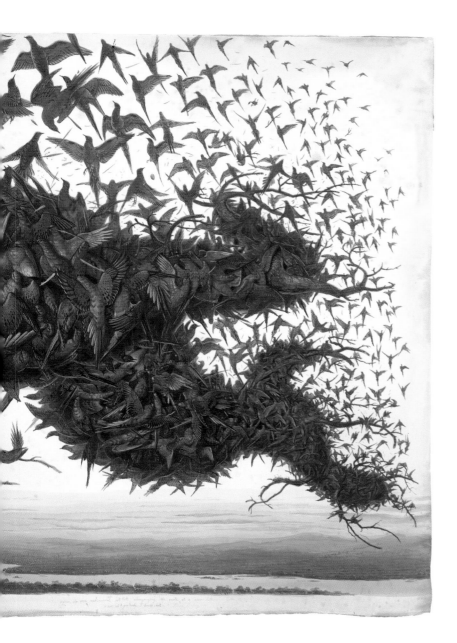

Walton Ford

Falling Bough, 2002
Watercolor, gouache, ink and pencil
on paper, 60¾ x 119½ inches
Private collection, Tennessee

brutal it can seem. And that's something I see in Goya or Breughel, or even R. Crumb.

This image of a branch falling, laden with these birds in this sort of hopeless metaphor, felt like the kind of mysterious image that Goya might come up with. I wanted to paint it in such a way that it almost seems to be floating. You've slowed time down and you can see what all the individual birds are doing on the branch. And I ended up mixing in all sorts of sins, foibles, or folly. I'm sort of taking a page from Goya in that way.

A lot of my work deals in metaphor or allegory and discredited modes of commu-nication. It seems archaic. It seems to fit with my way of wanting to communicate. And so it just seems like a big *Ship of Fools,* that branch. It's coming down; the inhabitants are oblivious to their own doom. As the crisis increases, they get more self-absorbed, more caught up in their own little daily struggles. They're not noticing this thing is about to crash. Plenty are fleeing, but there's plenty that are just staying there and finishing their little grievances or battles or meals or naps or whatever they're doing.

I often use text. Actually, I did put some text on that was particularly carefully chosen. *Falling Bough* is also a careful kind of title. I like to have titles add a layer of meaning. Also, I have quotes down at the bottom, early descriptions of the birds. The first has to do with how they all landed in great numbers on the lusty boughs . . . all this flowery description. As the descriptions go forward in time (the last one was from some guy in the eighteenth century) it says, "What it foretells, I know not." It's sort of the dread that people felt when these birds came in. I like that sort of ominous quote to end it.

"What it foretells I know not."

A Cabin Boy to Barbary

Barbary Lion - Panthera leo leo

Walton Ford

A Cabin Boy to Barbary, 2000
Watercolor, gouache, ink and
pencil on paper, 61 x 120 inches
Private collection, Brazil

Audubon painted birds life-size. They were quite small, and the largest image he would have to paint would be, say, thirty by forty or something like that. But I realized if I was going to paint something like a tiger and I painted it life-size in that mode, it would suddenly become an object that hadn't existed before. If you were Audubon, you'd shoot a specimen, you'd lay it out, you'd draw it, watercolor it, and put it in a folio and save it for later when you published a book. . . . So for me to suddenly make an elephant life-size or a tiger life-size, or in the mode of the notebook style to imply that it was done from a dead specimen or done from life in the field, was just this odd conceptual object to make. It didn't make sense anymore. It starts to break down as a logical thing . . . and it began to get very exciting because I realized I was making

something nobody had ever made before. And that's always a nice place to be as an artist, even when you're working in such a traditional way.

They are like gigantic pages from journals. They don't make any sense. The early natural history artists used to carry little sketchbooks with them. I've taken the exact techniques and the exact kind of paper and calligraphy that they used and made this enormous version that makes no sense. There would be no reason for a natural history study that was ten feet by five feet. But that is one of the things I was interested in doing. Taking small bits of history and magnifying them. The first animal I painted like this was a tiger. And after I finished sketching, it was a life-sized tiger on the sheet of paper. It was actually frightening to be in the room with it. It really could eat you.

Walton Ford

LEFT
Space Monkey, 2001
Watercolor, gouache, ink and pencil on
paper, 59½ x 36 inches
Private collection, Connecticut

FOLLOWING PAGES
Nila, 1999–2000
Watercolor, gouache, ink and
pencil on paper, 144 x 216 inches
Installation view at Paul Kasmin
Gallery, New York, 2002
Private collection, New York

I guess it's satire or parody. And then there's this idea of sending up the whole form of discovery, the mode of representation that I use that looks like nineteenth-century manuscript painting and the kinds of notebooks that these colonial guys kept where they did sketches of the local fauna and flora and named it after themselves. And so I used those modes of representation to paint these things as well. It kind of turns that tradition a little bit on its head and tells an alternative narrative.

All of this makes it sound like I have this great intellectual reason for making these things, but ultimately I want to paint a sexy monkey, and I want to paint a big, huge elephant with an erection. And there's this other sort of silly kind of underground comic aspect to me that just wants to paint this stuff.

I like overwrought emotion, melodrama, nineteenth-century modes of communicating. I'm not a minimalist; I'm a maximalist. The more you throw at it the better. It's just sort of a wasteland out there. I want to do rich things. I want to make rich dishes and put them out there.

Elizabeth Murray

When I really know certain things are working for me, they make me laugh. Like, "Oh! This is really silly!" And I just enjoy that. And I think for myself it's part of what gets me through, just being able to laugh at things. Not that you can laugh at everything, but there are things, as human beings, that we just laugh at and we need it. And I think that's just the life part in my painting that's really important to me. It's not something I consciously do or that I consciously want. As if I say, "Oh, I want to make this wacky, funny, goofy painting." It really is just what comes out. It's the most rudimentary part of the paintings, and I guess it's the most basic part of me. I don't like sentiment, and I don't like nostalgia. And I think the humor has to be something really goofy and really wacky. It can't be cute.

Helen Vendler, an expert on Shakespeare's sonnets, writes about what Shakespeare reveals and what he conceals. I think that art, all art, does that. That's what the artist's role

is. You don't always know what you're revealing, and you don't always know what you are concealing, until you get it out there, and then you make your decisions. And there, that's a decision—when I laugh at something. I know I want it to be there. It becomes intent.

I remember trying to paint with my son hanging onto my leg. He just grew up in my studio and he always had a lot to say about my work and, whatever he said, he was always right about it. I learned to listen to him.

Just, you know, "Mom, why is that shape red? I think it would be interesting if it were blue, and I think it would be interesting if you made a curve down there. What you should do is have that yellow go all the way across the space."

And I would do it, and it was as though he would intuit what I was afraid to do and, because he wasn't doing it, he could be completely objective. And he was really hard on me, too.

Elizabeth Murray

RIGHT
Empire, 2001
Watercolor on paper, 18 x 7½ x 1¾ inches

OPPOSITE, TOP
MA, 2000
Watercolor on paper, 12 x 10⅞ inches

OPPOSITE, BOTTOM
Inner Life, 2000
Watercolor on paper, 17 x 17 x ½ inches

You're posing problems for yourself. It's kind of like a battle of you against you, and you are trying to figure it out. And that's when it gets painful, when it's not coming together. And I have no idea how I am going to bring it together. It starts to feel like a mess. Like, I'll think I have it and I'll change one color and instead of it being the solution it becomes this big mess.

When everything is going well and I'm completely involved in it, I couldn't tell you what I'm thinking about. If I get stuck in something, it's frustration, anger. Or, it's like stream of consciousness, the chatter, chatter, chatter of the mind. And when I'm totally absorbed in the painting, I'm not aware of thinking anything. I'm just in the painting except like, "Okay, here I am, I'm painting this blue. I like the way it's feeling. Everything's okay." But then I have to step back. I have to change my brush or make another color. It's a continuous process and it's my art. I'm so into it. It just feels so normal to me and so exhilarating at the same time.

Elizabeth Murray

ABOVE
Bowtie, 2000
Oil on canvas, 85 x 77½ inches

OPPOSITE
Worm's Eye, 2000
Oil on canvas, 97 x 92 inches

It's one thing to be holding a pencil in your hand and to be sitting down . . . a whole different physical process. First of all, there's a lot more control and there's a lot less mind tripping. I think that's why drawing is so spontaneous sometimes compared to painting, or my painting anyway.

Painting is a whole other deal. It's so physical. You're squeezing the paint out of the tube, which is fun. You're mixing up the paint. There's a whole other kind of process, physical process, to get over to the space, to the canvas, to the actual painting, and then start putting the paint on. For me, and I think this is different for all artists, I can have as much control as I want to have. But the minute I start controlling it too much, it stops making sense. I don't want that mark-by-mark control. I want a certain amount . . . and

then I want to let go of it. And I'm not talking about happy accidents. That's not like what really happens in the work. If I let something just slide off, it's not something that I'm not seeing. I see every little inch of it. It's all about getting what I intend and what my head and my emotions want and what my arm does. And letting my arm do things that I think I don't know about.

In the beginning the drips just go on because you've got the paint at a certain consistency and you slap it on, and it drips. Then it's deciding how many drips you want. Do I really want those drips to be up there? Do I want them to fall down on the painting like Barnett Newman used to? He called them 'tears' . . . like the tears of the painting. And, no . . . I don't want these things in my blue shapes.

Elizabeth Murray

ABOVE
Bop, 2002–2003
Oil on canvas, 9 feet 10 inches
x 10 feet 10½ inches

OPPOSITE
The Lowdown, 2001
Oil on canvas and wood
89 inches x 8 feet 2 inches

For a couple of years I've been working with cutting out shapes and kind of glomming them together and letting it go where it may, like basically making a zigzag shape and making a rectangular shape and a circular, bloopy, fat, cloudy shape and just putting them all together and letting the cards fall where they may. I don't know why I'm doing it this way because what I want more than anything

else in my life and in my painting is for things to unify, to come together.

I'm working flat; it's not three-dimensional, even though the shapes are cut out and they have different kinds of perimeters. I don't know how they're going to resolve. That's the psychological part of it, just starting something that I had no idea how to put together. Another part was using very intense color, or different

kinds of color. I'd never worked with pastels before, which I always thought of as sweet and cloying and candy-like. So, with the color and the shape and the drawing inside the shape, it's just trying to make it work somehow, not knowing how it was going to happen except that all these shapes are stuck to each other in some kind of way, like a weird fence or lattice thing. It's been frustrating and fascinating . . . like being a safecracker with his ear up against the safe, listening for the right click for the right cylinders to drop down. Sometimes it's really like that. I'm just painting and painting and painting until the right thing happens.

I start in my notebook. I am just scribbling around, get the idea usually really quickly, and then put it into my overhead projector and blow it up on the wall. Do a big drawing. Then I usually put another piece of paper over that and correct that, do another drawing. Then these two young artists who are carpenters come in, take the drawing to their shop, and cut out the wood—the forms are made out of wood—if you can imagine a regular stretcher except like a cloud shape. Then they are covered with canvas and sized with glue and gesso, come back to me, and I start to work on them.

Elizabeth Murray

BELOW
Stirring Still, 1997
Oil on canvas on wood, 92 x 115 x 7 inches

OPPOSITE
Almost Made It, 1998–99
Oil on three canvases, 73½ x 99 inches overall

FOLLOWING PAGES
Elizabeth Murray: Recent Paintings
Installation view at PaceWildenstein, New York, 1999
From left: *Perfectly Morning,* 1998; *Mister Postman,*
1998; *Almost Made It,* 1998–99

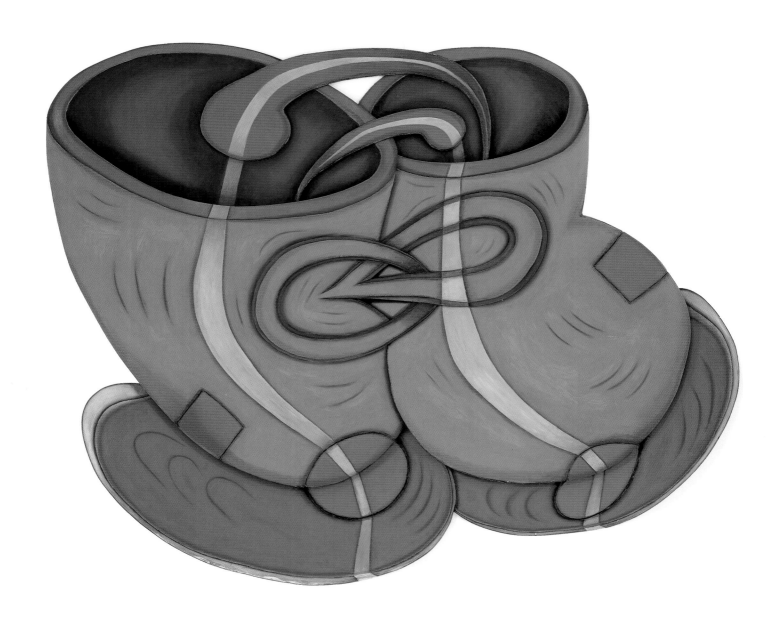

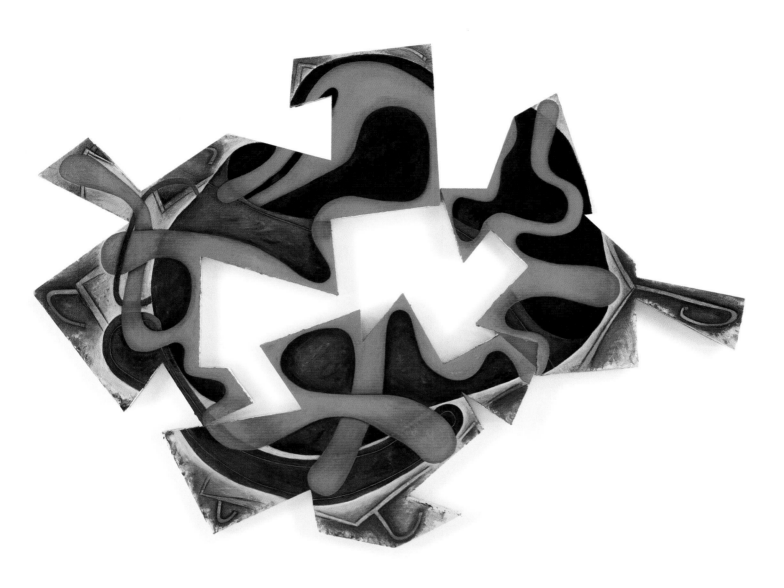

You're confronted, when you are looking at a painting where you don't have specific images or a figure or a landscape, with something that you are challenged to resolve and unify in some way, because there is a unity there. I keep harping on this; that's what has to work. It has to resolve in secret, almost. There has to be some kind of unification of shapes and colors And it just may be in a very surprising way. See how the red works with that green over there . . . how it makes this arc across the space. And it's not just formal. It's an arrangement like you're arranging your living room or arranging your face in the morning. It's so integral to all of us, that kind of arrangement that makes the form of the painting.

Raymond Pettibon

What you see are these motifs that keep recurring in my work. They never started as something that I chose—as something that was important to say over and over and over again. They started as one image and for whatever reason they did have this kind of resonance to me and that brought them back. And some of them have had a fairly long life.

I go through some periods perhaps where an image might be cropping up in my work quite a bit, and then it can just about disappear at a certain time. I guess, kind of working backward, that my work does have a formalist kind of quality to it. But it's not a program. And I don't feel constrained by subject matter. I mean, I welcome practically anything into the drawing.

I think, for some people, art can be a kind of therapeutic or kind of a fantasy life or wish fulfillment, or creating this alternate universe that they can dwell in vicariously. I don't think there's much of that in my work.

You can create your own universe. There is a kind of fascination about doing that. Art gives me the freedom to do that. But that doesn't mean I have to disappear into that or that I have any delusions that this is not just going to be art-historical but world-historical and affect other people. I don't think you have to sacrifice one for the other. To the extent that I do, that's just because at certain times I've sacrificed from one end of my life to my life as an artist, making art, producing art . . . for the most part because what I do really takes a lot of time to do properly. But I've really overdone that, too. That's of no interest to anyone else, just to explain that it can have an effect . . . but at the same time it's not something I'm driven to do.

I don't think humor is a bad thing at any time, really, or in these times. I make decisions all the time in my work that I won't do something just for the sake of going for some cheap laugh. I won't do that if it hurts someone who I would feel bad about . . . if it's based on things that people have no control over or that they're condemned for just because we as humans still so oftentimes feel the need to have someone to pick on who's different.

I don't think there is subject matter to consider too important to use humor with. A lot of times, people wonder if any of this was intended—you know, like humor is just by accident all the time and maybe it's not a good thing to laugh, or maybe they're not getting it, maybe they're seeing something in it that they shouldn't. But that's not the case. I have no problems with my own attempts at humor.

I don't investigate and find the right character that is going to express the way I want to do things. But it starts inevitably with just one drawing, and it resonates, and it keeps going from there. It snowballs into a persona that I keep going back to. But there isn't any design to it. It establishes its own kind of momentum and I don't have to consciously think about that. I get asked a lot, "Why is that character so important to you?" And it's not something that I thought was especially important to me the first time I did it, maybe. It's not something that even to this day, after I may have drawn certain subjects a number of times, that . . . I'm obsessed with or dwell on as the subject matter I'm aching to get back into as soon as possible.

It's a mistake to assume about any of my work that it's my own voice. Because that would be the most simple-minded ineffective art that you can make. That would really be talking down to people, and if I had such a burning need to express my opinions or whatever then I don't think art would be where I'd want to do it. It's not a good area for that. When we're talking about the schools and gangs and segregation and so forth, those are very obvious problems and no one really needs my weighing in on it. But there's more underlying problems or issues, and those will be the things I would want to cover in my work.

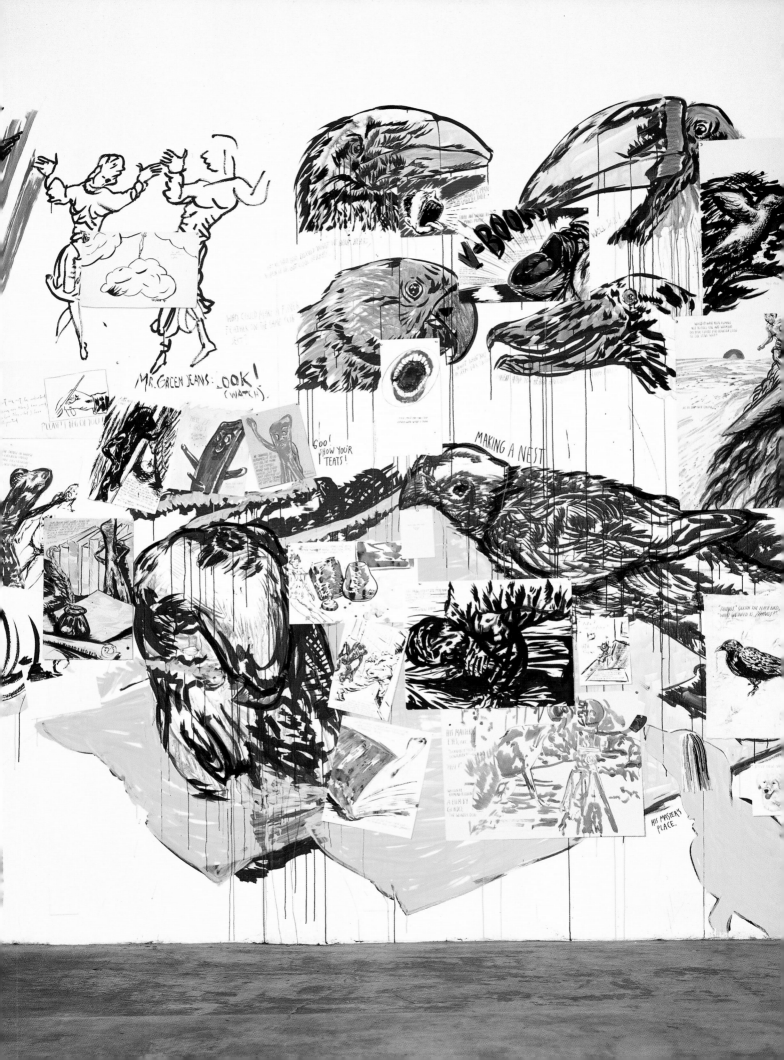

Raymond Pettibon

No title (There is a touch of poetry . . .), 1997
Ink and watercolor on paper, 16¾ x 8½ inches
Collection Zoe and Joel Dictrow, New York

Gumby? To put it in general terms, you'll see in my work this tendency to take on some very ridiculous subject. Possibly you can look at it as being so far out there as to be kind of just a stray thought. Going back to the heroic figures, you can speak about a wider area of things that happen that puts the responsibility on the shoulders of something like Gumby. It's not done in any sarcastic way. . . . It's not even meant to call attention to itself. All I'm really asking is for you to look at that with the same kind of respect that you would if it was some important historical figure or Greek statue or the usual subject matters that artists tend to use.

There's also a reason why Gumby in particular works for me so well. Because it does relate to the way I make work, which has very much to do with words and reading in particular. Gumby is a kind of metaphor for how I work. He actually goes into the book, goes into a biography or historical book, interacts with real figures from the past, and he becomes part of it. He brings it to another direction. And I tend to do that in my work. That's why Gumby is a particularly important figure to me. I have to give credit to the figure of Gumby himself because it's not something that I'm raising up by his bootstraps and putting in this high-art realm. Gumby's creator, Art Clokey, was a pretty brilliant guy, and it wasn't like the original Gumby cartoons weren't worth paying attention to and that I'm rescuing him from Saturday morning children's cartoons.

Gumby represents an alter ego for my work as an artist. He represents me as an alter ego.

LEFT
No title (Warning: our first woman president . . .), 1986
Ink on paper, 14 x 11 inches

RIGHT
No title (Self portrait . . .), 1995
Ink and watercolor on paper, 30 x 22 inches
Private collection, Switzerland

The way I think and the way I talk and
the way I write is not always very direct.
It can lead anywhere. But in the writing
I want it to be as fluent as possible. A
major part of my work, of what I want to
bring to it myself (almost like an athlete
would exercise his muscles and do the
same moves) is to get to the point where
it becomes almost instinctive and where
you react to something that's thrown at
you out of the blue, and you make the
right step for every situation.

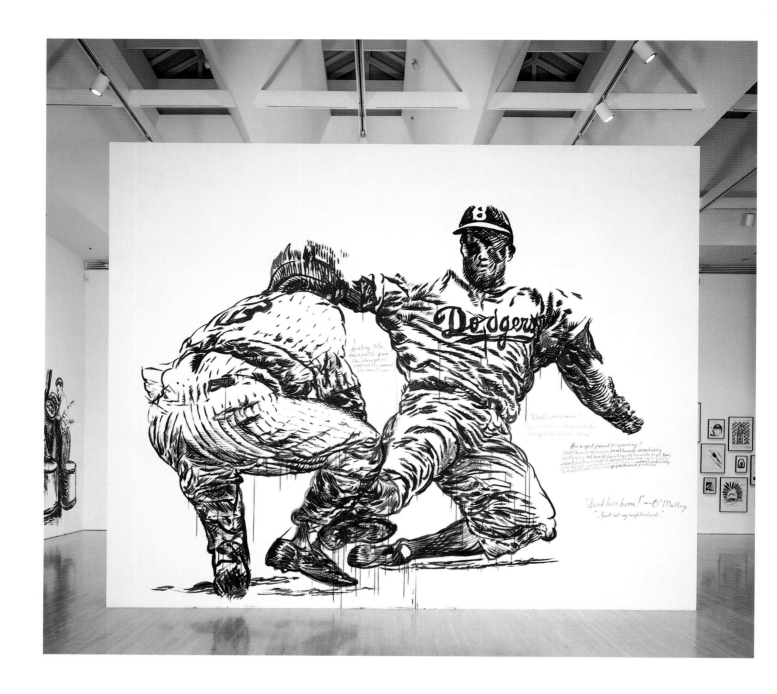

Raymond Pettibon

ABOVE AND OPPOSITE
Raymond Pettibon, Installation view at the
Museum of Contemporary Art, Los Angeles,
1999–2000

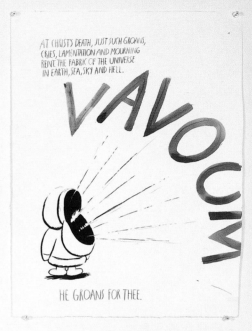

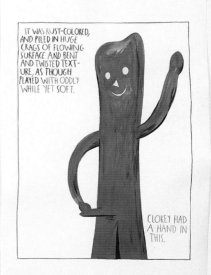
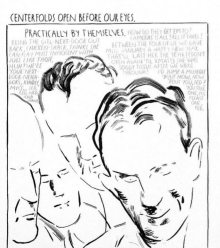
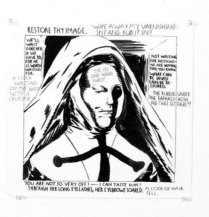

Raymond Pettibon

LEFT
No title (Sex with Nancy), 1985
Ink on paper, 11 x 8½ inches

RIGHT
No title (Look at me!), 1985
Ink on paper, 12 x 9 inches

OPPOSITE
No title (It sure helps), 2002
Ink and watercolor on paper,
30 x 22½ inches

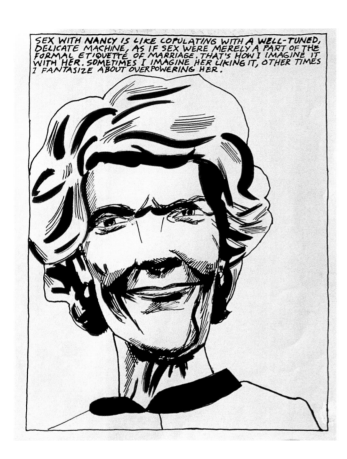

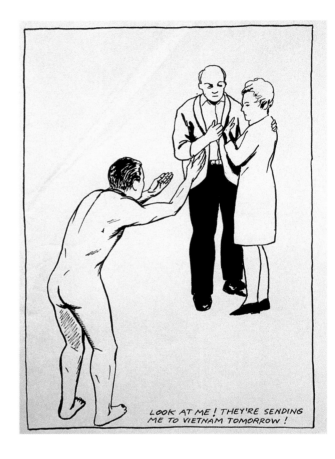

I've always considered myself learning on the job. I'd like to have a challenge where you see the challenge in the finished work itself . . . not just this glossed over kind of drawing, painting that someone has mastered and got, arrived there at that point and does the same thing over and over. I don't want to go back to that kind of style and stay there, but it's just something I want to keep and retain because it has its advantages. And you can lose it completely, the kind of eye-to-hand coordination, if you're not keeping active in working that way. And if you want to go back to it for any reason it's that much more difficult.

I've never considered myself much of a political artist. And most of my art doesn't really deal in explicitly political issues. But I'm not going to apologize or shy away from it any more than I would any other subject. But . . . there is no area where anyone is dealing with this in the way I am—which is for once not to assume someone . . . automatically has a claim on anyone's respect, to follow him or to take him seriously.

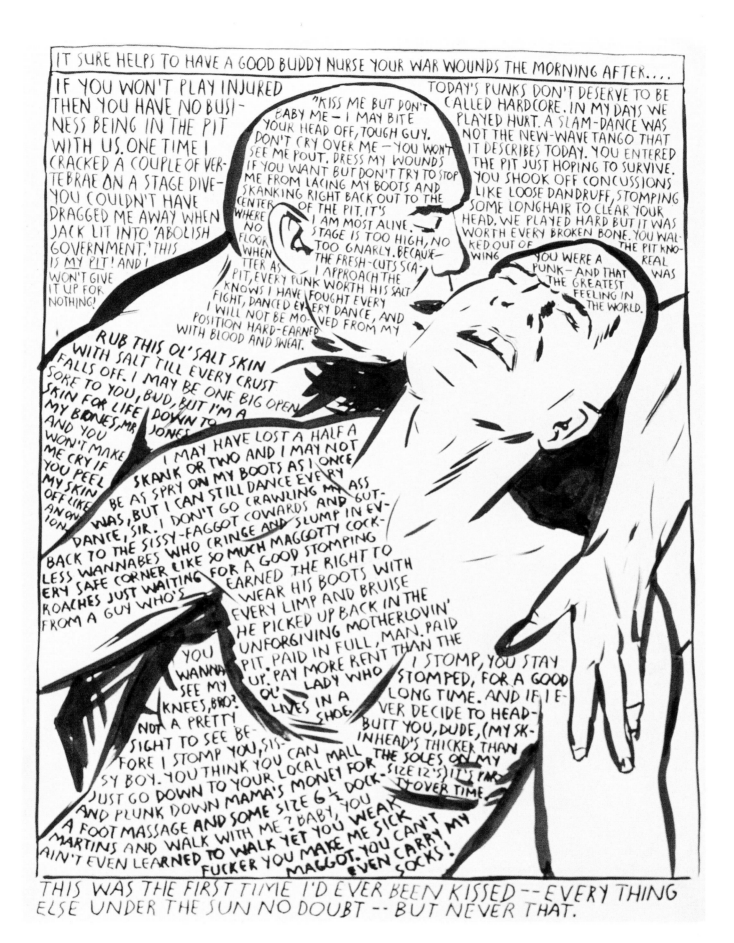

Raymond Pettibon

BELOW
No title (I must tell), 2002
Ink and watercolor on paper, 22½ x 30 inches

OPPOSITE
Self-Portraits My Ass, 1998
Unique artist's book
Pen & ink on paper & cotton, 100 pages, 7½ x 5¼ inches
Private collection, Chicago

My train drawings are about bringing the continent, the shores, together, about going west. At that time we still had vast frontiers left, so it's about the opportunity of escape. Even when I was a kid, when I heard the train at night I wasn't necessarily aching to run away from home and find my fortune elsewhere, but I guess every American kid had that somewhere in his mind, kind of embedded. Like the equivalent of running off and joining the circus.

It goes back to growing up. You could hear the trains, and I wasn't old enough to go wave at the engineer and throw a rock or put a penny on the rails. But you could see them and it did have a feeling like joining the circus or running away, not quite riding the rails. You know . . . when you're four or five years old, you can still have a fascination, and when the circus comes to town it's wonderful.

Even with something like a train, the text will be affected by the image. There might be a car, or some dramatic thing waiting to happen. There's text that I already have because it's a fairly common image for me. But a lot of the weird images—they might be ones that I purposely make that way. I'll make some kind of scenario in my mind and think about it—the associations, connections—textually. Some people comment that there's such a disparity between the image and the words, which is not necessarily the case. It's not random. It's more improvisatorial. I like to use odd images because there's no rational or cliché way of expressing things like that.

Perspective is not my forte. I think I have trouble with perspective. You can kind of fake it if you just cover it up with enough smoke and sparks from the wheels.

AS IF LAN-
GUAGE WERE
A PRETTY
WOMAN AND
A PERSON
WHO PRO-
POSES TO
HANDLE IT
HAD, OF
NECESSITY,
TO BE SOME-
THING OF A
DON JUAN.

with a red
kerchief
'round her
neck, pipe
in her
mouth,
and the
leer of a
gin-sod-
den
dockhand.

Worse yet, the hero develops no
personality or character.

RAMONA REFLECTED, "I AM HUMILIATION: FEELING
THE MASS OF MY HAIR WEIGH UPON MY FOREHEAD, I BE-
LIEVED TO WEAR A CROWN, AND MY THOUGHTS UNDER
THAT ROYAL WEIGHT WERE PURPLE. THE MEMORY OF MY
INFANT-HOOD IS LIGHTED UP BY A VISION OF CARNAGE
AND FIRES; MY PURE EYES SAW CURRENTS OF BLOOD,
MY DELICATE NOSTRILS FLARED WITH THE SCENT OF
UNBURIED DEAD.

ROOTS."

One never comes to care a straw what happens
to him.

Well you needn't take my precious time with marking and re-marking here how the above is condemned to speedy frustration and collapse.

Now that I am out of the tube and riding the wall history is written in my wake

It's all wiped-out in the whitewash.

Raymond Pettibon

No title (Well you needn't), detail, 1997
Acrylic on wall, approximately 168 x 360 inches
Installation at David Zwirner Gallery, New York

There's so many marks and gestures
and accidents and starting and stopping
and starting over again. And all those
can affect the work in a lot of ways. And
when that happens, I tend to welcome
it. One line can change a work.

But it tends to mirror the way I
work overall quite a bit, writing as
well. There's writing that is everything
planned. You have some idea, some
philosophy, some story—narrative—
whatever you want to express, that
you want to get down on paper, and
whatever literary devices or techniques
you have at your command with the
intent to express that. But there is
also writing that is more open, more
associational, and even accidental.
You don't necessarily know where
it's going to go while you're doing it.

Vija Celmins

Tim Hawkinson

Paul Pfeiffer

Martin Puryear

Time

Vija Celmins

I think that the meaning of the work is always somewhat ambiguous and that people project different things on it all the time. And there's no way of controlling it. I'm talking about how I thought I was making the work. But the work itself has different meanings to different people. People project on art, and they come to a certain kind of agreement, maybe, with the help of historians . . . with time, with people agreeing that something has qualities that they want to hang onto and save. But I would not say that . . . I know what those are. I like to talk about the work the way that I make it, in a very workmanlike way.

I tend to make surfaces like you would lay a floor. I make a structure that's two-dimensional and that has an image that implies another dimension, a third dimension, but remains flat at the same time. That's what interests me about it, that kind of double reality. And I make it like you would lay a floor, a mosaic floor with all the pieces. . . . It's a thing that's grounded pretty much in the turn of the century and an awareness of the artificiality of art, that art is not just an illustration but that it is a sort of invention. The thing that's kind of unusual is that I'm so thorough about it. That I have it like a dog with his bone.

I talk about what I know that I do. That tiny little area which a lot of people have left . . . you know, artists now do so many different things. They're like nomads; they go around and just point to things and they have dialogues with the culture and politics. I'm just sort of stuck in this little area, and

maybe my contribution is that I've been able to worry this area and work with it.

The reason I think I do images that require so much time is that it's like an attempt to have some other thing come through in the work, letting something unconsciously seep through, some subtlety that my brain was not capable of figuring out . . . maybe slowing the image down to where it really sat there and no longer wanted to be anywhere else, as if the image only existed in front of you in that form and was not something remembered.

I started taking photographs myself. But I was never happy to let the photograph be, because I'm not really interested in the image like that. The photograph always seemed to me kind of dead. I bring a certain life to it by putting it into real space, where the photograph always remains sort of an image of somewhere else.

I crawl over the photograph like an ant. And I document my crawling on another surface. And the other surface I adjust very subtly so that . . . somehow you know what it is. So that it doesn't look like these are just pieces cut out of a big thing but actually, because of a balance between the material and the image and the making, when you get very close to them you see that they're *made*. You can almost participate in seeing how it's made. It has totally other qualities than the photograph. But the photograph is really the subject, the photograph itself. It's not really like a reference. A reference implies that I'm just lifting the image off, but actually I'm not just lifting the image off. I'm redescribing it.

Drawing, Saturn, 1982
Graphite on acrylic ground on paper, 14 x 11 inches
Collection of Paine Webber Group Inc., New York

Vija Celmins

TOP
Pencil, 1967
Wood and painted canvas, 7 x 7 x 38 inches
The Edward R. Broida Collection

BOTTOM
Eraser, 1967
Painted wood, 12 x 18 x 4 inches
The Edward R. Broida Collection

Vija Celmins

Heater, 1964
Oil on canvas, 48 x 48 inches
Collection of the Whitney Museum
of American Art, New York
Purchased with funds from the
Contemporary Painting and
Sculpture Committee

Vija Celmins

I gave up painting. In my quest for clarity, I decided that I was going to do everything with just a pencil. You call them drawings; I don't even call them drawings . . . I don't even call them things. They are like areas that are made—concentrated on—thoroughly considered. As I was working with the pencil, I got into some of the qualities of the pencil itself. That's how the *Galaxies* developed. Just the pencil on paper makes this incredible darkness and a real unity between the paper and the pencil itself being very clear, yet being pushed to the point where it becomes quite rich. The starry night images came out of using the pencil . . . and making the image dark by going over and over and over until the surface is really filled.

At a certain point I had to drop the material because it was just too thin, and I went back to painting which, I think, is more malleable . . . richer. I can build a richer surface with it.

It's almost a trick of trying to get more into the work . . . almost childlike attempts to get more in . . . to fill it up by repeating it on top of itself, like I've been doing with the paintings. Making a work that has more of a feeling of a chord, like a chord in music, something instead of a line or something that's thin. Even though you only see the top surface, you begin to have a feeling that there's a depth there. But it's not a depth that's really thought out. It's like it's physically made.

Vija Celmins

Desert-Galaxy, 1974
Graphite on acrylic ground on paper,
17½ x 38 inches
Collection of the artist

It's like a double vision pushed into one. It really has no meaning. These images just float through from my life; they have no symbolic meaning. Generally, I think I pick images that are already surfaces and I put them on another surface and I hope what happens is that there is a kind of double awareness. You realize when you're looking at it that the reality is that the work in front of you has been *made*, and it has flatness and image. Image . . . but the image is like a ghost of something remembered. It's not so illusionistic. It's made very concrete.

I pushed these images together. I don't know whether it really has any meaning. It's like two surfaces: one is really a desert surface, and the other is more the paper surface. Or a kind of image that is extremely ambiguous that has been made into a surface . . . an image that you can't . . . pin down.

Vija Celmins

Constellation-Uccello, 1983
Four-color aquatint and etching on Fabriano
Rosapina paper, 27¼ x 23⅛ inches
Edition of 49, AP of 12
Published by Gemini G.E.L., Los Angeles

Uccello did this drawing of a chalice in a perspective showing a three-dimensional object on a two-dimensional plane. And I thought I would re-draw it. This is a soft ground, a copper plate that has a soft ground. When you put a paper down and press on it, it leaves a kind of fuzzy line. Because I was really, in a way, mimicking the drawing that Uccello had done . . . not really the drawing, but the reproduction of the drawing as I found it in the book, this is another instance where two images are kind of hanging onto each other.

This is an aquatint, with the little lights blocked out and then a little bit of scraping.

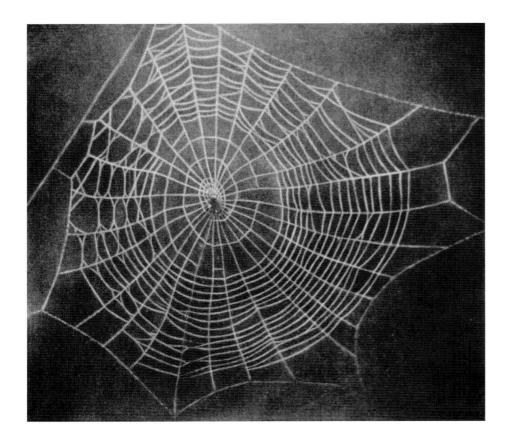

Vija Celmins

TOP
Untitled (Web 1), 2001
Mezzotint on Hahnemühle Copperplate
paper, 23 x 18¾ inches
Edition of 80, AP of 12 numbered 1–12, and
AP of 15 numbered I–XV
Published by Lapis Press, Los Angeles

BOTTOM
Untitled (Web 2), 2001
Mezzotint on Hahnemühle Copperplate
paper, 18 x 14¾ inches
Edition of 50, AP of 10
Published by Lapis Press, Los Angeles

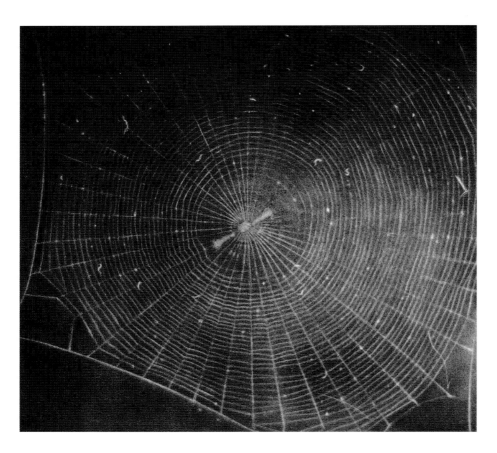

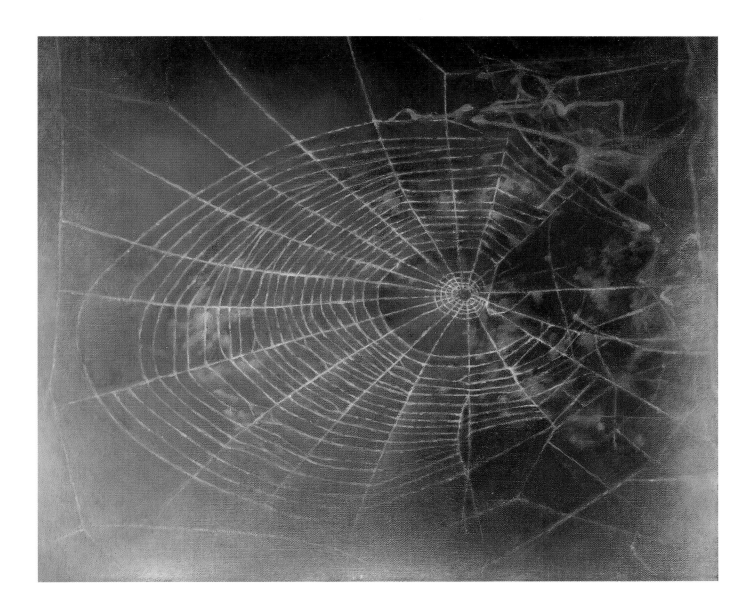

Vija Celmins

Web #2, 2000–01
Oil on linen, 15 x 18 inches
Private collection

I think I liked the image because it also described the surface and held onto the edges and made this flat plane which is of course the real flat plane that you see in front of you. . . . I started doing a series of webs that described that space. It's an image that's got a lot of associations with it, which I put in this very cold, scientific kind of dressing that I like to put my work in . . . you know, just the facts. I was seeing whether I could put an image that's so charged emotionally into this kind of context . . . into another element, because most of my images are pretty emotional

for some people. And it's one of the elements that I kind of neutralize.

It's charged maybe for me, too, like a little bit of a sign of age. A little despair. Something getting rotten, old . . . and those overtones of something very delicate and transitory. An impossible image to work with, actually. Then, physically of course you can see that this is also made out of little parts and fits right into my laying down my mosaic floor theory where I collect a series of little images that enliven the surface The work is still, but there's a little bit of life in there.

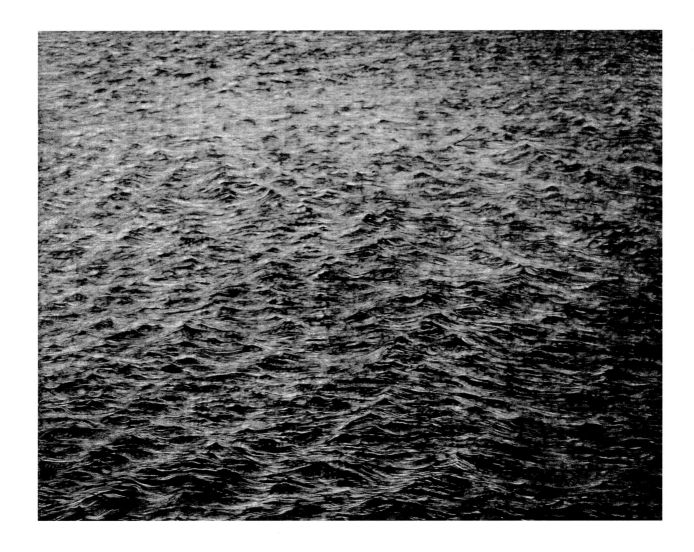

Vija Celmins

I try to make a piece that's strong and thorough and doesn't jump off the paper. It's neither ocean nor a piece of paper. It becomes a third thing.

I worked on this ocean image and I carved it. The thing that's so neat is that it has movement in it, and at the same time it's like a rock, so totally closed and solid. And it fluctuates between those two. When you're far away from the work, for instance, you see that it looks like a little gray area that's been worried to death. When you come up close you see that the thing has been made and

carved, and I hope at some point you get a little *boing!* like I still do.

This work is done with an engraving tool. It's just one of those things I wanted to try. The thing that's neat is that it looks so solid. I think somehow making work has to do with physical activity in some kind of mysterious fashion. I've always liked physical labor. The idea is that you carve the wood, take a roller, put black paint on it, put a paper on it, run it through the press. *Voila!* I liked it.

It was very hard to keep my place. What we did is put the image, which I

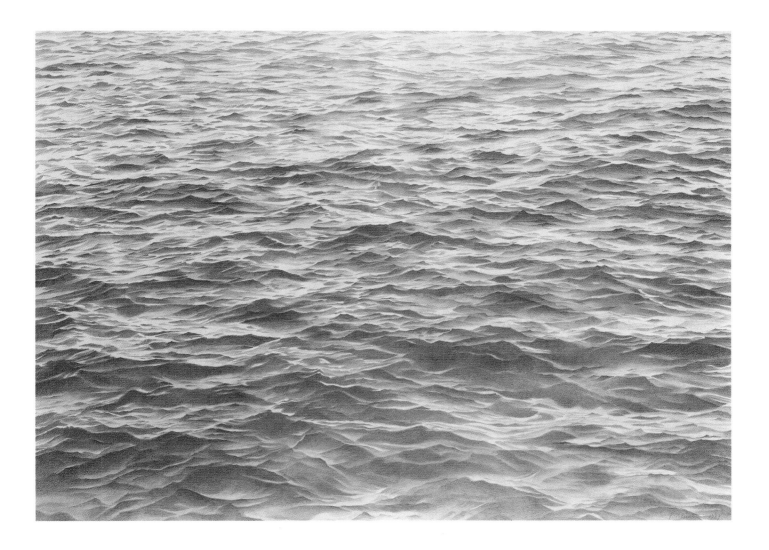

took many years ago, on the wood itself with an emulsion so that I would be able to see the image. As soon as you start carving, the wood underneath is white and then you see how you're drawing it. Then, of course, we print it and it all goes black. And then the new parts that you carve are white, but the old parts are black, and the middle is the medium. It's a help in seeing the image.

I cut it, not with any big sense of style or anything, very down-home, the way I tend to do things, a little bit anonymous but with some feeling. Anyway, it's very difficult to see your place in it, number one. And number two, very upsetting because when the print is printed, it's reversed. What pain that caused me, and what mental gymnastics! So then I have an image. I try to carve on it. I see certain movements I want in it. I put transparencies on . . . I put my finger down so I can see where I am. It's like you're wrestling some kind of image into another form, and it's not wanting to go. I tend to remove all signs of wrestling in the end because I'm so in love with that surface being unified.

Tim Hawkinson

There are certain recurring interests in my work and ways of looking at things, maybe having to do with the way I get ideas and the way ideas are formed . . . really obvious categories. The first thing that I think of is the human form and using my own body as the reference point, ways of depicting and referring to that, and 're-looking' at that through different eyes. There are also pieces that deal with time and the way we process time and are aware of it. There are mechanical interests and kinetic work, a fascination with moving parts—just the magic of seeing this kind of animation and making it happen. But then, I also like to keep a dialogue going with drawing and some painting, and these weird, quirky drawings that I kind of fall upon occasionally. A lot of times different interests overlap. For some of the drawings I'll make a mechanical device that will help in making the drawing, and stuff like that.

There's an organic aspect in much of my work that maybe has to do with keeping the 'rules' really open. And there's this hand-made aspect in a lot of the work that just by nature creates its own signature, creates these organic kinds of references. It's not something I'm trying to go after; it's sort of a by-product, I think.

Something that happens in my work is just staying really open at the onset of a project and not doing preliminary work and, so, allowing for accidents and idiosyncrasies.

Each piece and each direction have an approach. They're not really rules. They're more sorts of parameters or a process—a way of filtering out other things that aren't really concerned with the idea I'm working with and I guess—by a strict adherence to the process—it creates a certain distortion. But it's also what art is—the distillation of the idea. What I'm shooting for is just to stick with whatever that idea is and play it out till it's totally this pure form.

Tim Hawkinson

TOP
Egg, 1997
Ground fingernails and hair, superglue,
1 x 1½ x 1 inches
Private collection

CENTER
Bird, 1997
Artist's fingernail parings,
2 x 2¼ x 2 inches
Private collection

BOTTOM
Feather, 1997
Artist's neck hair, ½x 2¼ x 2 inches
Private collection

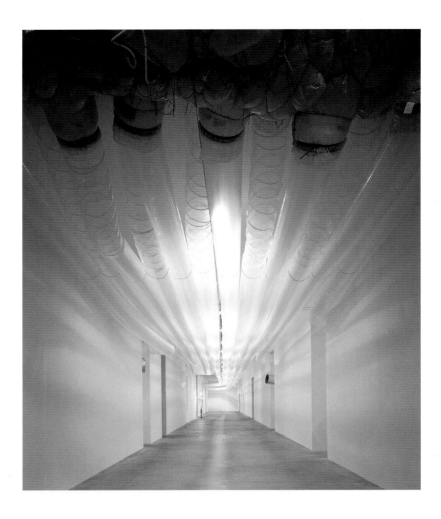

Tim Hawkinson

RIGHT AND OPPOSITE
Überorgan, 2000
Woven polyethylene, nylon, net, cardboard
tubing, various mechanical components,
dimensions variable
Installation view at Ace Gallery, New York, 2002
Collection of Ace Gallery

With the larger scale pieces, it's often the case where I don't even have an idea for something of this size unless there's already a venue set up for it. I don't really make studies. I don't use preliminary drawings for pieces, particularly three-dimensional work. Maybe I can't think that far in advance and really visualize the piece in a finished state. But also, I don't want to limit it to . . . a perspective where I am just sitting there drawing. I find it much freer to go right in and start making the piece and letting it take on whatever kind of shape it takes.

But with *Überorgan* I did make models of balloons. I think I was just a little nervous about filling fifteen thousand square feet. . . . I didn't want to get caught shorthanded. So I felt better seeing these little models in the space and having a basic idea of what it would feel like in there. I felt that I was going to have a real strong physical presence, but it needed also to have this kind of audible component. The balloons look like whales suspended in the air . . . hovering above you, and the sound

is kind of biomorphic like a bleating or wailing. But it's all based on a score that I put together using lots of old church hymns and *Sailor's Hornpipe* and *Swan Lake*. There was an improvisational piece that I invited a guest composer in for. So there was this score . . . constrained to a scale of just twelve tones. Then, there was also a series of switches that filtered or reinterpreted the initial score. One would flip-flop the orientation of the notes to the keyboard; another switch is the key that it's played in. All these switches are activated spontaneously by viewers going through the space. The keyboard consists of photosensitive switches. So by blocking out the light, you'd trigger one of the notes.

Using the materials—just these thin membranes filled with air—had a very attractive quality for me. Thinking of sculpting with air (in a lot of my work I use transparent materials, especially in mechanical pieces, because I like to be able to see what's going on) had an ethereal quality that really appealed to me.

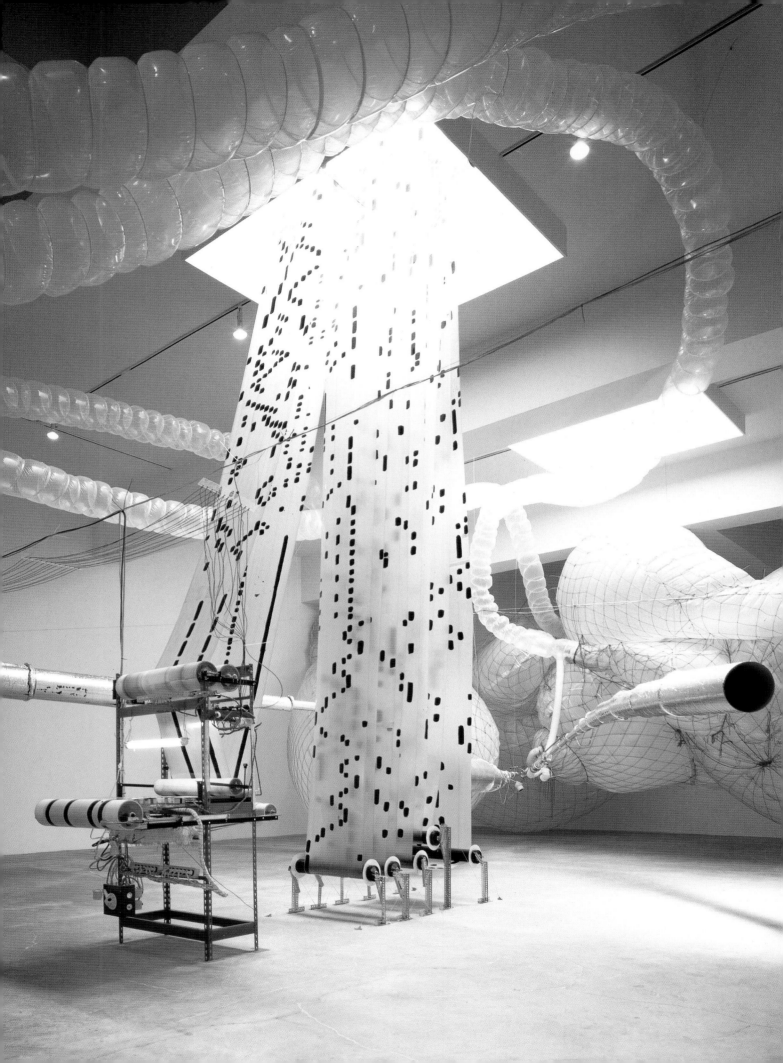

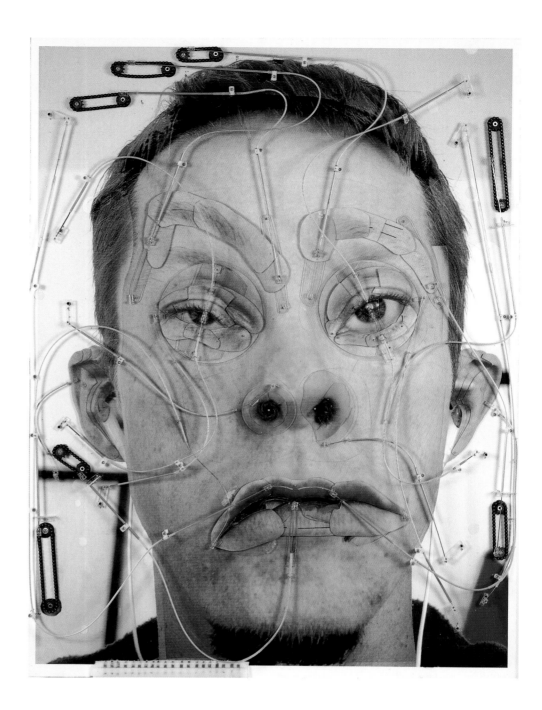

Tim Hawkinson

ABOVE AND OPPOSITE
Emotor, details, 2001
Mixed media: image, 49 x 36 x 4
inches; ladder, 27 x 24 x 19 inches;
cable, 174 feet
Private collection

It's something that emotes, and it's motor-
ized. . . . *Emotor* falls into the category
of body depiction, references to the body
like the bathtub-generated piece and
balloon self-portraits that I've done. But
it's much more about mechanics and
probably closer to a piece I did which
synthesized voice using really primitive
methods. *Emotor* uses the expressions
of the face that are so cued into reading
the face. I took a picture of myself and
cut the features up into little pieces, like
a puzzle, and rearranged the features.
And each time I did it, I created a different

emotion, and that's just something I
read into it. Anybody looking at it would
read into this, would reinterpret it, as I
think we all pretty much interpret the
same basic emotions—frowning, smiling—
but I was interested in seeing how much
inflection and emotion I could get out of
the face using random input of signals.

I was interested in using random
signals . . . in this case generated by a
television screen. And the screen had
lights instead of switches. So if there
was a dark area on the screen it would
turn the signal on . . . and a light signal

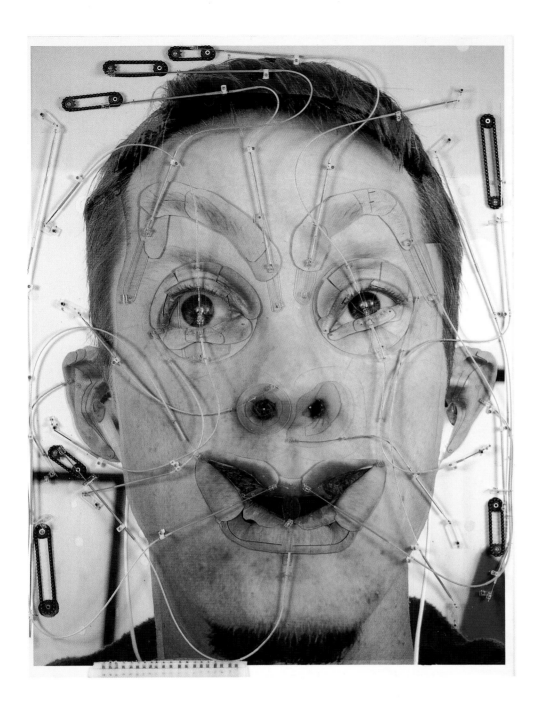

would shut it off. Just on and off, nineteen different on and off signals. There are nineteen wires for the nineteen switches and the nineteen motors in the face . . . all connected with Velcro. The initial idea was just taking random input and converting it into something. Originally I was thinking of making a three-dimensional realization . . . this kind of instant bas-relief sculpture. That was sort of interesting but still too abstract. Then I started thinking about imagery and the face and how any kind of input into the face—no matter how irrational or unpatterned—

would still create something we can decipher, look at, and read and get some sort of message from. I'm using my face, but I don't really consider it a psychological self-portrait or anything like that. I can't make most of these faces myself.

I took the photograph with this piece in mind. I use my image or my body in a lot of the work as my jumping-off point, but usually the end result is so abstracted that I don't really feel so identified with it any longer. Using images of myself or impressions of my body . . . is just a way of using a universal kind of stand-in for

anybody that I hope other people can identify with. It's not about my identity; it's about our identity and our experiences within our bodies, and our bodies' relationship to the external world.

A lot of the body pieces that I do are concerned with measuring the body, or presenting the body in this extremely specific way. So they're really accurate in one way, and almost hyper-realist. But at the same time, that process abstracts them and brings them away from a normal body so much that they no longer look like the original form.

Tim Hawkinson

BELOW AND OPPOSITE
*Wall Chart of World History From Earliest
Times to the Present,* with detail, 1997
Ink, graphite on rag paper, 51 x 396 inches
Collection of Ace Gallery

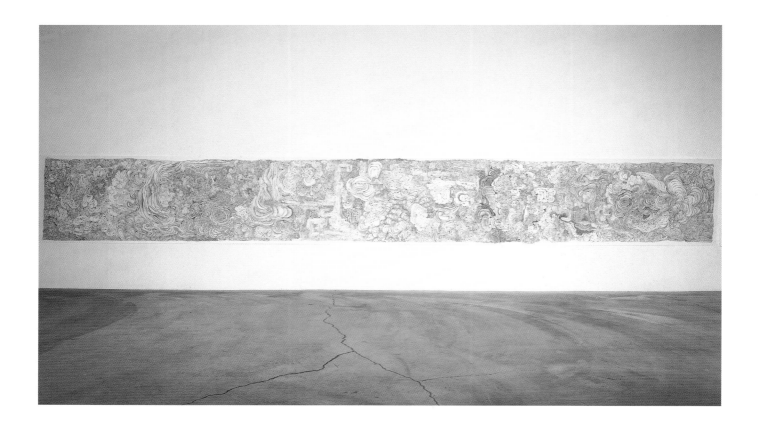

Some of the earlier pieces referred to time,
just a basic reference to the passage of
time—recording time. It's a general kind of
notion and interest . . . just the way history
repeats itself. There was the *Wall Chart of
World History* . . . and I think the reference
to history came after making this drawing
and seeing it as kind of a time line because
it has this feeling of different events being
portrayed, one taking over another. It was a
long red drawing and it looked like it was a
spirograph drawing. It had a real biomorphic
quality, almost like it was composed of
intestines or something.

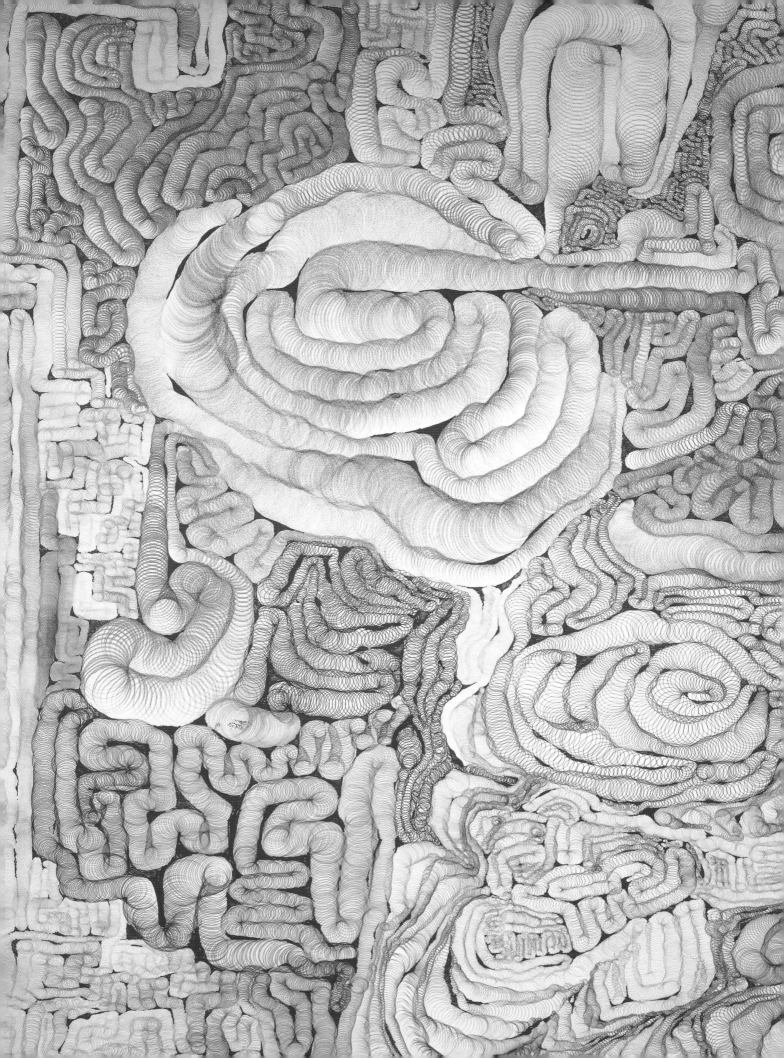

Tim Hawkinson

BELOW
Installation view at Ace Gallery, New York, 1995

OPPOSITE
Drip, 2002
Polyethylene, vinyl, aluminum, mechanical
components, water, dimensions variable
Collection of Ace Gallery

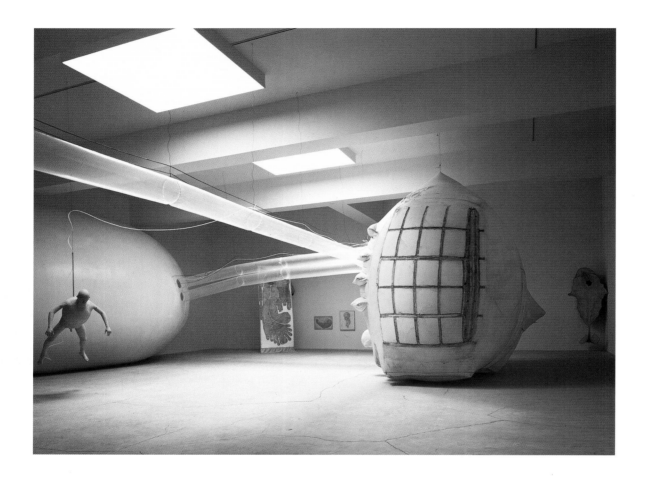

Sometimes we do get rain in L.A. A lot of us aren't really prepared. . . . The studio has areas in the ceiling that sometimes will leak. And it was really great, just walking in one time, and there were buckets around, all catching the drips. It just had a great sound in the space. So I was interested in using dripping water some way. I didn't want just random drips; I wanted something that really felt like something you could dance to, something kind of choreographed-sounding. So I ended up making this almost computerized abacus.

It was a machine that was sort of a drumming machine. It generated different rhythmic patterns. It was hooked up to solenoid valves . . . and each time the valve was triggered, it would allow a drip to drop into a bucket, creating a resonant 'plop.' Each bucket had its totally different resonance, so it was a kind of sound piece.

For me, it's about different kinds of rhythms. There's this visual rhythm throughout the piece—the twists and turns of the materials—and the rhythm created by the sound of the dripping water.

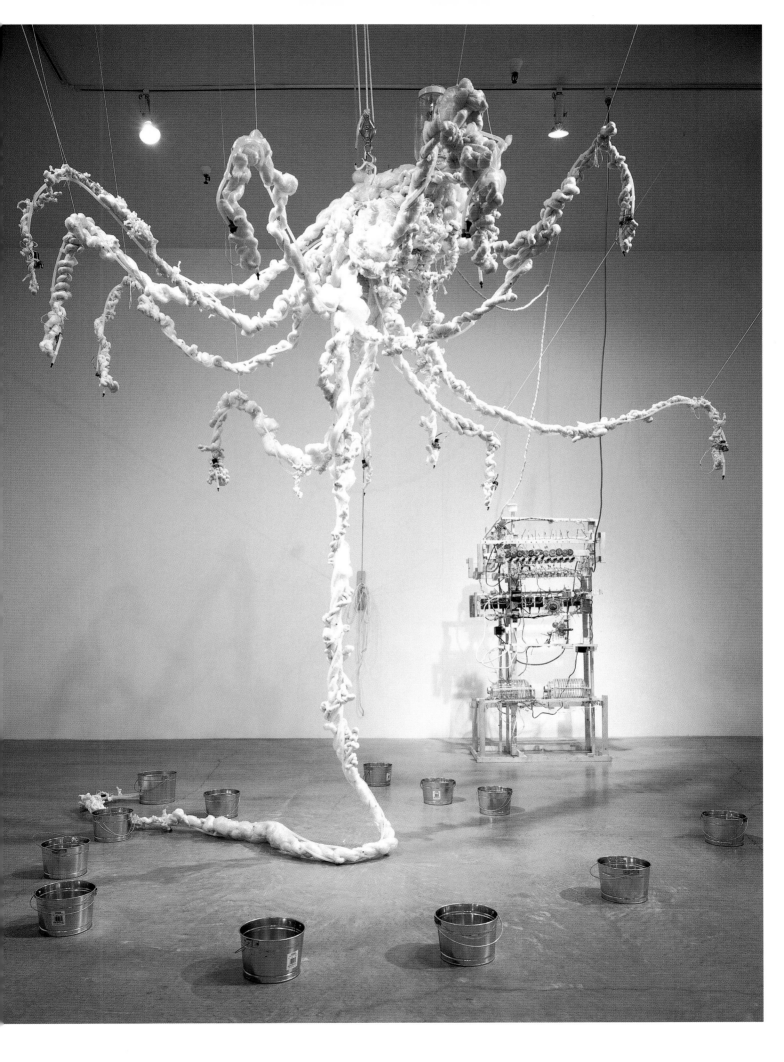

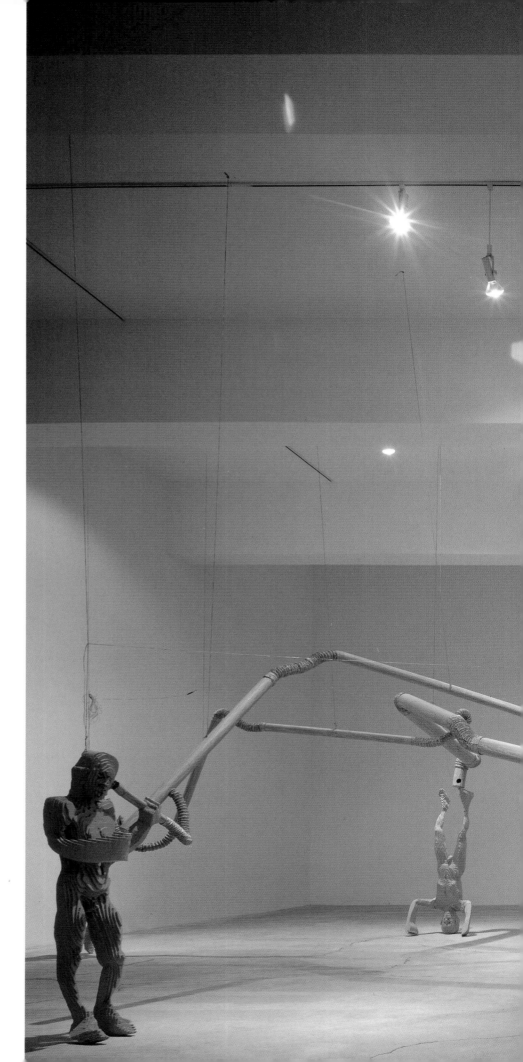

Tim Hawkinson

Pentecost, 1999
Twelve life-sized figures: polyurethane,
foam, sonotubes, mechanical
components, dimensions variable
Installation view at Ace Gallery,
New York, 1999
Collection of Ace Gallery

Other pieces involve more of a quirky
process, especially depictions of the
body. There was a series of works
that I did based on research that
involved taking a bath in black paint,
filling the bathtub slowly with this
black opaque liquid that would block
out my skin, and . . . photographing
it every couple of seconds as it crept
up and covered me.

And so I used that mapping as
the basis for some drawings that I
made, and also realized that three-
dimensionally in the figures that are
in *Pentecost,* a big tree piece with
figures tapping on the tree.

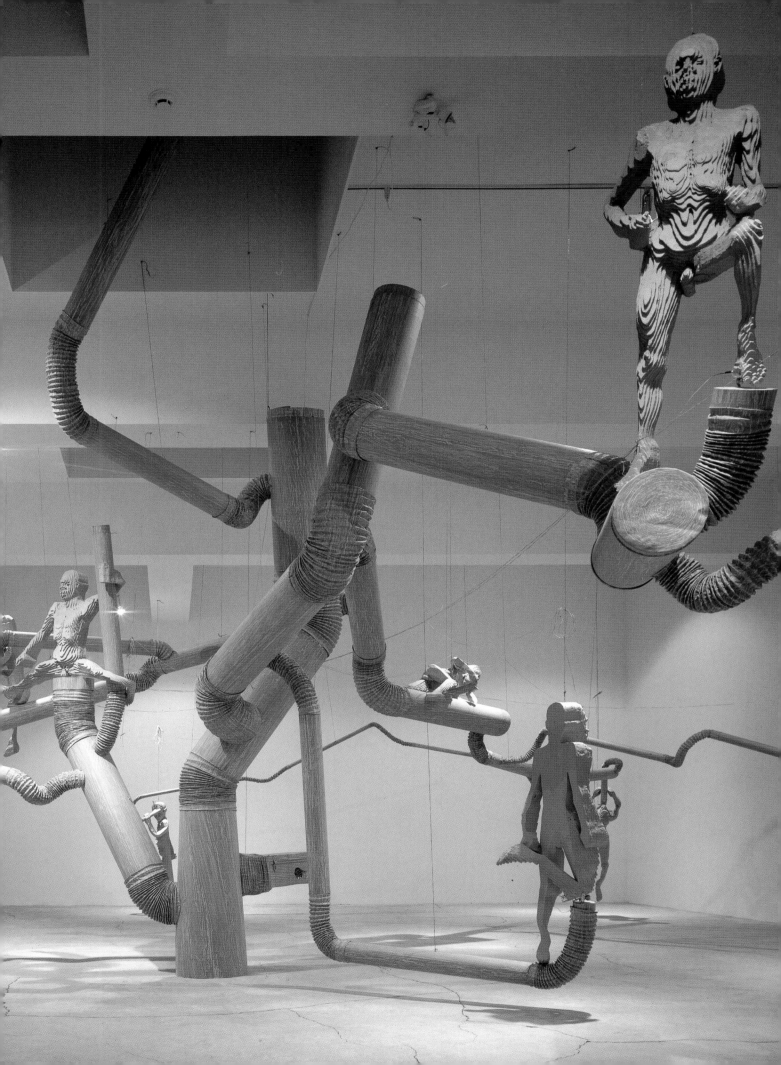

Paul Pfeiffer

I am interested in a certain spiritual dimension to the work that I'm doing. A lot of the titles I use come from either religious sources like the Bible or from religious painting. I'm less interested in religion, and more interested in the relationship between religion and the history of religion, the history of art, the history of human consciousness. To me, all these things are very interconnected. It seems difficult to think about contemporary video, even TV broadcasting, without talking about the precedent of painting.

In a way, I see painting as the predecessor to the spectacle—and you can't really talk about the history of painting without talking about the history of religious painting. There has always been a connection. It's that relationship between religion and art and the perception of reality—human consciousness—that interests me. That's why I make reference to religious sources, say, in the video *John 3:16*—a reference to a passage so often quoted that it's sort of the Biblical code for the New Testament that gives you the formula for salvation and eternal life. There's an interesting kind of resonance that I see between this idea of a formula for salvation and eternal life and the promise of digital media that never break down and literally can live forever, that can always be copied endlessly. In a way, the medium itself represents a kind of promise that almost has spiritual overtones.

I think there's something really humiliating about the way we're asked to live with images, to almost become images. I wonder sometimes if the reality of what's on the screen seems more real than people's lives. There's an incredible seductiveness to the kinds of intense, high-resolution images we're surrounded with today that makes the images so much more compelling than the quietness of reading a book or discovering who you are, without the TV on.

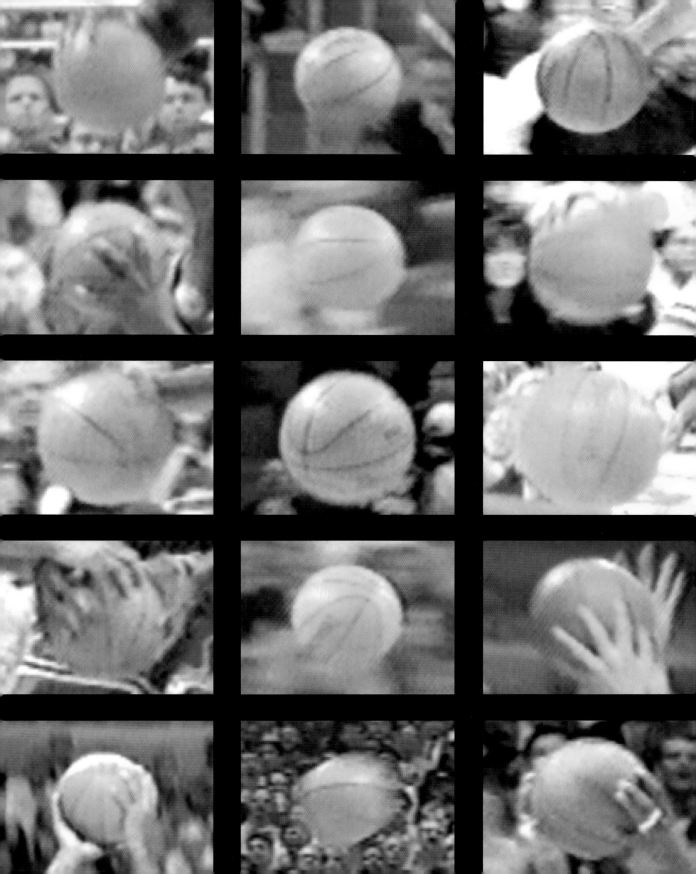

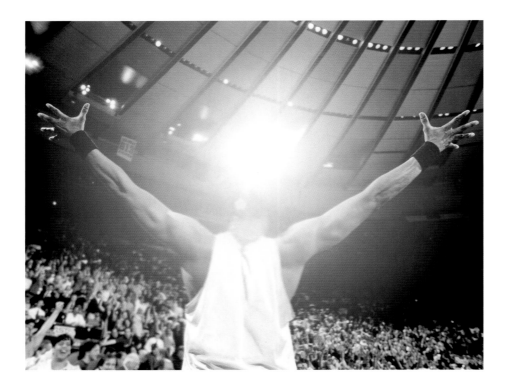

I'm playing a number of roles—director, spy, fan—because ultimately I think a work of art also plays a number of roles. It's not one-dimensional, but tries to do a number of things all at the same time. The real motivation that brings me to the arena . . . to the sport spectacle in general has to do with the kind of intensity of perceptual experience, the perceptual overload that it represents for me. When the game is going, the lights are very bright, the noise is intense, it gets very exciting, and I'm drawn to think about what it must be like down on the court, having to train one's perceptions and skills to play the game amidst all the . . . overload throwing you off balance.

It seems like something that I myself experience, and I imagine it's something we all experience, seeing how we live in a world that is defined by perceptual overload . . . thinking of TV and advertising and the many, many ways that technology penetrates our lives. I'm really interested in a kind of alienation that results from this situation and . . . how a person manages to operate in the media-saturated environment that we live in . . . what it means to live in a situation where you're constantly being not just bombarded but penetrated by images and technology.

Or what it means to be human in . . . a constant breaking down of the boundaries of what's individual and what's mediated by technology and by advertising.

There's definitely a thrill. There are certain images . . . scenes that I feel captured by. There's something special about the spectacle of seeing a human being at the center of the gaze of thousands of people. To me, it's thrilling and also terrifying. There's something very compelling about it to me. I feel empathy for the players on the court, and admiration when somebody's able to shoot a three-point shot amidst all the hoopla.

Looking at the sports footage that I've gotten off the TV . . . I'm interested in the close-up shots of the players right after they score. The camera generally stays panned back, catching all of the action. But when somebody scores, it zooms in. And there are interesting moments when the player happens to be faced away from the camera. They zoom in on the back of the head, and it seems like a very interesting contradiction—that in a way this is the money shot. It's the shot that the players are waiting for when they take center stage after they've done something good or something bad.

Paul Pfeiffer

ABOVE
Four Horsemen of the Apocalypse (7), 2001
Digital duraflex print, 48 x 60 inches
Edition of 6, AP of 1

OPPOSITE
Four Horsemen of the Apocalypse (6), 2001
Digital duraflex print, 60 x 48 inches
Edition of 6, AP of 1

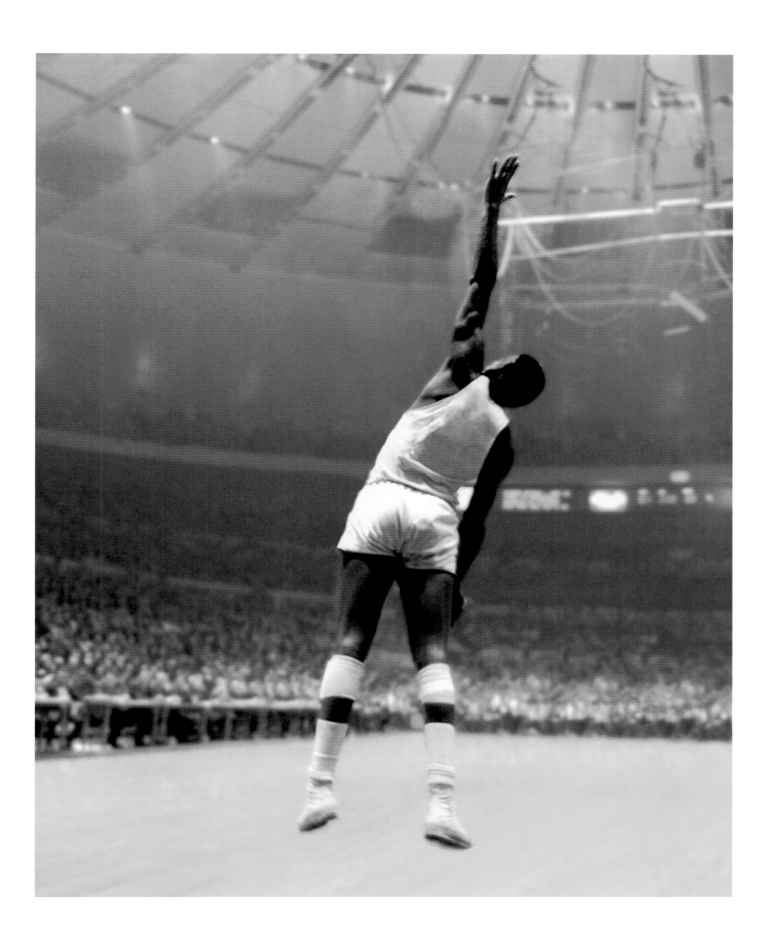

Paul Pfeiffer

Race Riot, with detail, 2001
Digital video loop, digital camcorder,
and wood, glass, and linen vitrine
Image size: 1½ x 2 inches
Vitrine: 20 x 20 x 22 inches
Edition of 6, AP of 1

Paul Pfeiffer

Corner Piece, 2002
Digital video loop with sound,
dimensions variable

Professional sport is usually thought of as a scene of acts of heroism. At the same time, there's also always a loser in the game. I see this contradiction between a kind of heroism of that lone figure at the center of the crowd's attention and, at the same time, that individual seems almost to get swallowed up by the spectacle itself . . . a kind of diminishment of that individual who's at the center . . . being made very small by the spectacle.

Paul Pfeiffer

The Long Count (Rumble in the Jungle), 2001
Digital video loop, LCD monitor, DVD player,
and metal armature, 6 x 7 x 60 inches
Edition of 6, AP of 1

What I'm really interested in is where the medium fails, so that what you are seeing is the point at which the erasure can't happen seamlessly. If the editing was done perfectly, then you wouldn't see where the figure was at all, but in the *Long Count* triptych you always do. There's always this trace of where the figure was, and in a way you're seeing the failure of my hand and the failure of the medium, and that's kind of the ghost that's left. And it's that point of failure that I'm really interested in.

I find myself questioning how much I want the inherent sparkle of high-end digital video to take center stage. A lot of the video work that's being done today . . . gets overwhelmed by its own spectacular effects. I'm really trying to balance that immediate pay-off of the cotton-candy effect of video with what I think is ultimately a more rewarding thing, a more sustained kind of contemplation of the medium. I think I'm getting deeper and deeper into looking at the different ways in which I can make the material . . . I don't know . . . not so much sing but kind of reveal the point at which it fails.

My background is in printmaking, and I think of printmaking as a medium that inherently has to do with repetition and multiple iterations of an image and with copies, and the degrading of an image over a series of iterations. I guess I see a connection between printmaking and video, or with digital tools in general, since both are inherently about mechanical reproduction.

I don't really believe that I can control how meaning is going to be generated from an image. In a way, I'm more interested in multiple readings or even contradictory readings that can come out of a single image. So I very much like the idea of putting an image out there and letting the viewer do some of the work to decide what it means.

Paul Pfeiffer

LEFT
Poltergeist, 2000
Laser-fused polyamide powder,
and wood, glass, and linen vitrine
Object: 4 x 4 x 8 inches
Vitrine: 22 x 22 x 24 inches
Edition of 3, AP of 2

OPPOSITE, TOP AND BOTTOM
Quod Nomen Mihi Est?, 1998
Wall-recessed diorama,
10 x 16 x 18 inches
Collection of Lois Plehn

Paul Pfeiffer

Paul Pfeiffer: Sex Machine, Installation view at The Project, Los Angeles, 2001
From left: *Four Horseman of the Apocalypse (6),* 2001; *Poltergeist (Fork),* 2001; *Dutch Interior,* 2001

Somebody asked me once what my relationship was to the Pop artists. And I think there definitely is a relationship there. I'm really interested in the way that Pop artists were taking things not considered to be art that were part of the popular imagination and attempting to communicate something through this material. At the same time . . . there is a big difference. I think of the Pop artists and that period of the 60s as being one of real celebration of the possibilities of America. I don't think the situation is the same today. . . . In these images I see evidence of a society that's in decline . . . kind of desperate to feel like things are okay . . . that things have been good and will continue to be good. That's the promise of advertising and that's the promise of the spectacle. That things will go on forever . . . no one will die, and things will be beautiful and glamorous for eternity.

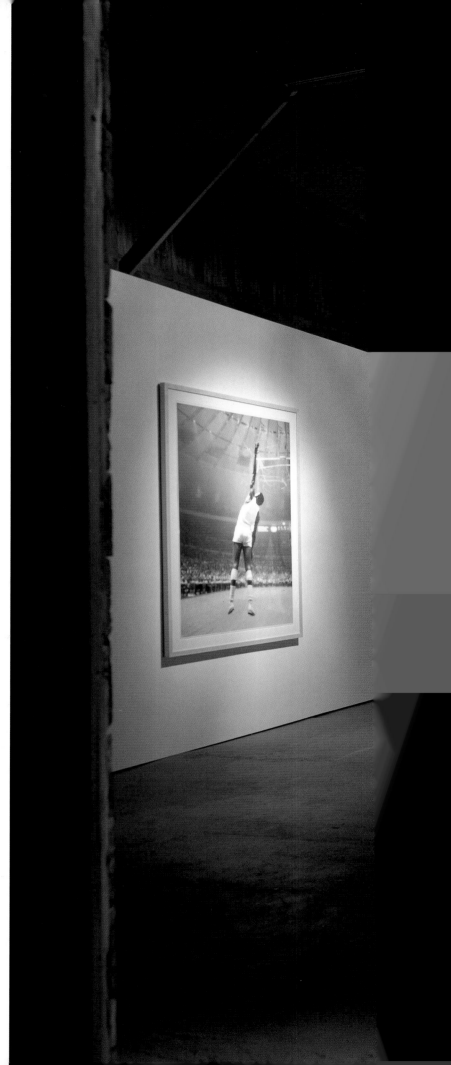

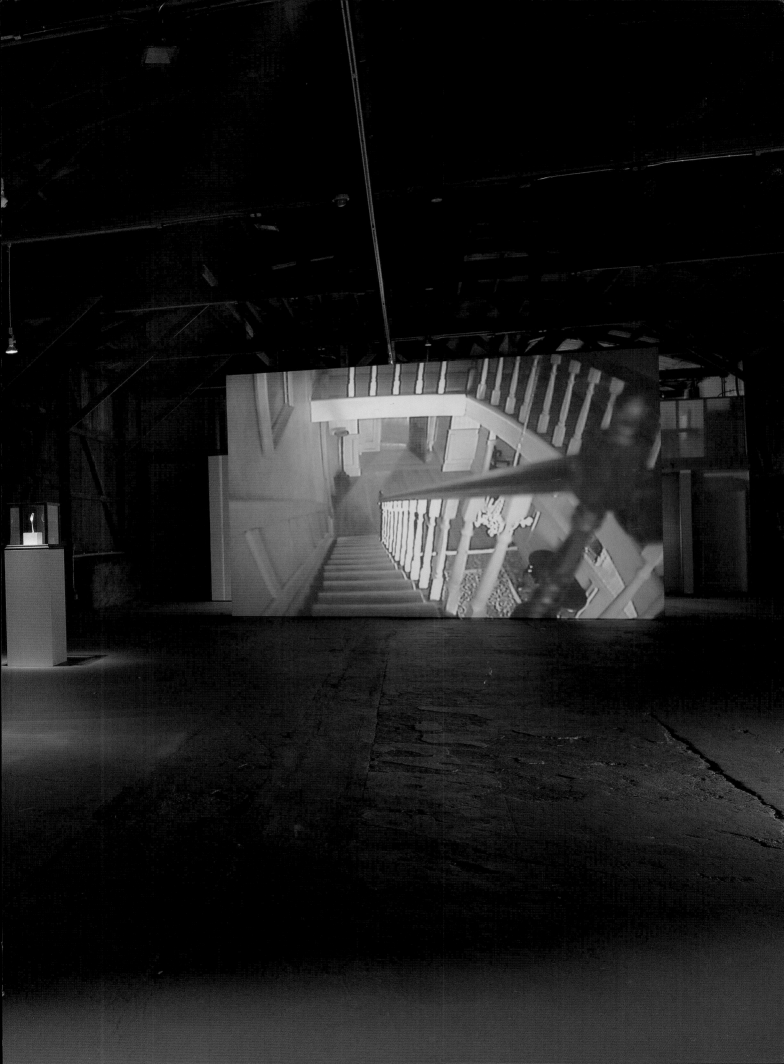

Martin Puryear

I guess I do visualize the work mentally. But often it's not a hundred percent clear, and it only becomes clear when I see it in space in front of me or try to draw it . . . but not usually with drawing. I mean, you can't represent all aspects of a piece of complex form in space. You can't do that. I can't. I can make a drawing and imagine what the back looks like and what the parts of it that you can't see from the drawing look like, and what the cross-sections are like. But it really requires actually shaping it in space. Sometimes you can work with geometry in ways that don't require that. I think it must be like what a musician does, knowing how to imagine a sound, looking at a page of notes and being able to hear it in his mind.

And so, sometimes, if it's simply a conjunction of geometries, simple geometries, not anything really compound and complex, but simple geometry, I think I can imagine something in space. But when it comes to more complicated shapes that are more twisted and torqued, irregular and quirky, it seems like it's more important to make the maquette, make the model, manipulate it, make it, squeeze it, or whatever you have to do to make it feel like you want it to be.

Untitled, 1997
Painted red cedar and pine,
68 x 57½ x 51½ inches
Collection of the Museum of
Modern Art, New York

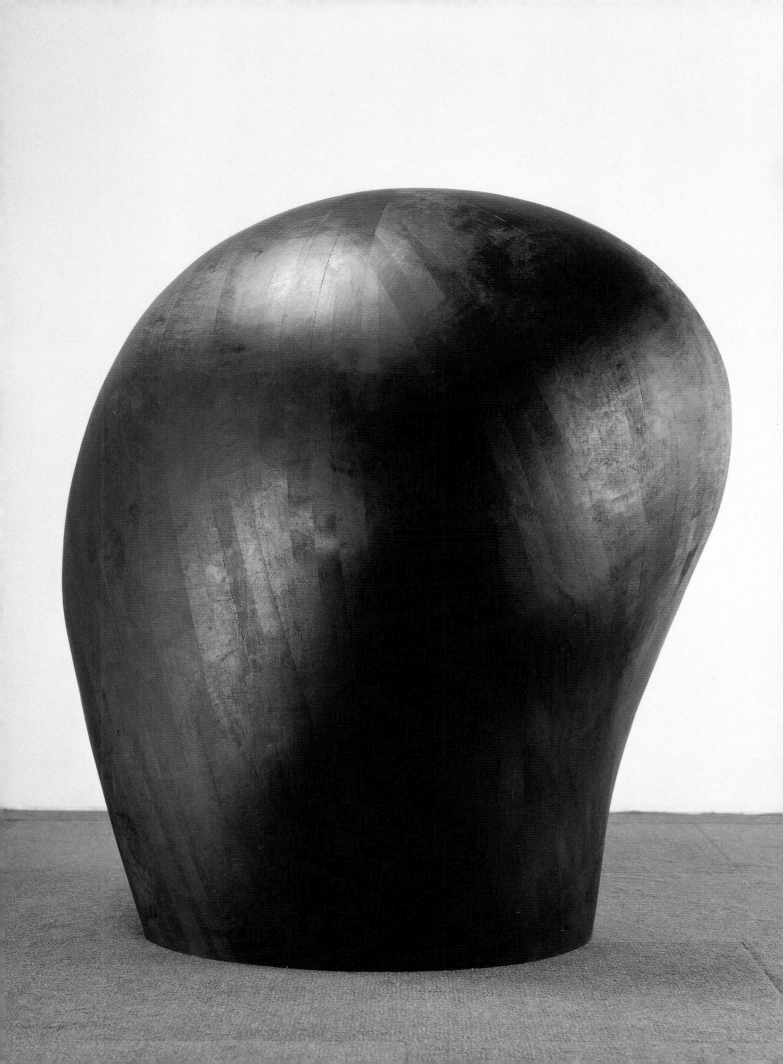

Martin Puryear

BELOW
In Sheep's Clothing, 1996
Pine, 53½ x 62¾ x 13½ inches
Des Moines Art Center, Iowa

OPPOSITE
Desire, 1981
Pine, red cedar, poplar, and Sitka spruce,
116 x 240 x 288 inches
Collection Panza di Buomo, Varese, Italy

A lot of my work comes from an interest in how things are made and how things are done. And the way materials are manipulated and used . . . and the whole history of that in mankind's past . . . and the language that develops around the way materials are used that has a life of its own.

I'm interested in vernacular cultures, where people lived a little closer to the source of materials and the making of objects for use. And for me, not to rely strictly on the history of art has always been an interesting process, to be looking into areas that we call craft and trades. I'm interested in trades, in ways that people make things that are not necessarily artistic. I mean, they're artistic in the sense that they can have a formal beauty, but

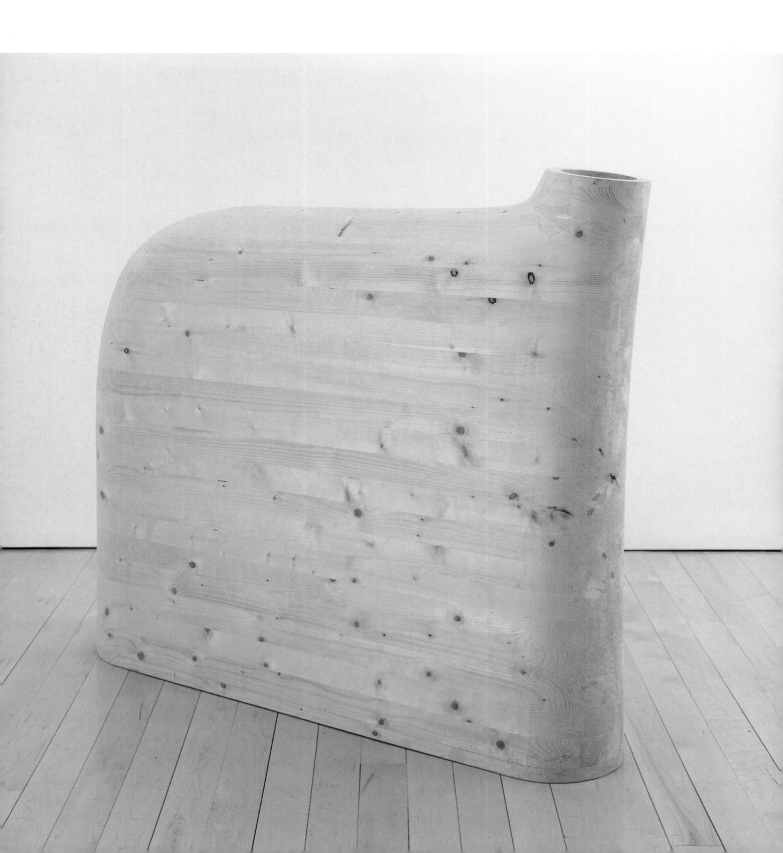

they're not done with an artistic motive. They're often done with a utilitarian motive. Things that are fascinating to me from that perspective have been very influential.

As a woodworker, I use tools all the time. And just paying attention to tools, the evolution of woodworking tools in itself . . . there's a certain art history to that. You look at the forms that various utilitarian things have taken throughout history and there's a whole sort of shifting sense of beauty with the way that the different cultures have shaped things that fit the hand and that are used to do a job, to move material that has some weight, or relate to the way the hand holds them.

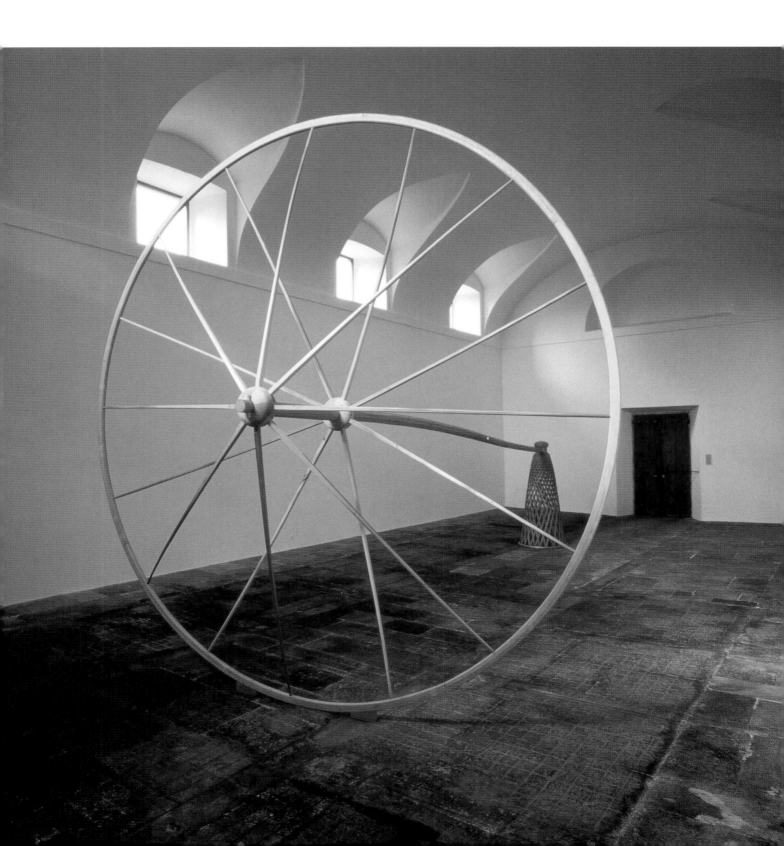

Martin Puryear

I remember when I was in West Africa in the Peace Corps, seeing and being for the first time in a culture that had the making of objects really central, not secondary . . . seeing carpenters, which is the influence I felt most strongly, and observing people who worked with hand tools and who could build things with hand tools. Because in many cases they didn't have electricity, it all had to be done by the power of the muscles in the arms and back. . . .

Being in Africa showed me that you can start with a real modicum of physical support if the will is there and the know-how to do it. That was important for me, my first chance to actually see joinery, hand-joinery, done . . . to see how dove-tails were cut, how mortise and tenons were cut, how efficiently they can be cut by hand. I use that in my sculpture sometimes. It isn't something that my work depends on completely, but it was a liberating thing to see.

I work with a lot of things besides wood, but wood remains my primary material when I want to shape or construct things. That's the natural way

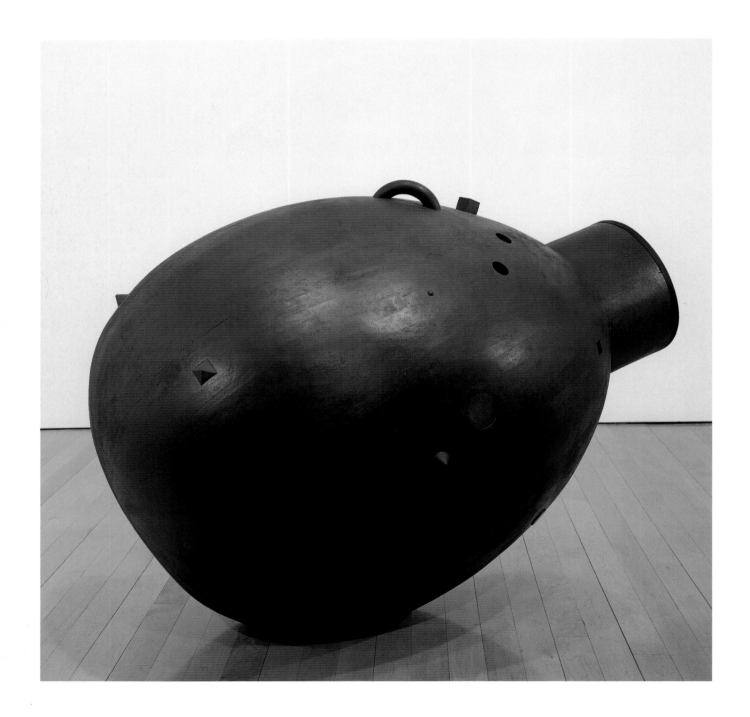

that I can easily get a result. . . . It's very flexible, very versatile, and doesn't require tremendous technological backup. . . . If you've got the right tools, you can do it all using your own physical body power. I do have machines in the studio, but they're used appropriately. They're not used for every single operation. And I don't use them for the most precise work. The most precise work is generally done by hand, with hand tools. Some people rely on machines for their precision, and my way of working is backwards.

I rely on the machines for doing the gross stock removal and then, when it comes to the final refinements and fitting of joints and things, making things work together, I rely more on sharp-edged tools that I push by hand.

When I work with something large, I like getting elements that allow a human relationship to the parts, rather than simply being faced with an enormous expanse of material that doesn't really have increments that you can grasp with your own body size.

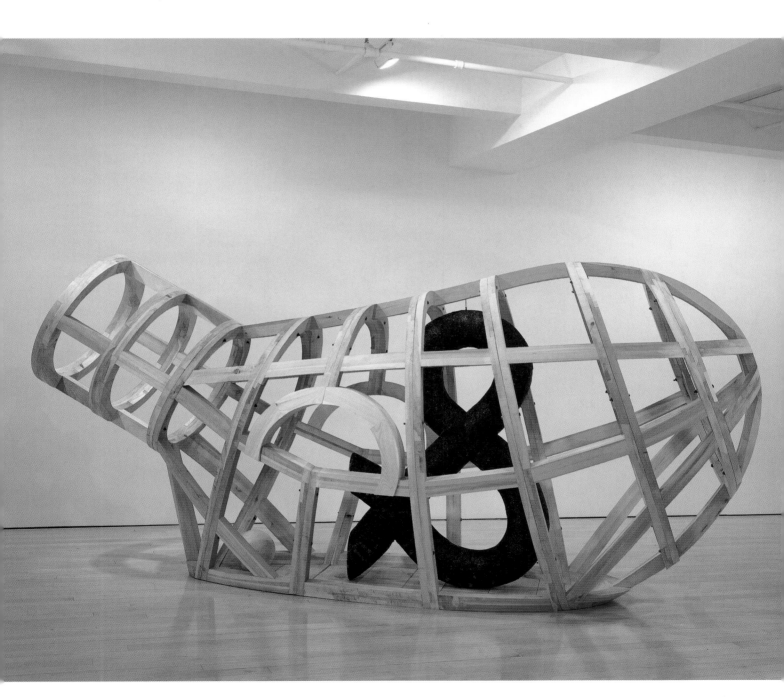

Martin Puryear

I didn't set out to make a work about Booker T. Washington. The work was really about using a sapling…and making a work that had a kind of forced perspective, which made it appear to recede into space faster than it does. It's an idea I've been fascinated with for a long time. It requires a certain length—it's a piece that couldn't have been done small. As it was, it was thirty-six feet long. It's the ideas of diminution in space and the manipulation of that perception that interest me.

Perspective is really what the work is about. And later, the idea of Booker T. Washington, the resonance of his life, and his struggle. And the notion that his idea of progress for the race was a long slow progression of, as he said, putting your buckets down where you are and working with what you've got. He was what you would call a gradualist. The joining of Booker T. Washington and his idea of progress and the form of the piece came after the fact. But when I thought about a title for it, it just seemed absolutely fitting.

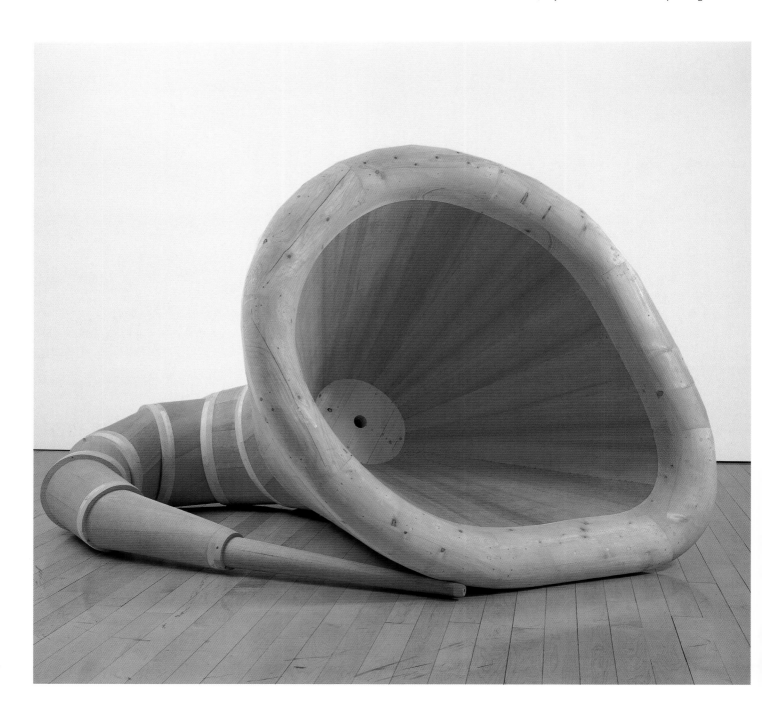

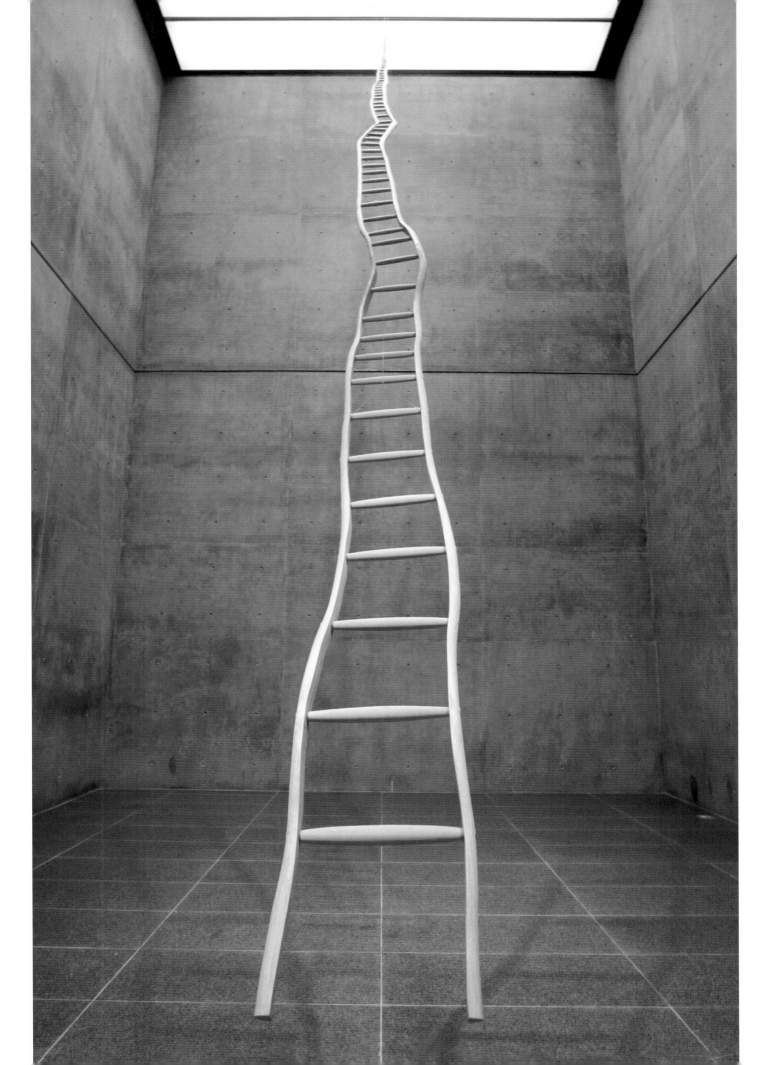

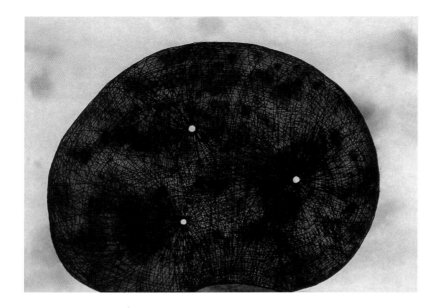

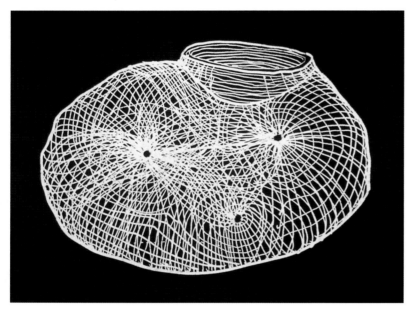

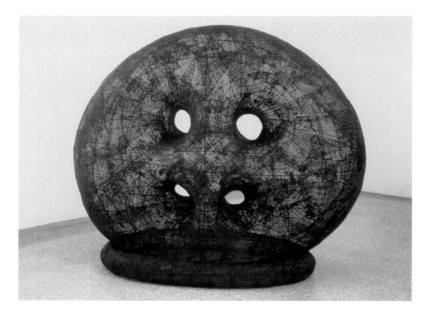

Martin Puryear

TOP
Three Holes, 2002
Spitbite aquatint etching with Gampi,
29 x 34 inches
Edition of 40
Published by Paulson Press

CENTER
Untitled I, 2002
Aquatint etching, 12⅝ x 14 inches
Edition of 40
Published by Paulson Press

BOTTOM
Untitled, 1997
Wire mesh and tar, 66 x 76½ x 37¼ inches
Collection of the Detroit Institute of Arts
Founders Society Purchase, W. Hawkins Ferry
Fund; Chaim, Fanny, Louis, Benjamin, Anne,
and Florence Kaufman Memorial Trust; Andre
L. and Gayle Shaw Cambden Contemporary
and Decorative Arts Fund; Mary Moore
Denison Fund, with funds from the Friends
of Modern Art; the Friends of African and
African American Art; Lynne and Stanley Day;
Gilbert and Ann Hudson; Burt Aaron; David
Klein; Desiree Cooper and Melvin Hollowell,
Jr; Dr. Edward J. Littlejohn; Jeffrey T. Antaya;
and Nettie H. Seasbrooks

I see a piece in my mind's eye. I think you have to, to start to either draw or shape it in space. But it's almost never seen without ultimate alterations when you start to really try to work it out. The mental picture is always something that's going to change when you try to make it, realize it in space, whether it's through trying to grasp it in drawings or shape it directly in physical space. It is always subject to change. . . .

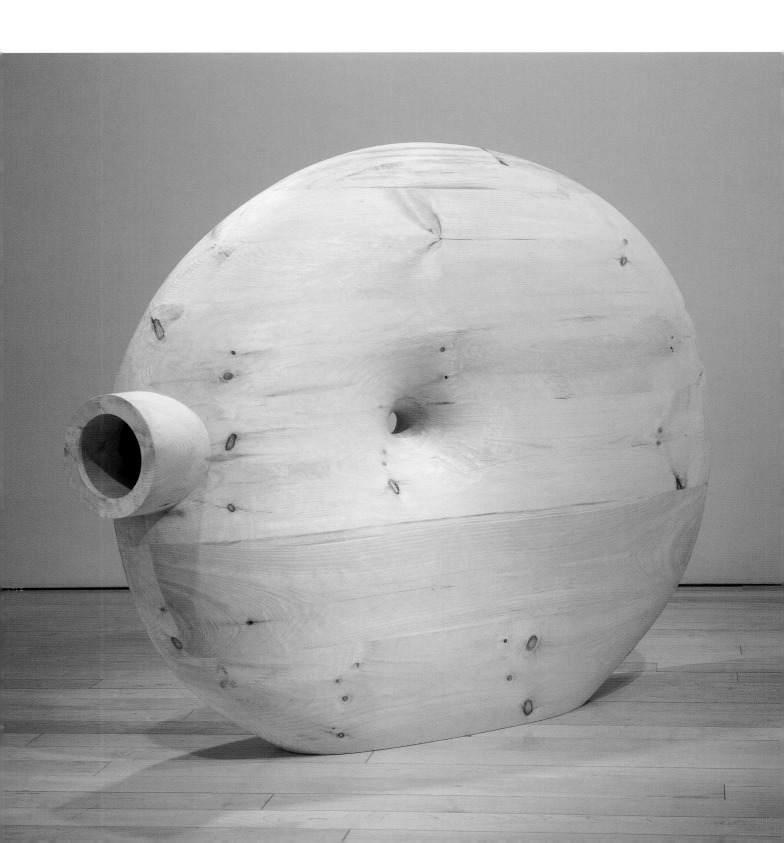

Martin Puryear

Untitled, 1993–94
Mortared fieldstone, 18 x 14 feet
Oliver Ranch, Geyserville, California

I wanted to work in stone. The idea of permanence was important to me. It was a puzzle to find the site that felt right to work in. And then once I found the site that felt right, having an idea that seemed to nestle into the site. . . . I wanted to do something that was like a folly, like an architectural folly.

It was just an attempt to make a work that had, literally, two sides—that had an experience of mystery and void. I almost think about it, in some ways, as a gender dichotomy, that there's a grotto-like half of this piece, half of this experience, that you can look into, you can peer into, but never really enter. It's mysterious. Then there's the other side of it that's very much a projection into space, a more aggressive—if you will—masculine side. And the two are divided by a wall. So it is a piece, depending on how you approach it, that gives you two completely different experiences, two very different readings.

It's about an artificial kind of nature, of created caves, man-made caves and man-made structures that are meant to represent an idealized or fantasized notion of nature.

I was interested in working with stone. The idea of making shapes out of that material that were not rectilinear and planar has always interested me—the fact that using stone, you can construct shapes in space, volumes and shapes that aren't about straight walls and ninety-degree corners. And ways that's being used in different cultures, in parts of Italy and in the dome-like shelters and structures in the countryside in southern France, in Provence. And all the other ways that stone can be used that's not strictly about planes and angles. It just fascinated me.

There were some serious engineering issues to be dealt with because the stone cantilevers out over space. The stone wants to go up vertically, at very least go vertically or, if anything go in, corbel inward. It doesn't want to go out over space—mortared stone—and this piece cantilevers out over space about five feet. So it took some serious engineering to allow that to happen safely.

The stoneworker was a crucial part of this whole process. He was fascinated by the idea that he was doing something that would end up having an identity as an art object rather than a utilitarian structure, a house or building, and that it was actually going to exist as an independent object for contemplation and to assume the identity of an art piece. That, to him, was fascinating.

I don't think I really did much in the way of drawing until I had the shape fairly established in three dimensions that somebody could follow for building it. . . . The whole project took place largely in three dimensions. Even the final construction of it was done without recourse to a lot of drawings.

We built this full-scale cage—or we can call it a network mold—out of reinforcement rod, half-inch or three-quarter-inch rod, bent into shape and then wired into shape so that it was in fact a pattern within which the stoneworker could work. . . . Conceptually, the planar part of it was something that developed after the shape of the original bulging thing, because once I got those two ideas I did want to have a separation between the negative side, the sort of mysterious void, the grotto-like part, and the other side that is so aggressive and protuberant. And I did want to have those experiences be quite distinct and quite separated. And that dictated in some ways how we oriented the piece as well in terms of the roads . . . what you see when you approach it from different angles.

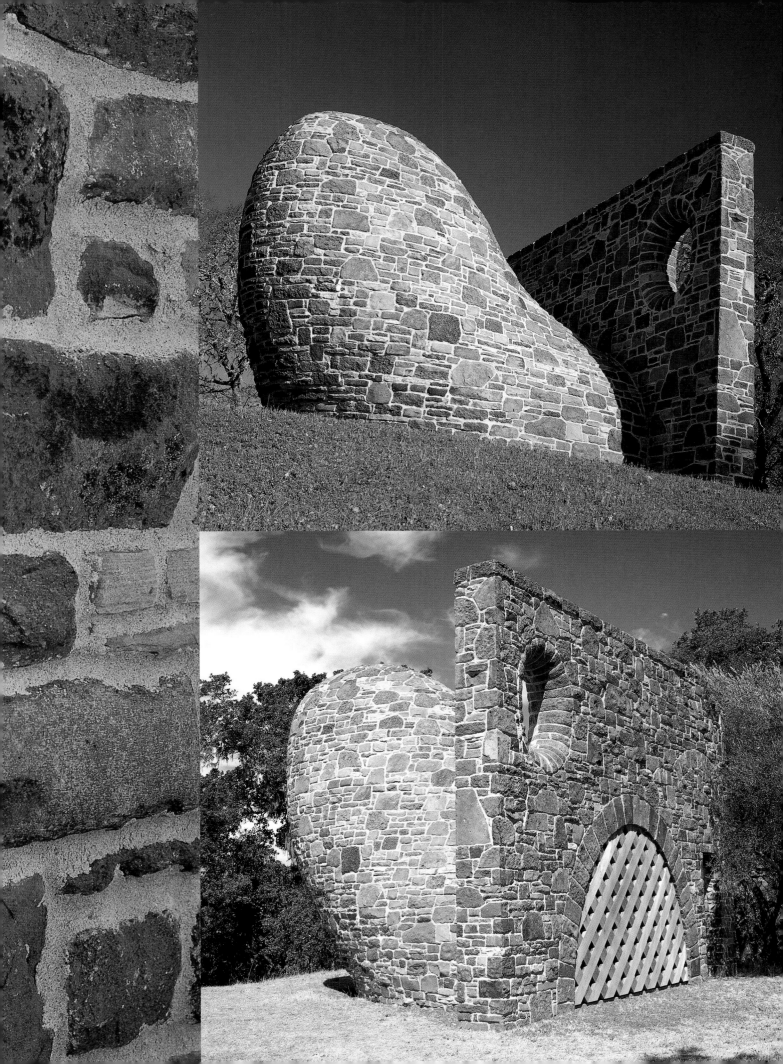

Biographies of the Artists

Eleanor Antin

Eleanor Antin was born in New York City in 1935. An influential performer, filmmaker, and installation artist, Antin delves into history—whether of ancient Rome, the Crimean War, the salons of nineteenth-century Europe, or her own Jewish heritage and Yiddish culture—as a way to explore the present. Antin is a cultural chameleon, masquerading in theatrical or stage roles to expose her many selves. Her most famous persona is that of *Eleanora Antinova*, the tragically overlooked black ballerina of Sergei Diaghilev's Ballets Russes. Appearing as Antinova in scripted and non-scripted performances for over a decade, Antin has blurred the distinction between her identity and that of her character. In the process, she has created a rich body of work detailing the multiple facets of her beloved Antinova, including a fictitious memoir and numerous films, photographs, installations, performances, and drawings. In her 2001 series *The Last Days of Pompeii*, Antin lingers behind the camera to stage the final, catastrophic days of Pompeii in the affluent hills of La Jolla, California. In *The Golden Death* from this series, the imagined citizens of Pompeii drown in the excess of their own wealth—an ironic parable of American culture in the throes of over-consumption. Eleanor Antin received a Guggenheim Foundation Fellowship in 1997 and a Media Achievement Award from the National Foundation for Jewish Culture in 1998. She has had numerous solo exhibitions, including an award-winning retrospective at the Los Angeles County Museum of Art in 1999. Antin is a highly respected artist and teacher, and has been a professor at the University of California, San Diego since 1975. She lives with her husband and son in Southern California.

Janine Antoni

Janine Antoni was born in Freeport, Bahamas in 1964. She received her BA from Sarah Lawrence College in New York, and earned her MFA from the Rhode Island School of Design in 1989. Antoni's work blurs the distinction between performance art and sculpture. Transforming everyday activities such as eating, bathing, and sleeping into ways of making art, Antoni's primary tool for making sculpture has always been her own body. She has chiseled cubes of lard and chocolate with her teeth, washed away the faces of soap busts made in her own likeness, and used the brainwave signals recorded while she dreamed at night as a pattern for weaving a blanket the following morning. In the video, *Touch*, Antoni appears to perform the impossible act of walking on the surface of water. She accomplished this magician's trick, however, not through divine intervention, but only after months of training to balance on a tightrope that she then strung at the exact height of the horizon line. Balance is a key component in the related piece, *Moor*, where the artist taught herself how to make a rope out of unusual and often personal materials donated by friends and relatives. By learning to twist the materials together so that they formed a rope that was neither too loose nor too tight, Antoni created an enduring life-line that united a disparate group of people into a unified whole. Antoni has had major exhibitions of her work at the Whitney Museum of American Art, the Solomon R. Guggenheim Museum, S.I.T.E. Santa Fe, and the Irish Museum of Modern Art, Dublin. The recipient of several prestigious awards including a John D. and Catherine T. MacArthur Fellowship in 1998 and the Larry Aldrich Foundation Award in 1999, Janine Antoni currently resides in New York.

Charles Atlas

Charles Atlas was born in St. Louis in 1949. Atlas is a filmmaker and video artist who has created numerous works for stage, screen, museum, and television. He is a pioneer in the development of media-dance, a genre in which original performance work is created directly for the camera. Atlas worked as filmmaker-in-residence with the Merce Cunningham Dance Company for ten years. Many of Atlas's works have been collaborations with choreographers, dancers, and performers, including Yvonne Rainer, Michael Clark, Douglas Dunn, Marina Abramovic, Diamanda Galas, John Kelly, and Leigh Bowery. *Television Dance Atlas*—the artist's critically acclaimed prime-time event on Dutch television—was a four-hour montage of original and found footage incorporating dance styles as varied as ballet, burlesque, and figure skating. Atlas also creates video installation works. *The Hanged One*—a work inspired by symbolism from the tarot and foot-fetish culture—incorporated numerous video elements as well as rotoscopes, motorized mannequins, and theatrical lighting. Atlas is the recipient of three Bessie (New York Dance and Performance) Awards. His feature-length film *Merce Cunningham: A Lifetime of Dance* won the Best Documentary Award at Dance Screen 2000 in Monaco. His work has been shown at international institutions including the Whitney Museum of American Art; the Museum of Modern Art; Musée National d'Art Moderne, Centre Georges Pompidou, Paris; the Institute of Contemporary Arts, London; the Museum of Contemporary Art, Los Angeles; and the Stedelijk Museum, Amsterdam. Atlas acted as Consulting Director for *Art:21*'s second season, creating the original *Program Opens* for each hour-long segment, as well as supervising the *Stories* and *Loss and Desire* hours. Charles Atlas lives and works in New York and Paris.

Vija Celmins

Vija Celmins was born in Riga, Latvia in 1938. Celmins immigrated to the United States with her family when she was ten years old, settling in Indiana. She received a BFA from the John Herron Institute in Indianapolis, and later earned her MFA in painting from the University of California, Los Angeles. Celmins received international attention early on for her renditions of natural scenes—often copied from photographs that lack a point of reference, horizon, or discernable depth of field. Armed with a nuanced palette of blacks and grays, Celmins renders these limitless spaces—seascapes, night skies, and the barren desert floor—with an uncanny accuracy, working for months on a single image. Celmins has a highly attuned sense for organic detail and the elegance of imperfection. Her most recent series of works take as their subject delicate spider webs. In works like *Web #2*, Celmins renders the translucent quality of the web, lending the image a sense of discovery and wonder. A master of several mediums, including oil painting, charcoal, and multiple printmaking processes, Celmins matches a tangible sense of space with sensuous detail in each work. Vija Celmins received an American Academy of Arts and Letters Award in 1996 and a John D. and Catherine T. MacArthur Fellowship in 1997. Retrospectives of her work have traveled to the Whitney Museum of American Art, the Walker Art Center, the Museum of Contemporary Art, Los Angeles, the Institute of Contemporary Art, London, and the Museum of Fine Arts, Houston. In 2002, a retrospective of Celmins's prints was held at the Metropolitan Museum of Art. Celmins currently resides in New York and California.

Walton Ford

Walton Ford was born in 1960 in Larchmont, New York. Ford graduated from the Rhode Island School of Design with the intention of becoming a filmmaker, but later adapted his talents as a storyteller to his unique style of large-scale watercolor. Blending depictions of natural history with political commentary, Ford's meticulous paintings satirize the history of colonialism and the continuing impact of slavery and other forms of political oppression on today's social and environmental landscape. Each painting is as much a tutorial in flora and fauna as it is a scathing indictment of the wrongs committed by nineteenth-century industrialists or, locating the work in the present, contemporary American consumer culture. An enthusiast of the watercolors of John James Audubon, Ford celebrates the myth surrounding the renowned naturalist-painter while simultaneously repositioning him as an infamous anti-hero who, in reality, killed more animals than he ever painted. Each of Ford's animal portraits doubles as a complex, symbolic system, which the artist layers with clues, jokes, and erudite lessons in colonial literature and folktales. Walton Ford is the recipient of several national awards and honors including a fellowship from the John Simon Guggenheim Memorial Foundation and the National Endowment for the Arts. Ford's work has been featured at Bowdoin College Museum of Art, the Southeastern Center for Contemporary Art, the Whitney Museum of American Art at Champion, and the Forum for Contemporary Art in St. Louis. After living in New York City for more than a decade, Walton Ford relocated his studio to Great Barrington, Massachusetts. Ford and his family reside in upstate New York.

Trenton Doyle Hancock

Trenton Doyle Hancock was born in 1974 in Oklahoma City, Oklahoma. Raised in Paris, Texas, Hancock earned his BFA from Texas A&M University, Commerce, and his MFA from the Tyler School of Art at Temple University, Philadelphia. Hancock's prints, drawings, and collaged felt paintings work together to tell the story of the *Mounds*—a group of mythical creatures that are the tragic protagonists of the artist's unfolding narrative. Each new work by Hancock is a contribution to the saga of the Mounds, portraying the birth, life, death, afterlife, and even dream states of these half-animal, half-plant creatures. Influenced by the history of painting, especially Abstract Expressionism, Hancock transforms traditionally formal decisions—such as the use of color, language, and pattern—into opportunities to create new characters, develop sub-plots, and convey symbolic meaning. Hancock's paintings often rework Biblical stories that the artist learned as a child from his family and local church community. Balancing moral dilemmas with wit and a musical sense of language and color, Hancock's works create a painterly space of psychological dimension. Trenton Doyle Hancock was featured in the 2000 and 2002 Whitney Biennial exhibitions, and is one of the youngest artists in history to participate in this prestigious survey. His work has been the subject of one-person exhibitions at the Contemporary Arts Museum, Houston, the Modern Art Museum of Fort Worth, and the Museum of Contemporary Art, North Miami. The recipient of numerous awards, Hancock lives and works in Houston where he was a 2002 Core Artist in Residence at the Glassell School of Art of the Museum of Fine Arts, Houston.

Tim Hawkinson

Tim Hawkinson was born in San Francisco, California in 1960. A graduate of San Jose State University, he later earned his MFA at the University of California, Los Angeles in 1989. Hawkinson is renowned for creating complex sculptural systems through surprisingly simple means. His installation *Überorgan*—a stadium-size, fully automated bagpipe—was pieced together from bits of electrical hardware and several miles of inflated plastic sheeting. Hawkinson's fascination with music and notation can also be seen in *Pentecost,* a work in which the artist tuned cardboard tubes and assembled them in the shape of a giant tree. On this tree the artist placed twelve life-size robotic replicas of himself, and programmed them to beat out religious hymns at humorously irregular intervals.

The source of inspiration for many of Hawkinson's pieces has been the re-imagining of his own body and what it means to make a self-portrait of this new or fictionalized body. In 1997 the artist created an exacting, two-inch tall skeleton of a bird from his own fingernail parings, and later made a feather and egg from his own hair. Believable even at a close distance, these works reveal Hawkinson's attention to detail as well as his obsession with life, death, and the passage of time. Hawkinson has participated in numerous exhibitions in the United States and abroad, including the Venice Biennale (1999), the Massachusetts Museum of Contemporary Art, (2000), the Power Plant in Toronto, Canada (2000), the Whitney Biennial (2002), and the 2003 Corcoran Biennial in Washington, D.C. Tim Hawkinson resides in Los Angeles with his wife.

Elizabeth Murray

Elizabeth Murray was born in Chicago in 1940. She earned a BFA at the Art Institute of Chicago and an MFA from Mills College in Oakland, California. A pioneer in painting, Murray's distinctively shaped canvases break with the art-historical tradition of illusionistic space in two-dimensions. Jutting out from the wall and sculptural in form, Murray's paintings and watercolors playfully blur the line between the painting as an object and the painting as a space for depicting objects. Her still lifes are reminiscent of paintings by masters such as Cézanne, Picasso, and Matisse; however, like her entire body of work, Murray's paintings rejuvenate old art forms. Breathing life into domestic subject matter, Murray's paintings often include images of cups, drawers, utensils, chairs, and tables. These familiar objects are matched with cartoonish fingers and floating eyeballs—macabre images that are as nightmarish as they are goofy. Taken in as a whole, Murray's paintings are abstract compositions rendered in bold colors and multiple layers of paint. But the details of the paintings reveal a fascination with dream states and the psychological underbelly of domestic life. The recipient of many awards, Murray received the Skowhegan Medal in Painting in 1986, the Larry Aldrich Prize in Contemporary Art in 1993, and a John D. and Catherine T. MacArthur Foundation Award in 1999. Her work is featured in many collections, including the Walker Art Center, the Museum of Modern Art, the Solomon R. Guggenheim Museum, the Art Institute of Chicago, and the Museum of Contemporary Art, Los Angeles. Elizabeth Murray and her family reside in New York.

Gabriel Orozco

Gabriel Orozco was born in Jalapa, Veracruz, Mexico in 1962 and studied at the Escuela Nacional de Artes Plasticas in Mexico City, and at the Circulo de Bellas Artes in Madrid, Spain. An avid traveler, Gabriel Orozco uses the urban landscape and the everyday objects found within it to twist conventional notions of reality and engage the imagination of the viewer. Orozco's interest in complex geometry and mapping find expression in works like the patterned human skull of *Black Kites,* the curvilinear logic of *Oval Billiard Table*, and the extended playing field of the chessboard in *Horses Running Endlessly*. He considers philosophical problems, such as the concept of infinity, and evokes them in humble moments, as in the photograph *Pinched Ball*, which depicts a deflated soccer ball filled with water. Matching his passion for political engagement with the poetry of chance encounters, Orozco's photographs, sculptures, and installations propose a distinctive model for the ways in which artists can affect the world with their work. Orozco was featured at Documenta XI (2002), where his sensuous terra-cotta works explored the elegance and logic of traditional ceramics—a pointed commentary on Mexican craft and its place in a 'high art' gallery space. Orozco has shown his work at distinguished venues including the Whitney Museum of American Art, the Museum of Modern Art, the Solomon R. Guggenheim Museum, the Philadelphia Museum of Art, and the Venice Biennale. A major retrospective of Orozco's work was assembled at the Museum of Contemporary Art, Los Angeles in 2000, and traveled to the Museo Internacional Rufino Tamayo, Mexico City, and the Museo de Arte Contemporaneo de Monterey, Mexico. Gabriel Orozco lives and works in New York, Paris, and Mexico City.

Raymond Pettibon

Raymond Pettibon was born in Tucson, Arizona in 1957. The fourth of five children, Pettibon earned a degree in Economics from the University of California, Los Angeles. After graduating from college, Pettibon worked briefly as a high-school math teacher, but soon after set out to launch a career as a professional artist. A cult figure among underground music devotees for his early work associated with the Los Angeles punk rock scene, Pettibon has acquired an international reputation as one of the foremost contemporary American artists working with drawing, text, and artist's books. Pettibon is as likely to explore the subject of surfing as he is typography; themes from art history and nineteenth-century literature appear in the same breath with American politics from the 1960s and contemporary pop culture. In his 1998 anthology, *Raymond Pettibon: A Reader,* the viewer can read over Pettibon's shoulder to discover a handful of the artist's muses—Henry James, Mickey Spillane, Marcel Proust, William Blake, and Samuel Beckett, among others. In the 1990s, Pettibon extended his work beyond the printed page and onto the walls of the exhibition space, creating wall-sized drawings and collages. Retrospectives of his work have been held at the Philadelphia Museum of Art, the Santa Monica Museum of Art, and the Museum of Contemporary Art, Los Angeles. In 2002, an exhibition of his drawings, *Plots Laid Thick,* was organized by the Museu d'Art Contemporani de Barcelona, Spain, and traveled to the Tokyo Opera City Art Gallery, and the Haags Gemeentemuseum in the Netherlands. Pettibon's work was also featured at Documenta XI in Kassell, Germany. Pettibon lives and works in Hermosa Beach, California.

Paul Pfeiffer

Paul Pfeiffer was born in Honolulu, Hawaii in 1966, but spent most of his childhood in the Philippines. Pfeiffer relocated to New York in 1990, where he attended Hunter College and the Whitney Independent Study Program. Pfeiffer's groundbreaking work in video, sculpture, and photography uses recent computer technologies to dissect the role that mass media plays in shaping consciousness. In a series of video works focused on professional sports events—including basketball, boxing, and hockey—Pfeiffer digitally removes the bodies of the players from the games, shifting the viewer's focus to the spectators, sports equipment, or trophies won. Presented on small LCD screens and often looped, these intimate and idealized video works are meditations on faith, desire, and a contemporary culture obsessed with celebrity. Many of Pfeiffer's works invite viewers to exercise their imaginations or project their own fears and obsessions onto the art object. Several of Pfeiffer's sculptures include eerie, computer-generated recreations of props from Hollywood thrillers, such as *Poltergeist*, and miniature dioramas of sets from films that include *The Exorcist* and *The Amityville Horror*. Pfeiffer is the recipient of numerous awards and fellowships, most notably becoming the inaugural recipient of The Bucksbaum Award given by the Whitney Museum of American Art (2000). In 2002, Pfeiffer was an artist-in-residence at the Massachusetts Institute of Technology and at ArtPace in San Antonio, Texas. In 2003, a traveling retrospective of his work was organized by the MIT List Visual Arts Center and the Museum of Contemporary Art, Chicago.

Martin Puryear

Martin Puryear was born in Washington, D.C., in 1941. In his youth, he studied crafts and learned how to build guitars, furniture, and canoes through practical training and instruction. After earning his BA from Catholic University in Washington, D.C., Puryear joined the Peace Corps in Sierra Leone, and later attended the Swedish Royal Academy of Art. He received an MFA in sculpture from Yale University in 1971. Puryear's objects and public installations—in wood, stone, tar, wire, and various metals—are a marriage of Minimalist logic with traditional ways of making. Puryear's evocative, dreamlike explorations in abstract forms retain vestigial elements of utility from everyday objects found in the world. In *Ladder for Booker T. Washington*, Puryear built a spindly, meandering ladder out of jointed ash wood. More than thirty-five feet tall, the ladder narrows toward the top, creating a distorted sense of perspective that evokes an unattainable or illusionary goal. In the massive stone piece, *Untitled*, Puryear enlisted a local stonemason to help him construct a building-like structure on a ranch in northern California. On one side of the work is an eighteen-foot-high wall—on the other side, an inexplicable stone bulge. A favorite form that occurs in Puryear's work, the thick-looking stone bulge is surprisingly hollow, coloring the otherwise sturdy shape with qualities of uncertainty, emptiness, and loss. Martin Puryear represented the United States at the São Paolo Bienal in 1989, where his exhibition won the Grand Prize. Puryear is the recipient of numerous awards, including a John D. and Catherine T. MacArthur Foundation Award, a Louis Comfort Tiffany Grant, and the Skowhegan Medal for Sculpture. Puryear was elected to the American Academy and Institute of Arts and Letters in 1992 and received an honorary doctorate from Yale University in 1994. Martin Puryear lives and works in the Hudson Valley region of New York.

Collier Schorr

Collier Schorr was born in New York City in 1963 and attended the School of the Visual Arts, New York. Best known for her portraits of adolescent men and women, Schorr's pictures often blend photographic realism with elements of fiction and youthful fantasy. For her 1998 project *Neue Soldatten*, Schorr juxtaposed documentary-style pictures of a Swedish army battalion with pictures of fake Swedish soldiers played by German teenagers. Several of these young men reappear in Schorr's 2001 project *Forests and Fields*, where this time they are dressed in an anxious assortment of German, Israeli, Weimar (Nazi), and Vietnam-era American army uniforms. Schorr's dubious images not only call into question the fractured role of soldiering in today's society, but also examine the way nationality, gender, and sexuality influence an individual's identity. For her *Jens F./Helga* project, Schorr set out to create a comprehensive, yet unusual portrait of a young man by photographing a German schoolboy posed as Helga, the housewife whom American painter Andrew Wyeth studied in secret for nearly twenty years. Whereas in this body of work Schorr compares the way men and women pose differently for the artist's gaze, in photographs of American high school and collegiate wrestlers she trains her camera on a tribe of young men whose bodies and athletic training homogenize personal differences. Schorr's work was featured in the 2002 Whitney Biennial and the 2003 International Center for Photography Triennial. Schorr has exhibited her work internationally at prestigious venues that include the Walker Art Center in Minneapolis, the Jewish Museum in New York, the Stedelijk Museum in Amsterdam, and the Consorcio Salamanca in Salamanca, Spain. Collier Schorr lives and works in Brooklyn, New York.

Kiki Smith

Kiki Smith was born in 1954 in Nuremberg, Germany. The daughter of American sculptor Tony Smith, Kiki Smith grew up in New Jersey. As a young girl, one of Smith's first experiences with art was helping her father make cardboard models for his geometric sculptures. This training in formalist systems, combined with her upbringing in the Catholic Church, would later resurface in Smith's evocative sculptures, drawings, and prints. The recurrent subject matter in Smith's work has been the body as a receptacle for knowledge, belief, and storytelling. In the 1980s, Smith literally turned the figurative tradition in sculpture inside out, creating objects and drawings based on organs, cellular forms, and the human nervous system. This body of work evolved to incorporate animals, domestic objects, and narrative tropes from classical mythology and folk tales. Life, death, and resurrection are thematic signposts in many of Smith's installations and sculptures. In several of her recent pieces, including *Lying with the Wolf, Wearing the Skin*, and *Rapture*, Smith takes as her inspiration the life of St. Genevieve, the patron saint of Paris. Portrayed communing with a wolf, taking shelter with its pelt, and being born from its womb, Smith's character of Genevieve embodies the complex, symbolic relationships between humans and animals. Smith received the Skowhegan Medal for Sculpture in 2000 and has participated in the Whitney Biennial three times in the past decade. Smith's work is in numerous prominent museum collections, including the Solomon R. Guggenheim Museum, the Metropolitan Museum of Art, and the Museum of Contemporary Art, Los Angeles. A major retrospective of Smith's prints and multiples is being organized by the Museum of Modern Art for 2003–04. Smith lives and works in New York City.

Do-Ho Suh

Do-Ho Suh was born in Seoul, Korea in 1962. After earning his BFA and MFA in Oriental Painting from Seoul National University, and fulfilling his term of mandatory service in the South Korean military, Suh relocated to the United States to continue his studies at the Rhode Island School of Design and Yale University. Best known for his intricate sculptures that defy conventional notions of scale and site-specificity, Suh's work draws attention to the ways viewers occupy and inhabit public space. In several of the artist's floor sculptures, viewers are encouraged to walk on surfaces composed of thousands of miniature human figures. In *Some/One*, the floor of the gallery is blanketed with a sea of polished military dog tags. Evocative of the way an individual soldier is part of a larger troop or military body, these dog tags swell to form a hollow, ghost-like suit of armor at the center of the room. Whether addressing the dynamic of personal space versus public space, or exploring the fine line between strength in numbers and homogeneity, Do-Ho Suh's sculptures continually question the identity of the individual in today's increasingly transnational, global society. Do-Ho Suh represented Korea at the 2001 Venice Biennale. A retrospective of the artist's work was held jointly at the Seattle Art Museum and the Seattle Asian Art Museum in 2002. Major exhibitions of Suh's work have also been held at the Whitney Museum of American Art at Philip Morris (2001), the Serpentine Gallery, London (2002), and the Kemper Museum of Contemporary Art in Kansas City, Missouri (2002–03).

Kara Walker

Kara Walker was born in Stockton, California in 1969. She received a BFA from the Atlanta College of Art in 1991 and an MFA from the Rhode Island School of Design in 1994. The artist is best known for exploring the raw intersection of race, gender, and sexuality through her iconic, silhouetted figures. Walker unleashes the traditionally proper Victorian medium of the silhouette directly onto the walls of the gallery, creating a theatrical space in which her unruly cut-paper characters fornicate and inflict violence on one another. In recent works like *Darkytown Rebellion* (2000), the artist uses overhead projectors to throw colored light onto the ceiling, walls, and floor of the exhibition space. When the viewer walks into the installation, his or her body casts a shadow onto the walls where it mingles with Walker's black-paper figures and landscapes. With one foot in the historical realism of slavery and the other in the fantastical space of the romance novel, Walker's nightmarish fictions simultaneously seduce and implicate the audience. Walker's work has been exhibited at the Museum of Modern Art, the San Francisco Museum of Modern Art, the Solomon R. Guggenheim Museum, and the Whitney Museum of American Art. A 1997 recipient of the John D. and Catherine T. MacArthur Foundation Achievement Award, Walker was the United States representative to the 2002 São Paolo Bienal in Brazil. Walker currently lives in New York where she is on the faculty of the MFA program at Columbia University.

List of Illustrations

Photographic Credits and Copyrights

OPENING SEGMENT ARTIST: pp. 14–18, 21 (bottom) courtesy the artist; p. 19, photo by Bob Goedewaagen, courtesy the artist; p. 20, 21 (top), photo by David Allison, courtesy the artist.

STORIES: pp. 2–3, 25–35, courtesy James Cohan Gallery, New York and Dunn and Brown Contemporary, Dallas; pp. 7, 38, 41 (top), 42, 44–45, 47, photos by Ellen Page Wilson, courtesy PaceWildenstein; p. 37, courtesy Pace Editions; p. 39, photo by Richard–Marx Tremblay, courtesy PaceWildenstein; pp. 40, 41 (bottom), photos by Kerry Ryan McFate, courtesy PaceWildenstein; p. 43, photo by Gregory Heins, courtesy the artist; p. 46, photo courtesy MASS MoCA; pp. 49–59, courtesy the artist and Lehmann Maupin Gallery, New York; pp. 60, 62–67, 69 (top), 70–71, courtesy Brent Sikkema, New York; p. 61, photo by Dan Dennehy for the Walker Art Center, courtesy Brent Sikkema, New York; pp. 68–69 (bottom), photo courtesy Solomon R. Guggenheim Museum, New York, courtesy Brent Sikkema, New York.

LOSS AND DESIRE: p. 74, photo by Brian Forest, courtesy the artist and Luhring Augustine; pp. 76, 77 (top), photos by John Bessler, courtesy the artist and Luhring Augustine; p. 77 (bottom), photo by Lee Stalsworth, courtesy the artist and Luhring Augustine; p. 78, photo by Prudence Cuming Associates Limited, courtesy the artist and Luhring Augustine; p. 79, photo by Anders Norrsell, courtesy the artist and Luhring Augustine; pp. 80, 82–85, courtesy the artist and Luhring Augustine; p. 81, courtesy the artist, SITE Santa Fe and Luhring Augustine; pp. 86–87, 90–93, 96–97, courtesy the artist and Marian Goodman Gallery, New York; pp. 88, 89 (top), courtesy the artist and Galerie Chantal Crousel, Paris; pp. 89 (center & bottom), 95, photos © Kleinefenn, courtesy the artist and Galerie Chantal

Crousel, Paris; p. 94, photo by Carol Shadford, courtesy the artist and Marian Goodman Gallery, New York; pp. 99–109, courtesy of 303 Gallery, New York.

HUMOR: pp. 4–5, 149–155, 157, photos by Joshua White, courtesy Regen Projects, Los Angeles; pp. 113–123, courtesy Ronald Feldman Fine Arts, New York; pp. 124–135, courtesy Paul Kasmin Gallery; pp. 137–138, 139 (bottom), 141–147, photos by Ellen Page Wilson, courtesy PaceWildenstein; pp. 139 (top), 140, photos by Kerry Ryan McFate, courtesy PaceWildenstein; pp. 156, photos by John Berens, courtesy Regen Projects, Los Angeles and David Zwirner, New York; pp. 158–159, courtesy Regen Projects, Los Angeles.

TIME: pp. 163, 165, 167–173, courtesy McKee Gallery, New York; pp. 164, 167, courtesy The Edward R. Broida Collection; pp. 166, photos by John Bigelow Taylor, courtesy McKee Gallery, New York; pp. 175–185, photos by Ace Gallery, courtesy Ace Gallery; pp. 186–188, 190 (top), 191, 192 (top), 193, 195, courtesy the artist and The Project, New York and Los Angeles; pp. 190 (bottom), 192 (bottom), photos by Erma Eastwick, courtesy the artist and The Project, New York and Los Angeles; p. 194, photo by Sheldon Collins, courtesy the artist and The Project, New York and Los Angeles; pp. 196–197, photo by Josh White, courtesy the artist and The Project, New York and Los Angeles; pp. 202–203, 207, photos by Michael Korol, courtesy McKee Gallery, New York; pp. 199–201, 204, 206, courtesy McKee Gallery, New York; p. 205, photo by David Woo, © David Woo; pp. 208–209, photo by Wardell Photography, © Wardell Photography.

PRODUCTION STILLS: pp. 8–13, 22–23, 72–73, 110–111, 160–161, 210–213, © Art21, Inc.

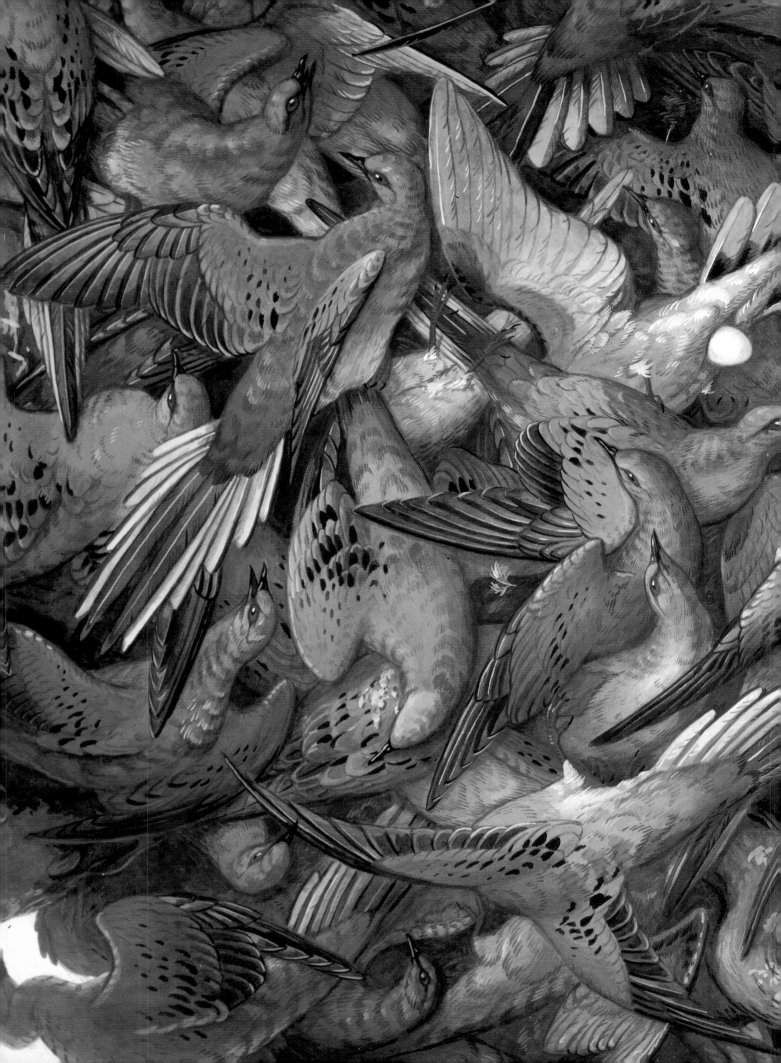